HOW IMAGES THINK

THE MIT PRESS CAMBRIDGE, MASSACHUSETTS LONDON, ENGLAND

RON BURNETT

HOW IMAGES THINK

This book was set in Gotham by Graphic Composition, Inc., Athens, Georgia, and was printed and bound in the United States of America.

Library of Congress Cataloging-in-Publication Data

Burnett, Ron, 1947–

How images think / Ron Burnett.

p. cm.

Includes bibliographical references and index.

ISBN 0-262-02549-3 (hc. : alk. paper)

1. Visual perception. 2. Imagery (Psychology) 3. Thought and thinking. I. Title.

BF241.B79 2004

153.3'2—dc21

2003052710

In memory of Johan van der Keuken,
photographer, filmmaker, teacher, and friend.

CONTENTS

ILLUSTRATIONS

ACKNOWLEDGMENTS

This book is the product of many conversations, interviews, meetings, and three years of writing. I could not have written the book without the support and encouragement of the Board of Governors of Emily Carr Institute of Art + Design. I was given a six-month sabbatical at a crucial point in the book's development, just enough time to bring together all of the many different pieces that I had assembled on the growth and development of new media. I would like to acknowledge the help and support of Emily Carr's former board chair, Georgia Marvin. I work with a team of people at Emily Carr: Michael Clifford, Wendy Wait, and Alisha Talarico. Their support during my absence was essential, and the book could not have been completed without their help. Monique Fouquet, Vice-President, Academic, encouraged me to continue working on the book, often in the face of daunting challenges. Our discussions both at Emily Carr and during many business trips were an important part of the evolution of the book.

It is not possible to acknowledge all of the people who have had a significant impact on my work, but I have learned from and been influenced by Jan Visser whose friendship and responsive criticism has always been constructive and supportive, as well as Dov Shinar who invited me to participate in one of the best conferences that I have attended over the last few years at Ben Gurion University. His colleague, Martin Elton, inspired me to a more historical approach in my analysis of new media. George Marcus and Michael Fischer have been very important to my work, as have Basarab Nicolescu and Michel Camus of the International Center for Research in Transdisciplinarity,

of which I am a member. Izumi Aizu's work on Internet security had a profound impact on my early research into the subject, and our discussions allowed me to think about networking in a very different way.

I was fortunate enough to be invited to New Zealand in 2002 as a William Evans Fellow, and over a three-week period at the University of Otago I presented many ideas that are in this book. I am grateful to Pamela Smart for her support and help during my stay at the university. Conversations with Brian Holmes, Brett Nicholls, Jo Smith, Kellie Burns, and Thierry Jutel were also very useful to me.

During the past three years I have been part of a team of people that has developed the New Media Innovation Center in Vancouver, which is devoted to research and development in new media and is a consortium of government, academia, and the corporate sector. Ron Martiniuk, Shahid Hussain, Alan Winter, Dave Chowdhury, David Vogt, Rodger Lea, Michael Hoch, Richard Smith, Andy Proehl, Eric Manning, Alan Boykiw, Sara Bailey, Maria Klawe, Fred Lake, Oleg Veryovka, and Norman Toms have all been very helpful.

A keynote presentation at a conference on interdisciplinary practices in the arts at Concordia University in March 2000 clarified some key ideas for me as did a series of presentations at York University, where I am an adjunct professor, Simon Fraser University, University of Western Sydney, and McQuarrie University. A number of presentations through the auspices of the American Educational Research Association and the Association for Educational Communications and Technology (Denver, Los Angeles, Montreal, and Dallas) also influenced my work on this book. In addition, I was asked to be a seminar leader at two conferences, *Visual Rhetoric* at Indiana University and *HearSay, 10 Conversations on Design* at the University of the Arts in Philadelphia. Both conferences clarified and sharpened my understanding of the role of images in the communications process. Thanks to Jamer Hunt and Barbara Biesecker for their invitations.

I learned a great deal from the following people in a variety of different and often unexpected ways: Hart Cohen, Chris Jones, Carol Gigliotti, Andrea Hull, Warren Sack, Ian Vercheres, Don Matrick, John Buchanan, Sharon Romero, Julian Gosper, Ryan Semeniuk, Loulwa Elali, Sean Cubitt, Eric Metcalfe, Hank Bull, the late Kate Craig, Yosef Wosk, Yusra Visser, Lya Visser, Justine Bizzocchi, Janine Marchessault, Jim Bizzocchi, Sara Coldrick, Ilana Snyder, Judy Russell, Manish Jain, Larry Green, Guy Larameé, Carol Becker, David Ticoll, Sheila Wallace, and Alan McMillan.

My close friend Virginia Fish has been a constant source of love and inspiration. Susan Feldman and her husband Danny have been a rock of

support and love for close to twenty years. My exchanges and discussions with Felix Mendelssohn have deepened my understanding of myself and my impulse to write and create. Shirley Daventry French continues to have a profound influence on me, as do friends like Mike Banwell, Frieda Miller, Danny Shapiro, Beverley Kort, and Ray Schacter.

I also want to thank Doug Sery, my editor at MIT Press, for his patience and support during the writing of this book as well as the external readers whose suggestions were invaluable in the final stages of writing.

My parents, Walter and Sophie, have always supported my dreams and aspirations. I thank them and my sister Sandy and her family for all of their support and love.

Above all, the love of my daughters, Maija and Katie, and my wife, Martha, has been instrumental in making this book a possibility. I dedicate this book to them.

INTRODUCTION

Throughout this book reference is made either directly or indirectly to debates about perception, mind, consciousness, and the role of images and culture in forming and shaping how humans interact with the world around them. As more knowledge is gained about the human mind, embodied and holistic, the role of culture and images has changed. Images are no longer just representations or interpreters of human actions. They have become central to every activity that connects humans to each other and to technology— mediators, progenitors, interfaces—as much reference points for information and knowledge as visualizations of human creativity. However, the relationship between human beings and the cultural artifacts they use and create is by no means direct or transparent. Human consciousness is not passive or simply a product of the cultural, social, or political context within which humans live and struggle. Although the cognitive sciences have dreamed of developing a clearer picture of how the mind operates and although there have been tremendous advances in understanding human thought, the human mind remains not only difficult to understand but relatively opaque in the information that can be gathered from it (Searle 1998, 83). Notwithstanding numerous efforts to "picture" and "decode" the ways in which the mind operates, profound questions remain about the relationships among mind, body, and brain and how all of the elements of consciousness interact with a variety of cultural and social environments and artifacts.

How Images Think explores the rich intersections of image creation, production, and communication within this context of debate about the mind and

human consciousness. In addition, the book examines cultural discourses about images and the impact of the digital revolution on the use of images in the communications process. The digital revolution is altering the fabric of research and practice in the sciences, arts, and engineering and challenging many conventional wisdoms about the seemingly transparent relationships between images and meaning, mind and thought, as well as culture and identity.

At the same time, a complex cultural and biological topology is being drawn of consciousness in order to illuminate and illustrate mental processes. I labor under no illusions that this topology will solve centuries of debate and discussion about how and why humans think and act. I do, however, make the point that images are a central feature of the many conundrums researchers have encountered in their examination of mind and body. One example of the centrality of images to the debate about human consciousness has been the appearance of increasingly sophisticated imaging and scanning technologies that try to "picture" the brain's operations. The results of research in this area have been impressive, and the impact on the cultural view of the brain has been enormous.

In general, this research has led to a more profound understanding of the rich complexity of the brain's operations. Since I am not a specialist in these disciplines, I do not comment in detail on the medical or scientific claims that have been made about the usefulness of the research. My main concern is the role played by images as the output of scanning procedures and the many different ways in which those images are appropriated and used. The use of scanned images is one of many indicators of the significant role played by image-worlds in sustaining research across the sciences.

For better or worse, depending on the perspectives one holds and the research bias one has, images are the raw material of scanning technologies like Magnetic Resonance Imagings (MRIs). In other words, the brain is visualized at a topological level, mapped according to various levels of excitation of a chemical and electrical nature, and researched and treated through the knowledge gained. MRI technology captures the molecular structure of human tissue, which produces enough of a magnetic charge to allow the signals to be reassembled into images. This is primarily a biological model and leaves many questions unanswered about mind, thought, and relationships between perception and thinking. In particular, the issues of how images are used to explain biological processes needs to be framed by cultural argument and cultural criticism.

These lacunae would not be an issue except that the use of images entails far more than the transparent relationship of scanning to results would

suggest. The biological metaphors at work make it appear as if the interpretation of scanning results were similar to looking at a wound or a suture. The effort is to create as much transparency as possible between the scans and their interpretation. But, as with any of the issues that are normally raised about interpretive processes, it is important to ask questions about the use of images for these purposes from a variety of perspectives, including, and most important, a cultural one.

The use of scanning technologies does not happen in a vacuum. Scientists spend a great deal of time cross-referencing their work and checking the interpretations that they make. (Many issues about image quality arise in the scanning process. These include, contrast, resolution, noise, and distortion. Any one of these elements can change the relationship between images and diagnosis.) The central issue for me is how to transfer the vast knowledge that has been gained from the study of images in a variety of disciplines, from cultural studies to communications, into disciplines like medicine, computer sciences and engineering, which have been central to the invention and use of scanning technologies.

In the same vein, how can the insights of the neurosciences be brought to bear in a substantial fashion on the research being pursued by cultural analysts, philosophers, and psychologists (Beaulieu 2002)? If, as I often mention in *How Images Think,* interpretations about the impact of technologies on humans flow from reductive notions of mind and thought, it is largely because I believe that consciousness cannot solely be understood in an empirical fashion. Even though a great deal of work has been published by writers such as John Searle, Jerry Fodor, and Noam Chomsky on the relationships of mind to thought, as well as on the infusion of biological metaphors into speculation about thinking and perception, many of their insights do not cross the boundaries into the sciences (Searle 1998, 1992; Fodor 2000; Chomsky 2000). This is a matter of disciplinary boundaries and the silos that exist between different research pursuits. It would not necessarily be a problem were it not for the manner in which some perspectives actually filter through and others don't.

I am an advocate of interdisciplinary studies and research. As someone who has studied the many ways in which images operate as information, objects for interpretation, sites for empathy and creativity, and windows onto the world, I feel that there is a need to infuse image analysis with as many perspectives as possible (Burnett 1995, 1996a, 1996b, 1999). Interdisciplinarity is very much about crossing boundaries, but it is also about rigor within disciplines themselves. It is the application of that rigor *across* disciplines that interests me and is a constant subtheme of this book (Latour 1999).

One outcome of the rich body of knowledge gained from scanning technologies is that the mind and the brain are increasingly viewed as input and output devices. This mechanical orientation has its roots in behavioral and computer-based models of mind, which have circulated within the sciences and popular cultural contexts for decades (Dennett 1998). I explore this issue at various points in *How Images Think,* and it hovers in the background of the book as a major concern. The dominance of mechanical metaphors of mind leads to reductive paradigms of communications and interaction among and between human subjects. From a cultural perspective, it becomes easy to talk about the relationships that viewers, users, and audiences develop with images through simplified notions of stimulus and effect. These reductive notions have been particularly powerful in discussions of new media and interactive technologies as well as with respect to computer games.

Within the life sciences there often is not a clear recognition of the differences between the brain as biological, as part of the living body, and the mind (Damasio 1999). In the cultural arena, much of the same biological information and research has been treated in a variety of different ways and has been the subject of many different perspectives without enough attention paid to the role of the life sciences. The work of Katherine Hayles and Janet Murray addresses the lineage of this research as well as provides overviews of the various levels of debate in this area (Hayles 1999; Murray 1997). In the life sciences and many disciplines in the humanities and social sciences, images are still talked about as if they had specifiable effects. The most limiting example of this is the powerful trope of images as purveyors of violence and transparent vistas onto the events of the world.

This book examines the power of these metaphors and what they say about the relationships that humans develop with the images that surround them. I am also concerned with the romantic and often superficial manner in which technological innovation is discussed as an outcome of image-based communications processes. (See Coyne 1999 for an excellent analysis of these issues.) This has implications for research into digital culture and virtual reality. The latter extends the computer from its desktop location into three-dimensional spaces of far greater complexity, yet remains locked into a variety of complex image-based metaphors that treat viewers from a behavioral perspective.

My emphasis on these issues is also the result of working in an interdisciplinary environment with groups of engineers and computer scientists. (I was an artist/designer at the New Media Innovation Center in Vancouver during 2002.) One quandry that I have faced is the easy fashion in which

computer programmers talk about "users." I have not resolved this ambiguous problem in *How Images Think.* I continue to use the term for lack of any other way of characterizing the complexity of human-computer interactions.

Images provoke and dismay. They are sites of intense and sometimes violent debate. The defacement of religious icons runs many risks, not the least of which are charges of heresy and possible death. In all of this, the vocabulary to describe viewers or in the case of digital technologies, users, is challenged by the shifting ground of human subjectivity and changing definitions of what it means to engage with image-worlds. Many different terms have appeared over the last few years that try to summarize the experiences of immersion and simulation. These include participant, navigator, immersant, and interactor. None seems capable of fully capturing the complexity of interaction with images, screens, and new technologies of visualization. It will take some time for this situation to change. This book explores the landscape of media forms that are challenging fundamental notions of viewing and spectatorship. I have a modest goal. If the terrain can be mapped, then perhaps some rich models of what it means to engage with new media can be applied to the task of rethinking how people are traversing and interpreting this new mediascape.

The notion of the user has its origins in a reductive model of human subjectivity and is essentially an engineering term. Tor Norretranders's brilliant book, *The User Illusion: Cutting Consciousness Down to Size* (1998), investigates this problem in great depth, and it is clear that richer paradigms of computer-human interaction are needed to move beyond the limitations of mechanical modes of thinking about digital technologies and their impact on human consciousness.

How Images Think also explores the technological context within which images operate and from which they gain their legitimacy. This raises the further question of how images think. In a *literal* sense, images do not think. However, a great deal of intelligence is being programmed into technologies and devices that use images as their main form of interaction and communications. The screens that mediate the relationships humans have to the technologies that surround them have become increasingly sophisticated both in texture and detail as well as in content and what can and cannot be done with them. I use the term *image* to refer to the complex set of interactions that constitute everyday life within image-worlds. The ubiquitous presence of images far exceeds the conventional notions that images are just objects for consumption, play, or information. Images are points of mediation that allow ac-

cess to a variety of different experiences (Latour 2002). Images are the interfaces that structure interaction, people, and the environments they share.

In that sense, this book is about the ecological framework within which a vast amount of intelligence is being placed into images for the purposes of communications and exchange. This is an ever expanding ecology that is altering not only the ways in which people interact with each other, but the very substance of those interactions. This alteration raises many issues, but *How Images Think* is concerned with the various cultural manifestations of this growing network of exchange from transformations in photography and photographic practices to the extraordinary growth and importance of computer games. The increasing interdependence shared by humans and their machines has led to more and more intelligence being programmed into a variety of technologies. The boundaries separating humans from their technological creations have become thinner and thinner. There is no better example of this change than cell phones. The earliest versions of these phones now look as if they came from a distant past, rather than ten or fifteen years ago. As cell phones mutate into Personal Digital Assistants (PDAs), video cameras, and game consoles, their use shifts the expectations that consumers have about human interaction and the communications process. Machines become the focus of a series of shared relationships that link technology to human need and vice versa.

This means that the newer technologies of the late twentieth and early twenty-first centuries are no longer just extensions of human abilities and needs; they are enlarging cultural and social preconceptions of the relationships between body and mind. Irrespective of the problems that this raises, this book explores both the implications of this shift and the foundations that are being built to sustain it. To the extent that a device can talk back to humans and images can mediate the conversation, some fragment of the thinking process is being moved from humans to their machines.

At the same time, there are now so many tools available for "envisioning" (imaging) the human body as a living, breathing, and material incarnation of information processes that the many claims that arise from this research must be examined. I am not suggesting that the human body is just "information." At a number of points in this book I critique that very idea. However, the metaphors of body as information are very powerful and cannot be dismissed. One of the cultural outcomes of a dependence upon scanning technologies is the assumption that mental processes can be translated into information. But a clear distinction has to be drawn between magnetic

Introduction

resonance images of the brain and their effectiveness in finding diseases of the body and the translation of thinking processes into images. I am not suggesting a Cartesian separation here between body and mind; rather, it seems obvious that the markers for disease are not the same as the markers for thought. The brain may lend itself to topographical mapping but little is revealed by claims that electrical activity can open a window into consciousness. The philosophically powerful suggestion that it might be possible to understand the human mind through imaging technologies says more about images and human desire than it does about thinking. This in no way dilutes the importance of the research. Rather, what needs to be understood are the metaphorical underpinnings that guide the conclusions scientists and cultural analysts are coming to from these efforts.

Many of the claims about understanding the operations of the mind through scanning imply that the barriers that separate images from humans (screens and other technological mediators) can be breached. This also represents one of the fundamental assumptions of research into virtual reality. Virtual reality as an experience seems to overcome distinctions among images, perception, feelings, and thought. Move too quickly in a three-dimensional world, and participants get nauseous. The experience of immersion using a helmet, for example, places the immersant in a space of intense intelligence where the body gives way to a dreamlike flow that joins daydreams with conscious perception. Where are images, sights, thoughts, and reflections located within virtual environments? They are certainly not in one place and, most assuredly, not only or singly within the minds of participants. The quality of the experience is largely the result of what I call a *middle space,* which combines the virtual and real into an environment of visualization that has the potential to displace conventional notions of subjectivity. This quality of thirdness is a middle ground within which new forms of exchange and interaction are created. The result is a continuum of experiences that are generated by a variety of creative choices on the part of viewers and users. The creative results cannot be attributed in a simple fashion to the images or participants. Much of this book tries to distill the characteristics of this complex and highly mediated space.

The ubiquity of computers means that they are increasingly being anthropomorphized, which for me is one of the best examples of the symbiotic relationships that humans have with their technological creations. My impulse throughout *How Images Think* is to examine the many different cultural manifestations of these integrative phenomena. As wary as I am of utopian claims about new media and new technologies, this book explores the cultural and

technological transformations that are redefining the relationships humans have developed with information, images, communications, and knowledge.

I developed a Web site for *How Images Think* that will be updated constantly and will reflect comments and feedback from readers, reviewers, and respondents (http://www.eciad.ca/~rburnett). I encourage readers to extend the terms of the debate in this book and to use the Web site as a locus for response and discussion.

CHAPTER ONE Vantage Point and Image-Worlds

Time past and time future

Allow but a little consciousness.

To be conscious is not to be in time

But only in time can the moment in the rose-garden,

The moment in the arbour where the rain beat,

The moment in the draughty church at smokefall

Be remembered; involved with past and future.

Only through time time is conquered.

—T. S. Eliot, "Burnt Norton"

I begin this chapter with an exploration of television not because this most important of mediums will be examined in any great detail in *How Images Think,* but because television's influence goes far beyond the boundaries of the medium. As I mentioned in the introduction, images are mediators between all the different layers of what are increasingly complex image-worlds. No technology has had a greater influence on this unfolding history of images than television.

Over the last decade the focus of television as a broadcast medium has changed from entertainment to news. This shift has been dramatic with international networks like BBC, FOX, and CNN spawning many local, national, and international imitators. The news now comes to audiences as a flow of information—part of a continuum with exceptional events as punctuation marks. This flow connects a variety of sources together (from the Internet to radio, daily newspapers, and many other media sources) and knits space, time, and history into a set of visual, oral and textual discourses that are for the most part based on the increasingly sophisticated use of images. The notion of flow that I am using is slightly different from the one that Raymond Williams developed (see Williams 1989).

Broader and more diffuse notions of information and visualization are replacing older forms of journalistic enquiry. Digital technologies are not just adding to this flow. On the contrary, the availability of the news on a twenty-four-hour basis through the Internet and television irrevocably alters the meaning not only of information but the formal means that are used to communicate ideas and events to broad and geographically nonspecific audiences.

In this context, the role of images as purveyors of meaning and aesthetic objects changes. What are the formal properties of images designed to "represent" the flow of relationships among a variety of events that are classified as newsworthy? How do images change when they move beyond boundaries of convention ("seeing" dead bodies) and standards of artifice (docudrama melts into documentary)?

Images combine all media forms and are a synthesis of language, discourse, and viewing. Images are not one isolated expression among many and are certainly not just objects or signs. Within the continuum I am discussing, CNN is a blur of sounds and pictures folding into the shows and channels that surround it. Live television merges with technologies in the home and is a portal into a variety of experiences and uses that link digital cameras, computers,

FIGURE 1.1 Screen shot, CNN.COM (April 4, 2002)

and games. In other words, images are both the outcome and progenitors of vast and interconnected image-worlds. All of these elements may have been discrete at one time or another but not anymore. Pictures of a series of crises, for example, come from so many sources, that the parts become the whole and the whole seems to have no end or even any parts. Viewers who watched the first Gulf War in 1991 and the invasion of Iraq in 2003 experienced the intensity and breadth of round-the-clock coverage. The same concentration of passion and despair characterized the events of September 11, 2001. During crises image-worlds become all-encompassing. This raises important issues about history and identity, some of which I respond to in this chapter, issues that are at the core of what is meant by experience, memory, and viewing at the beginning of the twenty-first century.

This screen shot of CNN.COM (figure 1.1) underlines the complexity of the continuum I have been discussing. Texts, images, stories, news, and the or-

ganization of information combine into an image that no sooner appears on the computer screen than it becomes part of another page and another set of images. The parts fold together as if there were no end in sight—a continuum. The television version of this has converted the TV screen into a multidimensional map with any number of different elements trying to burst out of the boundaries of the screen.

As part of this continuum, viewers begin their morning or nightly viewing experience engaging with a variety of image-based and often, news-oriented phenomena. The images might be centered on an event or a moment in history, a sitcom, or groups of people protesting the impact of globalization on the world's poor. Alternately, viewers may change the channel. They might be interested in the impact of the cinema on working class culture in Britain (Documentary Channel). They may have a desire to understand more fully why so many young people enjoy video games and go to entertainment centers throughout the world (Independent Film Channel). They may be interested, as I am, in the role of images in society, in their use and the ways in which they are incorporated into everyday life (the subject of a number of shows produced by the British Broadcasting Corporation). Some viewers may decide to play video games, some may choose to connect their digital cameras to the TV to view images of relatives, or some may turn on their computers and retrieve a completely different set of elements to further enhance their experiences of image-worlds.

This screen shot from the CBS site (figure 1.2) crosses all of the possible boundaries between the news and fiction. *America Fights Back* is set against *CSI* and *The Amazing Race*. The former is dramatic fiction and the latter, a mixture of reality shows, documentary, and old style game shows. But the centerpiece of the page is *Survivor,* which is one of the best examples of the synthesis of reality/fiction ever created on television.

All of these elements interact in sometimes new and unpredictable ways. Images become tools for the creation and expression as well as visualization of stories. Stories are never limited either by the medium used to express them or by viewers or listeners. It is this expansive landscape that has provided the media with a toehold in nearly all aspects of human life irrespective of nationality or ethnicity. The pervasive presence of narratives of every sort told through the multiplicity of shapes and forms of modern media far exceeds the conventional boundaries of human conversation and interaction. This excess is not a negative characteristic. Rather, it is a marker of the profound shift in the ways in which humans act upon the world both within

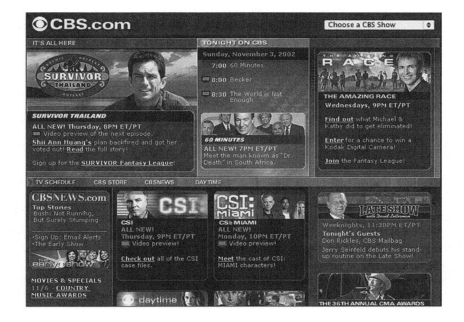

FIGURE 1.2 Screen shot, CBS.COM (April 1, 2002)

the media context and outside of it. In this chapter I begin to examine whether these claims about change and transformation hold up as images and as the cultural context within which they operate shifts from analogue to digital forms of expression.

Nature and Artifice in Image-Worlds

Television, radio, and the Internet are always on. The media don't disappear when viewers turn off electrical switches, just as electricity doesn't disappear when it is not being used. This continual presence is part of a new natural and constructed environment being built through human ingenuity and inventiveness. These are not simulated worlds. They are the world. The distinctions between what is natural and what is not natural have thankfully disappeared.

The trees on the horizon and the stars in the sky no longer come to viewers through a purity of process and vision divorced from the *images* they have seen of trees and stars. Over the last two centuries, Western societies have built physical and psychological infrastructures that are dependent upon images or what I call image-worlds. This pulls trees from their natural location into a more complex mediated space that is inscribed rather than natural. The images viewers watch are no longer just images; rather, as the great photographer Jeff Wall ([1998] 2002) has suggested, images represent a technological intelligence that shifts the ways humans see themselves, from individuals to hybrid personae, where identity no longer resides in one particular place, object, or person (90–92).

In this context, there are many identities within humans performing different functions, most of which are dependent upon the relationships humans have with image-worlds. Inside these worlds images disperse their content through screens physically housed within any number of technologies or media institutions. In other words, there is no such "thing" as an image divorced from a variety of media or social contexts of use and application. Most societies use a variety of materials to give life to images. And the beauty, as well as contradiction of this process, is that spectators become less and less aware of the influence of those materials upon the experience of viewing (Burnett 1995). In effect, the hybrid spaces viewers occupy reflect the competence and flexibility they have developed to handle the multiplicity of levels of communications and interaction with which they engage to survive. Events are no longer viewed through the simple relations of viewer and image; rather, viewers deal with increasingly complex discourses as they struggle to make sense of images that literally seep into every aspect of their lives.

For example, events on television are discussed as if the event and its depiction were one and the same or as if the screen that separates viewers from the event were unimportant. "An airplane has been hijacked," not "Those are images of an airplane hijacking," or "That is a depiction of an airplane hijacking," or even "Those images are smaller than the event itself." The viewer's challenge is to describe events as if the visual field, artifice, and form actually move language from representation to visualization. The event is internalized, personalized, and then discussed as if the images approximate "being there." Even though the event is heavily mediated by technology and medium, conventional categories of analysis and description, as well as conventional ways of talking about image-worlds make it appear as if mediation is unimportant.

In this context, images seem to be powerful enough to overcome how language is used to portray the events to which they refer (if indeed reference

as a concept is adequate to describe how humans interact with image-worlds). Viewers are continuously probing the boundaries among different levels of reality and image and among the various elements that constitute depiction, representation and visualization. The challenge is to find the connections and to make the experiences personal. The challenge is also to map the experiences of interacting with images into a process that is discursive, intellectual, and emotional so that it can be understood and applied to the viewing process. Part of the joy here derives from the ways in which viewers establish dialogues with images, the ways in which they talk to images, and the manner in which images talk to viewers.

I am fascinated with the stories that are told through this confusing haze of mediation, experience, and screen. The experience of viewing is, for the most part, about a struggle between proximity and distance. Viewers sit far enough away from the television or computer screen to be able to see its contents. At the same time, viewing is about the desire to enter into the screen and become a part of the images and to experience stories from within the settings made possible by the technology. I believe this explains the remarkable growth of video and computer games because they invite participants into the screen and give them the ability to change the graphic interface as well as the aesthetic look of the games they are playing. The games also actualize a collective engagement with technology in general. This is extended even further through Internet-based gaming cultures. However, video games are an intermediate step between conventional viewing and complete immersion. Their narrative content and structure are still evolving and it is unclear whether total immersion (the disappearance of mediation) is really possible or even desirable.

This struggle between closeness and distance is at the heart of storytelling. It is, after all, the role of the storyteller to weave language, images, and sounds into a magical space that listeners or spectators can move into and experience (Walton 1990). The sounds of someone telling a story are distant until the connection is found, and this permits the listener to enter a daydream that encourages the linking of sounds, and internal and external images. Films also encourage this type of entry into images and sounds and bring spectators closer to what is depicted while at the same time sustaining the distance between viewer and screen. Experiments in virtual reality immersion are about collapsing these boundaries, and they represent the next stage in the human love affair with images. At the same time, unless everything becomes image, it is unlikely that the tensions between closeness and distance will fade away. In fact, an argument can be made that they should not disappear.

As I have mentioned, images are increasingly intelligent instruments that can be used for so many different purposes that a titanic shift may be needed in the discourses that are used to examine them. It is not possible to be a part of Western culture *without* some reference to the impact of images on everyday life. By extension, the meaning of the term "image" has to be carefully rethought. In other words, it is not possible or desirable to talk about the social construction of meaning and messages without reference to images as sites of communication, miscommunication, mediation, and intelligence.

The issue is not whether there are images or phenomena to examine. The issue is what methods work best for each of the particular situations under examination. What focus should there be? What points of entry will facilitate the creation of rich and engaging discourses that will also be accessible and meaningful in trying to understand the convergence of human experiences and images? This is as much a challenge to the analyst as it is a challenge to viewers.

For example, what happens when there is a loss of consistency to the everyday experience of images and sounds—when expected patterns of explanation and interaction are disrupted as with the tragic events at the World Trade Center in September 2001? The importance of images to this event cannot be overstated. However, a great deal of what happened was beyond the images and instead was in people's houses, on the streets, and in shared thoughts about the pain and suffering of those who died. The images were powerful, but they were not enough as people looked for social contexts in which they could share their pain and shock at the events with others. Images of suffering have this dual effect of distance and closeness and are examples of the frailty of communication as well as its strength.

This raises other questions. Does human participation in and acceptance of image-worlds require new definitions of history and a radical reimagining of what it means to engage with events, both near and far? Are new definitions of place, locality, and community needed? Are images predicting a dramatic move to an oral culture, where notions of preservation and memory shift from written language and discourse to traces, fragments, the verbal, the musical, and the poetic (Carpenter 1970)?

Vantage Point

What methods of analysis will work best here and which methods have become less relevant? I suggest that method (the many ways in which the anal-

ysis of phenomena is approached, analyzed, and synthesized) is largely dependent on *vantage point,* a concept that is closely related to perspective and attitude. This means not only that the phenomenon is important, but also that position, placement, who one is and why one has chosen one form of analysis over another (ideological, philosophical, or personal) need to be transparently visible.

To varying degrees, I believe that images are not just products, representations, or copies of reality. Images are not the by-product of cultural activity. They are the way in which humans visualize themselves and how they communicate the results. They are at the very center of any coherent and historically informed definition that can be made of human nature and the cultural and social configurations that humans create. The construction, use, and distribution of images are fundamental to every culture. Furthermore, just as the human mind is wired for language, it is also wired for images. In fact, language, images, and sounds are inherent parts of human thought and the human body, as well as generative sites for the thinking, feeling process.

The ability that humans have to speak sits in an interdependent relationship with their aptitude to image and imagine the world around them. By extension, I agree with Noam Chomsky's carefully articulated argument that the ability humans have to use grammar is innate, although I am also convinced that experiences shape that innateness in early childhood (Chomsky 1968). Similarly, I believe that children are born with the ability to transform the world into images of an imaginary nature or through the application of sounds, fantasies, and dreams to experience (Winnicott 1965). Therefore, the ability to use and create images comes from an innate disposition that humans have that is sometimes proportionately balanced by experience and sometimes not. I am convinced that dreams are one of the royal roads into a world that does not need a narrator to be effective and that daydreams are among the most important residual strategies that humans make use of to manage the swirl of thoughts and images they encounter within themselves and in the environments of which they are a part (Grotstein 2000).

Seeing Sight

The vantage points I have chosen for this book can best be summarized through the following story. As a child, I was always fascinated with my eyes. I actively searched for some explanation for how my eyes worked. I wondered why seeing was a relatively unconscious process, although I didn't use those words. Most of the time, I scanned the world around me for particular points

that were more or less important depending on circumstance and state of mind. I read voraciously and watched television not only because it was a new medium, but also because it somehow grabbed me into a world I could not control. (I will return to this point often. One of the great errors of the modern concern for interactive technologies is the failure to understand the pure and unadulterated pleasure of simply allowing images and sounds to be in control—allowing the process to take over as in a dream.) Then, one day I was walking down to the basement of my parents' house and had this odd sensation that I was looking at myself *seeing*. It was a profound moment, as close to an epiphany as I have ever had. Fleetingly, I was able to step outside of myself and recognize the flow of seeing, the flowing contours of sight.

Seeing freed from the constraints of sight. Or perhaps, sight rediscovered through an act of insight.

Why is this story important and, to return to my earlier point, does it help in understanding vantage point? Perspective comes from many different strategies, tests, and hypotheses about experience. Therefore, perspective is not the result of one approach to reality or fantasy. The ability to see, seeing, that is to enter into a metaexperiential and metatheoretical relationship with the process of sight, is fundamental, to any critical analysis of culture. The "visible," the many phenomena available to sight, is always partial and fragmentary. As a result, vision and thought are an engagement with the various "pieces" that make up perception and subjectivity. But no analysis of subjectivity can ever account for all of the fragments, and, as a result, "the act of seeing with one's own eyes" is always contradictory because it is not clear if vantage points can really be found. That lack of clarity is the site of an intense struggle among a variety of subjectivities, which make up every human being.

The arguments I have been developing in this chapter are the result of self-observation and to varying degrees engagement with "cultures of vision" over a lifetime. This is where vantage point rears its head once again. There are many competing points of view about vision, but the bottom line for humanists is that an ethnographic study of viewers (valid up to a point, more concrete in some very limited ways) of what they see and why, for example, would still be faced with the same contradictions that I have just mentioned. A study of patterns of viewing in relation to different forms of expression will still end up making claims about perception and sight that are the product of what people say, feel, and think. And the central issue remains, what can be said about sight and vision, about processes that require inner reflection to be understood? According to John Berger (1980), "There is a widespread assumption that if one is interested in the visual, one's interest must be limited

to a technique of somehow *treating* the visual. Thus the visual is divided into categories of special interest: painting, photography, real appearances, dreams and so on. And what is forgotten—like all essential questions in a positivist culture—is the meaning and enigma of visibility itself" (41).

Berger captures a crucial point in this quote. The enigma of visibility is also the enigma of sight, but at least some evidence for these enigmas can be found in the everyday reality of image-worlds. The visual in all of its complexity can be broken down for the purposes of analysis and criticism, but essential components of vision will remain enigmatic. Submersion inside image-worlds is as fundamental to human existence as eating and breathing. The question of vantage point is thus even more important, but the solutions are not that self-evident. Image-worlds can be mapped but that suggests a geography that can be seen and comprehended. This circles back to the problem of seeing "sight."

This circle of contradictions is precisely why the *choice* of vantage point is so crucial. The challenges of vantage point have become even greater with the arrival of digital technologies, which have added more and more layers to image-worlds. The tensions of visualizing place and self have only increased. These tensions are productive, necessary, and often exhilarating. From my vantage point, these ambiguities are provocative enough to open up the "viewpoints" that are needed to enter into new and challenging discourses about the impact of image-worlds.

"There is a natural link between vision and light. It is not an accident that the 'enlightenment' was about learning and discovery, about new ways of bringing truth, discourse, science and religion into more productive relationships with each other. Light, in the fifteenth and sixteenth centuries, was as mysterious as the eyes themselves, the manifestation of a physical effect without simple causality." (Park 1997, 237)

Photography and Visualization

In order to explore these issues in greater depth, let me turn to the photograph in figure 1.3.

I took this photograph (figure 1.3) during a period of my life when I was thinking, dreaming, and reading about the Holocaust. A large part of my family was lost in this terrible event. I have lived my life in the shadows, stories, and metaphors of that experience and the familial memories that are attached to it. Yet, I did not set out to *shoot* this picture with the Holocaust in mind. How then can one "write" about this image? Does it "speak" to me? Am I conferring a particular and personal meaning onto the photo in an effort to

FIGURE 1.3 Smokestack against a night sky (Ron Burnett)

make it relevant? In fact, am I imposing a meaning upon it for the purposes of this discussion?

Is this photograph like a text? Must I "read" it in order to understand what it is saying? I recognized the importance of this photograph some weeks after it had been taken. What time does this photograph come from? Is it the time of its taking or the time of its interpretation? When exactly did all of these aesthetic, personal, and historical factors come into play? What if I had said that this photograph had been taken in 1944 or 1955? Can one "play" in such an arbitrary fashion with both the photo and the experience of viewing it? Should one?

An argument could be made that this photo more accurately documents *my* feelings than any other photo I have seen taken during the Holocaust or subsequently recovered from that period. Something happened when I saw the scene presented to me—and irrespective of the fact that there is no way of validating the relationships that I am establishing here, the process of interpretation is creating a variety of vantage points. Something distant—events, memories, and histories—comes into "view."

And perhaps that is the issue. Vantage point does not come in a simple or direct way but must be *created*. Seeing is an activity of creative engagement with processes of thinking and feeling, and, as a result, there is not a transparent relationship between figure 1.3 and its meaning. Seeing and thinking have often been bundled into reductive notions of perception as if perception were somehow less mediated and more instantaneous than just gazing or looking (Arnheim 1969). If to see is to create, then images are never "just" the product of one or many internal or external processes. The distance needed to understand "sight"—distance from an event, person, or picture—is created through an act of engagement that temporarily connects and overcomes the storm of thought within the human mind. Even familiarity with a scene may not provide enough information to make vantage point clear or usable for interpretive or experiential purposes.

This issue of creativity is central to *How Images Think*. The intersections of creativity, viewing, and critical reflection are fundamental to the very act of engaging with images in all of their forms. This would suggest that the notion of the passive viewer, for example, is a myth. The experiences of seeing images are always founded upon a series of engagements. To me, there is no such "person" as a couch potato (although it would be necessary to examine why that myth is so strong and why it has endured).

Figure 1.3 does have an intrinsic meaning for every viewer. I had to draw upon my personal history and create a text for the photograph. I find figure

1.3 extremely sensuous. As a result, I am able to move from its flatness and two-dimensional nature to words in an easy and unforced manner. At the same time, the symbolic "value" of the image seems to move it into the realm of representation.

I would prefer to "see" figure 1.3 as *visualization*. This is an important distinction. Visualization is about the relationship between images and human creativity. Conscious and unconscious relations play a significant role here. Creativity in this instance refers to the role of viewers in generating what they see in images. I am not talking about vision in general but the relationships that make it possible to engage with images. Visualization as a concept is also an entry point into the depth of the viewer's experience—a way of moving beyond the notion that there is depth "in" the image. Even more so, this approach tries to understand the various and complex ways in which a subjective basis for visualization can be analyzed.

Images do not stand in a symmetrical relationship with depiction, understanding, and analysis. To visualize also means to bring into being. This may eliminate some of the traps that the notion of representation sets, for example, that creators actually have a great deal of control over what they create and viewers generally respond in kind (Maynard 1997).

In a more general sense, how does one arrive at the meaning of images? The content of images and photographs seems to be self-evident. How large is the photo? What objects are present? What color do they have? Do the contents of the image translate into "smokestack" (Wittgenstein 1965, 2)? These are important questions about the character and nature of the photo, but they describe the empirical surface of what is being pictured. In order to deal with this image one would have to move to a higher level of abstraction (Barthes 1981). My comments about figure 1.3 provide a frame that surrounds the image and a context for examining it. My interpretation of the image would have been self-evident if I had added the caption "Holocaust" or "Auschwitz" to it.

My discussion transforms the photograph into a complex metaphor and may reveal the motivations that attracted me to the scene in the first place. In a general sense, the meaning of the photograph depends on the discursive efforts I put into it and on the tensions between my own interpretation and that of other viewers. This is at least one part of the creativity and tension of viewing, which encourages the development of a variety of different vantage points as well as contestation around the meaning of images.

In the nineteenth century photographs were seen as transparent windows onto the scenes that they pictured. This is why photographs were not regarded as "art" but as records of events, people, and environments. The im-

pact of that attitude remains to this day even as the introduction of digital techniques alters the terrain of expectations around truth and transparency in photographs. The problem is that when images are seen as records, the perspective that is chosen for analysis will generally shift to whether what they show reflects the reality the images are meant to depict. This locks images into a representational triangle of object, image, and viewer. The creative intervention of viewers is then seen as a disruption of the intentions of the image-creators rather than a necessary part of the process of visualization.

Some photographs are more opaque than others and derive their strength from a set of references that are internal to the aesthetic of the picture. This poses challenges of interpretation and explanation, as well as realism. Figure 1.3 does not "demonstrate" a clear relationship with the meaning and/or message(s) I am trying to communicate in this text. I conferred a particularly personal meaning onto figure 1.3. However, there need not be any congruence between what I say and what another viewer does with the photo. There is a constant tension between the universal and the particular here. This is because photographs suggest a *demonstrable* relationship between objects and subjects in pictures and what is seen, even though the activities of viewing are about different levels of visualization and often, increasingly complex levels of abstraction and thought (Mitchell 1992).

> "Images freeze movement, demonstrating choice. Once sights are set in pictures, fleeting experience is stilled. Movement is not banished; rather, it appears residual, a memory of the process of fashioning the image, a reference to potentially disturbing spaces beyond the edges of pictures."
> (Ossman 1994, 19)

However, since I consider viewing to be an intensely creative act, it is likely, if not desirable, that what I see is not what someone else will see. I am not suggesting that the interpretation of images is entirely subjective and relative. There are conventions, codes, and rules governing the elements in an image and its overall organization. The issue is what happens to images when they are placed into a viewing environment? Certain images say a great deal instantly, and it seems as if creative engagement were far less important than recognition and identification. I will return to this question, since I believe that what feels instant at one moment is not at another.

The images of the destruction of the World Trade Center by terrorists were not static; they immediately became part of a dynamic, ongoing historical process. It is precisely because images are the product of a particular moment that more must be added to them than is ever present in the images themselves. This excess, which is often seen as somehow interfering with the meaning of the image, is a necessary staging ground for interpretation and analysis (Deleuze 1986; Eco 1984).

Imagine someone standing to the side of figure 1.3, pointing toward it, and saying, "That is a smokestack set against a fiery sky." The image seems to become more specific and constrained. Yet the statement will only be valid if it is accepted. Images depend upon a shared agreement among viewers and a fairly structured set of conventions (Eco 1997, 57–122). Yet they remain a site of dispute if not contestation. There is a social and linguistic agreement to accept the word "smokestack" to describe a particular object, but the same arrangement has not been made with *images* of smokestacks.

This is what allows me to make a claim about figure 1.3—my claim, however, may not be true. This argument has important implications for what is meant by the term "image." In a sense, image as a term makes it appear as if all of these contradictions could be contained—this is the seduction—while at the same time, engaging with images far exceeds the boundaries of the frame and involves a process of visualization that cannot be constrained (the mental space of the viewer) nor should it be (Bourdieu 1990; Stafford 1996).

Clearly, figure 1.3 is related to images that I have seen of Auschwitz and other concentration camps. And, to some degree, it reflects an unconscious desire to possess those images—a desire to create some kind of present tense out of experiences that are historical but traumatically felt as if time had not passed. Photographs contribute to this sense that time has been marginalized even as they come to stand for events from the past.

In his book *The Art of Memory,* Francis Yates describes a useful distinction originally developed by Francis Bacon between active images and thinking. Bacon's goal was to distinguish between memories formed through the worship of idols and traditions of rational thought linked to the bible and its interpretation (see Huizinga 1966). In some respects, both Yates and Bacon point to a central issue in the history of photography. The appearance of photography in the nineteenth century resulted in many criticisms, including accusations that mechanically produced images would lead to the destruction of truth and therefore to the undermining of human memory. This has not happened. Photographic images have become the foundation upon which historical events are viewed and archived. Yet there is a lingering cultural sense that photographs can and often do lie. These tensions have increased as digital technologies have made it possible to alter photographs in more and more sophisticated ways. The active image in Bacon's sense is very much in the present tense (felt immediately, as in images of human suffering), in contrast to images that require more lengthy contemplation in order to be understood. It is the active image that risks overwhelming spectators so that questions of truth and rationality become secondary to the viewing experience.

According to Yates ([1966] 1974), "[Francis] Bacon fully subscribed to the ancient view that the active image impresses itself best on memory, and to the Thomist view that intellectual things are best remembered through sensible things" (372). Nevertheless, the active image is one that is never forgotten and remains sensuously engaged with viewers even as it is layered with more and more meanings. The presence of all of these layers moves the photograph from *its* time to another and perhaps more abstract moment. This tension is not between the present and the past; rather it is an expression of the problems that arise when different levels of expression collide with each other because time and history continuously recontextualize meaning and viewership. No photograph and no image retains its meaning for very long, which creates serious problems for vantage point. If there is so little stability, how can perspective be maintained?

This lack of stability suggests that different meanings have to be searched for in other ways and through other means. For example, who built the large buildings and infrastructure at Auschwitz that were necessary to kill so many people in a relatively short period of time? (There were actually twelve construction companies involved. They ranged from specialists in ventilation to a company that waterproofed the gas chambers.) Of course, figure 1.3 cannot reveal these details on its own which creates both a problem and a challenge for visualization and how memories can be contextualized.

There is a photograph available that shows Heinrich Himmler studying the plans for Auschwitz with an engineer of the IG Farben Company. How could that photograph be included in figure 1.3? The map reproduced in figure 1.4 indicates the closeness of the factory to the concentration camp. The point is that figure 1.3 cannot contain enough of the historical elements of the situation to allow for the breadth of interpretation and analysis I am developing here.

Images piled upon images. Memories contained by images in frames. Ideas that move far beyond what individual images signify. The process of layering through language and analysis, as well as through the exploration of "seeing" leads in many different directions. The photograph of a smokestack reaching to the sky brings to mind Alain Resnais's devastating exploration of Auschwitz in *Night and Fog,* the film that he made in 1955.

The images in the film, as Bacon suggested, have never disappeared from my memories of the war itself. Yet I was born after the war. This means that I am combining images, films, stories, a whole host of media, a plethora of texts, and familial testimonies into a series of memories and discourses that bring all of these pieces together. This is precisely what *Night and Fog* does as a film because Resnais cannot return to the moments he describes and pic-

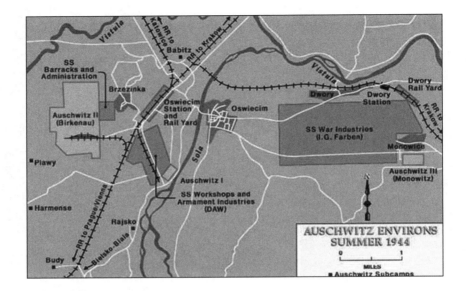

FIGURE 1.4 Map of Auschwitz

tures in the film. This is a good example of a set of relationships formed through a chain of interrelated images and texts where there is no real unity to the outcome.

It is evidence of my submersion in a world that is almost entirely made up of traces, in which no message is complete in and of itself. It is this incompleteness and the inability of images to assert absolute meanings that sustains the viewer's interest in them as instruments of exchange and communications. It is also why images are so multidimensional even in those instances when they picture something in a very direct or active way.

However, the personal and discursive process that permits claims to be made that there is a difference between images and people's experiences of them needs to be explored. When someone says, "That is not a picture of me," is he or she claiming that the picture is not a likeness or that the image cannot contain or express the subjective sense that the person has of himself or herself?

For example, a photographer snaps an image of Jane. When Jane sees it, the photographer says, "I took that photo of you!" It appears as if the image can stand for Jane and will be used by the photographer to illustrate Jane's appearance to a variety of different spectators. In a sense, the image separates itself from Jane and becomes an autonomous expression, a container with a label and a particular purpose. For better or worse, the photo speaks of Jane, and often *for* her.

The photograph of Jane is scanned into a computer and then placed onto a Web site. It is also e-mailed to friends and family. Some of Jane's relatives print the image and others place it in a folder of similar photos in their computers, a virtual photographic album. In all of these instances, Jane travels from one location to another and is viewed and reviewed in a number of different contexts. At no point does anyone say, "This is not a picture of Jane." Therefore, one can assume that a variety of viewers are accepting the likeness and find that the photo reinforces their subjective experience of Jane as a person, friend, and relative.

The photograph of Jane becomes part of the memory that people have of her, and when they look at the photo a variety of feelings are stirred up that have more to do with the viewer than Jane. Nevertheless, Jane appears to be present through the photo, and, for those who live far away from her, the photograph soon becomes the only way that she can be seen and remembered.

Picture the following. Jane's photograph is on a mantel. When Jane's mother walks by, she stares at her daughter's picture and then kisses it. Often, when Jane's mother is lonely, she speaks to the image and, in a variety of ways, thinks that the image speaks back to her. Jane's mother knows that the photograph cannot speak; yet, there is something about Jane's expression that encourages her mother to transform the image from a static representation to something far more complex, in other words to *visualize* her daughter's presence and to recreate the distance between herself and the image.

This example points out that the language of description that usually accompanies a photograph cannot fully account for its mystery. It is as if the photograph exceeds the boundaries of its frame in an almost continuous fashion and brings forth a dialogue that encourages a break in the silence that usually surrounds it. Where does this power come from? It cannot simply be a product of the emotional investment in the image. To draw that conclusion would be to somehow mute the very personal manner in which the image is internalized and the many ways in which it is made relevant to human experience (Deleuze 1988).

Could it be that viewers see from the position of the image? Do they not have to place themselves inside the photograph in order to transform it into something they can believe in? Aren't they simultaneously witnesses and participants? Don't they gain pleasure from knowing that Jane is absent and yet so powerfully present? Isn't this the root of a deeply nostalgic feeling that overwhelms the image and brings forth a set of emotions that cannot be located simply in memories (Baudrillard 1990)?

What would happen if someone tore up the photograph? The thought is a difficult one. It somehow violates a sacred trust. It also violates Jane. Yet if the photo were simply a piece of paper with some chemicals fixed upon its surface, then the violence would appear to be nothing. Why and how does the image exceed its material base?

This question cannot be answered without reflecting upon the history of images and the growth and use of images in every facet of human life, in other words the creation of image-worlds. Long before humans understood why, images formed the basis upon which they defined their relationships to their experiences and to space and time (Jay 1993). Long before there was any effort to translate information into formal written languages, humans used images to communicate with each other and with a variety of imaginary creatures, worlds, and gods (O'Donnell 1998). The need to externalize an internal world, to project the self and one's thoughts into images remains as fundamental as the act of breathing. Life could not continue without some way of creating images to bear witness to the complexities of human experience, and this applies to those instances in which images were banned or destroyed. This wondrous ability, the magic of which surrounds people from the moment they are born, is a universal characteristic of every culture, social, and economic formation. This is the case with language and what needs to be understand and accepted is the degree to which it is the same with images (Mitchell 1986).

The invention of photography, for example, did not happen in a vacuum. Aside from the long history of experimentation with chemistry that preceded the insight that light leaves a trace on certain surfaces that have been treated with chemicals, centuries of experimentation with images of every type and shape occurred (Hillis 1999). Photography simply reflected a continuing and quite complex desire to translate and transform the world into many different forms. Images are not a reflection of this desire; they are the very incarnation of the need to take hold of the world and visualize experience. Images are one of the crucial ways in which the world becomes real (Scharf 1968; Kittler 1986).

Images are also one of the most fundamental grounds upon which humans build notions of embodiment. It is for that reason that images are never

simply enframed by their content. The excess this produces is a direct result of what people do with images as they incorporate them into their identities and emotions. Images speak to people because to see is to be within and outside of the body. Images are used as a prop to construct and maintain the legitimacy of sight. It is as if sight could not exist without the images that surround most cultures. The translation of sight into various forms of expression suggests that vision and images are codependent (Hayles 2002).

Think for a moment of the shock that comes from looking at the world through a camera obscura. Here is a device whose sole purpose is to translate the world into images. Why not simply revel in the delights of seeing? Why build an apparatus that reduces the world to an image? Perhaps, images are not reductions. Perhaps, they are the very basis upon which the body and the eye can manage the experience of being in the world. Perhaps, it would not be possible to see without images? If that were true, then the impulse to create the camera obscura, as well as the many experiments that took place at the same time, came from a deeper source. Ultimately, there may be a need to simulate the world in order to understand it, but this would introduce even more mediators into the experiences of seeing and understanding than I have mentioned up until now (Stephens 1998; Levi-Strauss 1997).

This is something that Roland Barthes (1981) recognized when he declared early on in *Camera Lucida* that he "wanted to be a primitive, without culture" (7). Barthes did not want to know about all the cultural mediators that transformed a photograph of his mother from being a simple reflection of her face and body into a complex artifact. He wanted to experience the kind of direct pleasure that sensuously and instantaneously connects viewers to what they see. This is similar to the Thomist view that Yates mentions in the earlier quotation. It is at the heart of why time seems to disappear in photographs, not because of depiction or realism, but because memories of past scenes are lost and regained every time a photograph is viewed and because the excess that is generated transforms images into traces within and outside time.

This excess cannot be derived in a simple sense from photographs themselves and reveals as much about the strength of memory as it does about the fickleness of "remembering." It is both the force and the frailty of remembering through "sensible things." What is sensible can be approached as if in a dream, and dreams can be approached as if they were part of reality. In all of this, the visible world that is recovered by billions of photographs shot by humans of every culture, stands as an encyclopedic compendium of the human desire to preserve the endless circle of memories and forgetting, dreams and insights, experiences and reflections.

HE You saw nothing in Hiroshima. Nothing.

SHE I saw everything. Everything.

SHE The hospital, for instance, I saw it. I'm sure I did.
 There is a hospital in Hiroshima. How could I help seeing it?

HE You did not see the hospital in Hiroshima.
 You saw nothing in Hiroshima.

SHE Four times at the museum . . .

HE What museum in Hiroshima?

SHE Four times at the museum in Hiroshima. I saw the people walking
 around. The people walk around, lost in thought, among the photo-
 graphs, the reconstructions, for want of something else, among the
 photographs, the photographs, the reconstructions, for want of
 something else, the explanations, for want of something else.

— Marguerite Duras, *Hiroshima Mon Amour*

The main character, Riva, in the film *Hiroshima Mon Amour,* from which this dialogue is taken, has "forgotten" her love affair with a German soldier during the war. *Hiroshima Mon Amour* explores the slow unveiling of her repressed memories as a trope for the ways in which forgetting becomes endemic and trauma is forgotten (Burnett 1995, 178–182). According to Primo Levi (1988), "Human memory is a marvelous but fallacious instrument. This is a threadbare truth known not only to psychologists but also to anyone who has paid attention to the behavior of those who surround him, or even to his own behavior. The memories which lie within us are not carved in stone; not only do they tend to become erased as the years go by, but often they change, or even grow, by incorporating extraneous features" (23).

Levi, of course, had to tell the tale of his experiences at Auschwitz over and over again in a variety of stories and through a variety of metaphors, much as Jorge Semprun, the French writer, in order to keep the trauma alive not only for himself but for succeeding generations. For Levi, history had to be lived everyday to be understood. Semprun (1997) has spent his life exploring and testifying to the experiences of being a prisoner at Buchenwald:

I'd need only to close my eyes, even today. It wouldn't take any effort—on the contrary, the slightest distraction of a memory brimful of trifles, of petty joys, would be enough to summon that ghost. . . . It would take only a single instant of distraction from oneself, from others, from the world, an instant of non-desire, of quietude this side of life, an instant when the truth of that long-

ago, primal event would rise to the surface, and the strange smell would drift over the hillside of the Ettersberg, that foreign homeland to which I always return. (Pp. 6–7)

In *Hiroshima Mon Amour,* a seemingly endless series of conversations "produces" a reawakening—history comes to life because the past always exists within the present and because speech, memory, and image cannot be disengaged. (This is one of the central themes of "Burnt Norton," the poem by T. S. Eliot quoted at the beginning of this chapter.)

Yet, this is one of the fundamental ambiguities of images whether moving or still, which "announce" a relationship to time (and to a period) while marginalizing history. The instant of a photograph is in fact only one moment of history and is therefore open to many different interpretations. The same variability exists in the cinema and other media. A photograph shot in one period of history becomes archival in the next. In fact, some photos are almost instantly archival such as pictures from wars and large-scale human tragedies.

There is an irony here, because traumatic events are more often than not the *most* difficult experiences to remember, let alone picture. It is by bearing witness to trauma that humans learn how to connect time, subjective experiences, and history. Weaving trauma into art, images, and aesthetic forms is part of bearing witness to occurrences that cannot be understood or experienced in any other manner (Felman and Laub 1992, 57).

Levi and Semprun work with words and stories, and they move easily between fiction and nonfiction. The difficulty with images is that they bear witness in very different ways and make it seem as if events could be pictured or reconstructed when they can only be *reimagined.* This is perhaps one of the greatest ironies of historical photographs. They are meant to demonstrate a relationship to the past that appears to be empirical but, for the most part, their impact is almost entirely contingent upon the imagination of viewers (Baer 2002).

Technology and Vantage Point

Technology seems to elevate photographs beyond these kinds of relative and contingent restrictions. Instruments, tools, and technologies seem to be neutral purveyors of the interests of humans. Unlike literature, the use of technology to bear witness to trauma supposedly elevates pictures, for example, to a level of truth that does not need additional explanation.

Yet, this is clearly one of the central issues of vantage point. The story of an event is not the event itself. At any given moment, as events are mediated by everything from the medium of expression to the imagination of the individual viewer, a chasm is created that spectators have to bridge. This is one of the sources of visualization. It is as if the bridge between event and depiction needed to be created, but since that is a physical impossibility, it is done mentally and from within carefully constructed and imaginative scenarios, what I would like to call a 'dynamic daydream.'

Figure 1.3 is therefore as much a reflection of what I know as it is an expression of what I have remembered *and* repressed. It is a visualization of events that I have not experienced. My desire to "take" the photograph and to witness a scene that cannot be *reproduced* is what makes this image important. Auschwitz cannot be reproduced not only because of the horror that it represents but also because of the very nature of history *as* a set of traces open to continual reinvention in the present.

Michel Serres (1995) suggests that "people usually confuse time and the measurement of time" (60–61). Photographs make it seem as if time can be seen and the past is waiting to be "produced" in order to be understood. In reality, photographs and images are traces or signs of what *may* have been. There is a constant interplay between events, their recounting, and images. And, for the most part, all these elements exist in contingent relations with each other. This is a challenging fluidity since it suggests that the ways in which viewers *link* the traces is far less dependent on what is depicted than might appear to be the case.

What then happens to memories and images of trauma when an even more complex aesthetic and artistic process is introduced?

In figure 1.5 I have taken the original photograph and altered it digitally. It now seems as if figure 1.3 were the original and figure 1.5 is a transformation. I have moved (seemingly) from the record of a moment and experience to a more aesthetic and mediated version. Is it valid to ask which is the more mediated of the two? What if the viewer had come upon figure 1.5 before seeing figure 1.3? This is at the heart of the paradox about photographic truth. Photographs are only records if viewers agree by convention that truth is present. This agreement often comes in an instant, as recognition. It can also be validated by a variety of social and cultural processes.

If photographs are always a medium for reimagining the scenes that they depict then the differences between figures 1.3 and 1.5 are not that important. This may explain why the content of a photograph is always open to challenge. It is as if reinvention were as important to viewing as the image it-

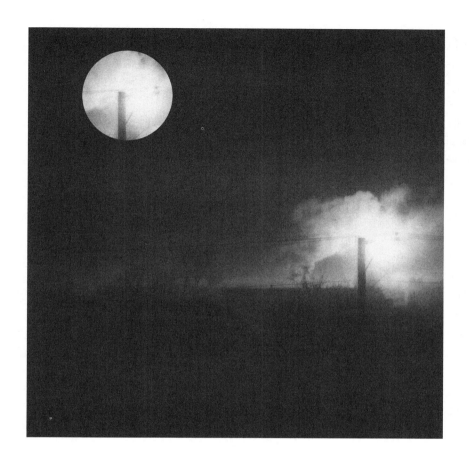

FIGURE 1.5 Smokestack against a night sky with moon (Ron Burnett)

In a short but important work on the Holocaust, historian Saul Friedländer comments on what he feels is the "indiscriminate word and image overload on topics that call for so much restraint, hesitation, groping, on events that we are so far from understanding" (1984, 96). This is a crucial point. Yet, it has not stopped an endless procession of images and texts on the Holocaust from appearing year after year. This is a situation in which the excesses of the image cannot constrain the boundaries of exploration and visualization. In part, this is because the Holocaust can only be visualized in fragmentary form.

self. Is there an identifiable pattern to these relationships that explains their interaction? A variety of potential connections and disconnections exist among reinvention, visualization, imagination, and retelling. But it is not clear that a claim can be made about the patterns and therefore about the conventions that govern any one of the four categories that I have just mentioned. The challenge is to work with these categories as if images were only a part of what is ultimately a creative process *for viewers.*

In figure 1.5, I have gone from "taking" a photograph to *creating* an image. The smokestack no longer has the same set of references; rather, I imposed a new set of potential meanings upon the process and operations of the medium. Figure 1.3 is a scanned Polaroid picture, while figure 1.5 has been scanned into my computer and altered inside Adobe Photoshop. It was compressed into a JPEG before being imported into the word processor that I am using.

Are all of these processes simply minor variations on an existing theme? Or do they speak of the fluidity and fickleness of images in general? Is it true that images are things or objects that can be handled in any number of different ways? Each effort to handle images is really about a set of relationships among subjects *and* objects, capable of exchanging positions all of the time (Latour 1996). The questions about what is pictured and what is real or not real have to do with vantage point and not necessarily what is in the image. The irony is that when photography initially became a mass medium, the ambivalence about its truth-value increased. With time, the very photographs that were challenged for their authenticity have become historical documents, treasures, as it were. This shift toward archival value is about the strengths and weaknesses of human memory. Oral cultures sustained stories and myths for generations without archives. Western cultures need archives to validate memory.

From Analogue to Digital Photography

Analogue pictures have now become one of the standards for the measurement of historical truth. But what happens when

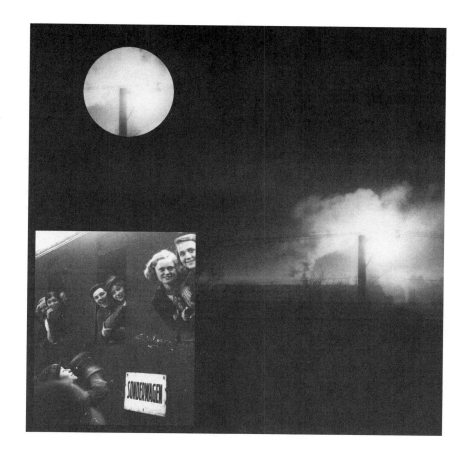

FIGURE 1.6 Smokestack against a night sky with train, Vienna, 1938 (Ron Burnett)

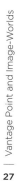

analogue and digital pictures can be mixed or when digital pictures increasingly become the norm? Digital images fundamentally alter not only meaning but also materiality; images become defined by the layers of artifice that have been placed in them. Reference then becomes a function of the interior organization and architecture of the photograph, the traces of what has been done to it and the manner in which those traces are interpreted. This has always been recognized with respect to painting, and the move to digital technology will make it clearer in photography as well. It may be that it is of no value to speak of "taking" a photo; rather, value must be extracted from what is visualized or recreated by both creators and viewers.

Up until now, I have used "photograph" and "image" interchangeably. To me, photographs become images the minute they are seen. The moment that photographs enter into relationships with subjects they shift from one level of reality to another. It could, of course, be argued that photographs never work in isolation of creators or viewers. That is precisely why photographs only exist in the instant they are shot. That is also why Barthes was so perplexed by meaning in photographs, because he tried to link the instant creation of images with postmortem analyses. The shift to the digital has shown that photographs are simply raw material for an endless series of digressions. They lie tethered to moments that have long since disappeared. As images, photographs encourage viewers to move beyond the physical world even as they assert the value of memory, place, and original moments. In that sense, the flow of references does not end with the photograph as an object. Rather, every photograph that becomes an image pivots on a variety of contingent directions.

The beauty is that images are so malleable; they encourage processes of sculpting, change, and transformation. They invite the addition of words and texts. Photographs permit and encourage an eruption of fantasy *as if* they had become subjects. I return to this argument in chapter 4 when I discuss virtual reality experimentation in greater detail, but it should now be clear that my concerns for the many ways in which images contribute to the creation of meaning requires a redefinition of the subject-object distinction as it has been applied to visualization.

Figure 1.6 is a further transformation of the original Polaroid. In the left-hand corner there is a cropped picture of a train leaving Vienna before the war. The people you see leaning out of the train are leaving their families for an unknown future. One of those people is my mother.

The train, of course, brings other memories to bear, including the ways in which the Germans transported Jews and many other nationalities to the

concentration camps. The transformation of figure 1.3 now means that it is more of a collage than a photograph. There is an increasingly tenuous connection to the original, and intention is more visible, or so it seems. The image began as an innocent "snapshot" and has become a rhetorical device in the development of an argument. In a sense, I am beginning to "write" on the picture, recasting the original impulses or perhaps more fully understanding them. I am also trying to bring more evidence of the original motivations for taking the photograph into its actual makeup.

Increasingly, the distinctions that might allow for some consistency in the original photograph are being disrupted. This is not so much a matter of tinkering with the original as it is bringing the power of discourse into the actual construction of the photograph itself and therefore moving beyond the "instant" of its taking. Clearly, time is being altered to fit the orientation that I am choosing. For example, was the time spent working in Photoshop more important and more significant than the historical elements of the image and when it was shot? What has scanning done to the original photograph of the train, and has the fact that the photograph has become a data file changed its meaning? Am I violating the poignancy of the original photo of my mother by cropping it?

In figure 1.7 the image has a third element to it, a photograph of my paternal grandmother and great-grandmother. The former, Elly, survived the war, and the latter, Helene, died in Auschwitz.

The image, including its mixtures of color and shape, is becoming more and more stylized. Although elements are being added to it, the language that I am using to describe the photo tends to naturalize the relationship between what I am saying and what I want the photo to mean. There is also an inevitable tension between what I am saying and creating and another viewer's own relationship to the image. Even more important, I am identifying the faces in the image(s) and claiming that there is a relationship between "their" time and my own.

In fact, by personalizing this image, I am diluting the flexibility that viewers may need to produce their own interpretation. I not only made the original "historical," but I added elements to reinforce my initial premise about the photo and used archival images to validate my interpretation. Keep in mind that I have introduced a series of "effects" into the Polaroid to accentuate the photograph's ability to "speak" in the full knowledge that it is my own voice that I want viewers to hear. However, this is a site of struggle rather than a place where my needs will be fulfilled. As any creative person discovers, the gap between intention and communication is vast and requires a variety of

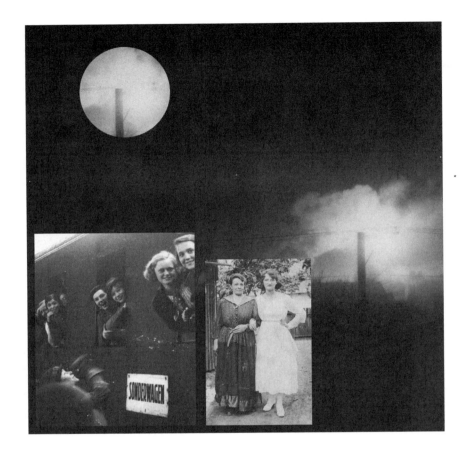

FIGURE 1.7 Smokestack against a night sky, mother, grandmother, and great-
grandmother (Ron Burnett)

compromises that often seem to have nothing to do with the images themselves. Of course, I am arguing that the compromises are part of a negotiation that is at the core of how image-worlds operate (Weiss 1989).

Voice is an ongoing problem for photographs. The fact that technology has to be used to "take" the photo implies that the role of the photographer is actually less important in the creative act. The photograph seems to be disengaged from its creator. James Elkins (1999) suggests, as does Roland Barthes, the following: "Fundamentally, I think we wish pictures could sometimes be pure, devoid of codes, signs, letters, numbers, or any other structured sources of meaning. At the same time, we hope that the pictures we are interested in will always have enough structure to yield meanings—to be, in the inevitable metaphor, legible" (57).

This contradictory desire for purity and legibility, for instant recognition and understanding, is part of the reason that so much "intention" is conferred onto cameras. Thus, the quality of a lens is equated with the quality of an image and sometimes given as much weight as the photographer herself. Polaroid photographs are seen as instant, quick, and produced through a process that does not have as much intentionality attached to it as a carefully composed 35-mm shot. Purity and legibility can mean that technology has replaced the creator of the image. What is the balance between the camera eye and the human eye? Which side of this unsteady fulcrum is best suited for analytical purposes (Sontag 1978)? For example, what has the image of the smokestack in figure 1.3 been modeled on? The "scene" was there for me to capture or, it could be said, that the scene captured me. Did I "create" it, or is it just a snapshot? Whose voice is dominant here and how can it be discerned from the photograph? What is legible and what is not (Tyler 1987)?

Rather than assuming it is the *real* that has to be captured or reproduced, the *production* of the real as image may be one of the foundations for the visible and may be the key sign of voice at work (Vasseleu 1998). Historical information can be reshaped to fit into the framework provided by images. Nevertheless, the difficult issue here is that there is no necessary equation between history and image. This means that the integration of images into every aspect of modern culture has resulted in a sophisticated and yet inevitably flawed inventory of images that is supposed to point toward the real and toward history.

I would make the claim that very little of what is described as the real exists in isolation of its double as image *and* text. In other words, it is not just the case that images depict events. Images and events coexist within a shared context and are part of a shared foundation that upholds and gives coherence

to reality. This doppelganger is a source of tremendous energy and anxiety (Kember 1998). It is also the reason why it seems so difficult to find vantage points that would allow some perspective to be taken with respect to events, images, creativity, and interpretation (Schwartz 1996).

Although figure 1.3 is not a copy of the smokestacks at Auschwitz, it hints at a relationship with the past. The vantage point that I have chosen allows for an interpretation that brings the original concentration camp smokestacks into a relationship with the present. This "production" and visualization of the real bring some coherence to memory, but also become the basis for new memories.

Vantage point is about the rather tenuous relationship or perspective that is used to describe these interactions. The statement "This is a picture of my grandmother" lends empirical weight to the image, produces the image, and attempts to mirror the past while, at the same time, *situating* figure 1.7 and recreating it. My vantage point allows me to make all of these claims, but, for the most part, they are not verifiable. I can point to the contingencies, assert their validity, and argue about the truth, but none of this will resolve the ambiguous power that my discourse has over the picture.

I am reversing the conventional notion (and cultural myth) that images have the power to overwhelm the viewer, and I am describing a process that is far more *collaborative*. I am arguing that this creative engagement with pictures begins the moment that images enter into relationships with viewers. I am making the claim that images are not outside of conventional perceptual activities, not the place where things happen that don't happen elsewhere. Rather, images are integral to, and are at the foundation of, visual, linguistic, and perceptual processes.

It is not the case that what viewers watch *as* image comes to them in the form of a tabula rasa, nor is it the case that spectators approach images in isolation of their historical relationship to photography in general. In fact, photography has been a part of historical discourse since the invention of the medium, although it took until the 1960s for the skepticism about pictorial truth to become diluted. Now there is a complete reversal, where the value of images *as history* far exceeds their capacity to visualize the past.

As I have been saying, images are fundamental to the growth and development of human consciousness (Piaget 1951; Chomsky 2000). The role of language is equally foundational. According to Steven Pinker (1997),

The eminent psychologist D. O. Hebb once wrote, "You can hardly turn around in psychology without bumping into the image." Give people a list of

nouns to memorize, and they will imagine them interacting in bizarre images. Give them factual questions like "Does a flea have a mouth?" and they will visualize the flea and "look for" the mouth. And, of course, give them a complex shape at an unfamiliar orientation, and they will rotate its image to a familiar one. (P. 285)

Pinker is pointing toward the power of visualization, and although Hebb was a behaviorist and thus not really concerned with images as sites of recreation or fantasy, Pinker's comments make it clear that imagination is at the heart of what he means by mind.

These fundamental issues of language, thought, and images will be dealt with in greater detail in this book. For the moment, it is crucial to understand that images are both mental and physical, within the body and mind, and outside the body and mind. To see images is also to be seeing *with* images. The visual field is as psychological as it is "real" and external to the viewer. From a cognitive point of view it is just not possible to separate what has been seen from what has been thought, and the question is, why would that type of separation be suggested or even thought of as necessary (Ramachandran and Blakeslee 1998)?

There is no particular sequence to the activities of visual engagement. To be able to see and understand images means that human subjects have already been engaging in the process. Spectators often think of their engagement with images as some sort of input process, as if humans were merely reacting to what they see and not collaborating in the creation of the experience. If any allowance were to be made for the complexities that characterize the multifaceted lived experiences that human subjects have, then the ability and the competence to view images cannot be reduced to the simplicity of input/output models (Edelman 1989, 2000).

Another way of thinking about these claims is through the following example. Disgust at the image of a child running from a village that has been napalmed can be shared by a wide variety of different people, but disgust is not *in* the photo (Chong 1998). *Disgust is the representation.*

It is commonly assumed that what is seen in a photograph is something that represents something else. A photographed tree is accepted as such, even though the tree has been reduced to a small size and is two-dimensional. Culturally, this jump in logic seems natural because the language that allows the word "tree" to be used in the first place doesn't change dramatically because there is an image of a tree. But the tree as image is only there by virtue of an agreement that is both cultural and individual. This agreement says that

the image can be used to refer to "tree" without any necessary loss in meaning (Rorty 1991).

Disgust is the product of a relationship that links and reinforces these agreements about meaning and represents the conventions as well as the social context that has made them possible. It is what I bring to bear on the photograph, how I frame and examine my experience, what my experience and sense of identity is, that converts the interaction into feelings of disgust. This is why even the most painful of images can be looked at, in part because the images are not the experience but point to some of its elements.

In a similar vein, the pain that I feel looking at figure 1.4 (a map) is of course present to me, but only to the degree that it is seen as such, only to the extent that there is an agreement that links history to cultural convention and my experience to the Holocaust. However powerful, images remain within a set of relationships that are based on the creative and interpretive abilities of viewers. Figure 1.4 requires a quick movement into it and a projection as well as identification with the pain of the past, but this does not happen solely as a function of the map itself. If the instant of recognition were the only important feature of figure 1.4, then all of the complex attachments of the map to its history and context would disappear. It would speak with even less of a voice than it deserves.

Earlier in this chapter I spoke about ambiguity and the particular way in which photographs nurture contradictory meanings that require the intervention of human subjects to generate and create order. Often, images promote a quick and recognizable clarity. That is both their power and a source of their undoing. The challenge is to move the image continuously around so that its context can be examined from a variety of perspectives and vantage points. For example, the photograph I mentioned of a child running from a napalmed village during the Vietnam War and a Viet Cong soldier being shot in the head are intensely voyeuristic, posing crucial questions about the photographers who took them, their motivations, and the need to place the images into the context of the news. Keep in mind, I am not claiming that I know why the photographers took the shots. I am simply addressing my own reaction and trying to examine the relationship between the immediacy of my reaction and my skepticism about the assumed spontaneity of the photographer's role.

Why were there cameras at those scenes in the first place? Of the many photographs taken during the Vietnam War, why were these used as extreme examples of brutality, and why have they remained so famous? If these two photographs have become symbols of the wrongheadedness of the Vietnam

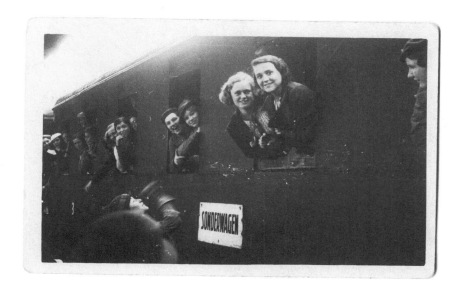

FIGURE 1.8 Leaving Vienna, 1938

War and the role of the Americans in it, was this the reason that they were taken? Does the exposure of the child's body suggest something about the desire of the photographer for intensity and effect? All of these questions may simply return the images to their point of departure as powerful antiwar statements. But if the photograph is to be taken beyond its role as a phenomenon, then the levels of meaning I have suggested need to be mapped. This mapping will allow the image to be replaced, recreated, then positioned in a loop of communications, visualization, and exchange.

How Images Become Virtual

Figure 1.8 is a shift away from figure 1.3, to an archival image that is over sixty-two years old. Yet it is no more original than the Polaroid. It is a *virtual* image of an historical event, a train leaving from Vienna just prior to the beginning of World War II. The stages through which this photo has become virtual are listed in figure 1.9.

FIGURE 1.9 The trajectory of figure 1.8 from visualization to the virtual

The events that influenced the departure of my mother from Vienna in 1938 would have happened with or without the photo being taken. Yet, after the events, the photo helped create a shared familial and communal knowledge about the war and the Holocaust. It is not a record in the strict sense of that word, meaning a pure reproduction. Historical events overwhelm efforts to reproduce what has happened. The representations are always traces. The full historical quality of figure 1.8 cannot be flushed out through the photo itself. This is both the dilemma and potential richness of the photo. A variety of intellectual and discursive tools must be applied to the photo in order to move beyond an initial view of it. These tools will dynamically reengage viewers every time they come across the photo, and it is this reengagement that converts the photo into an image. Note that in figure 1.9 representation is at some distance from the more essential tasks of visualization.

The transition from event to photograph suggests a relationship without creating interdependence between history and image. At the same time,

the photographs immediately become archival and objects of interpretation quite distinct and different from the moment in which they were taken. Once the photo has an archival quality, a great deal of historical weight is placed upon it (Price 1994). Increasingly, it becomes a vehicle for interpretation and, in so doing, becomes a metaphor for the event. As an archival object its location in time changes, and the web of conversation and discourse around the image grows ever larger. As metaphor, it can only suggest a part of what happened, a trace of how the event came to be and why. This process can be viewed as evolutionary, but it is also ambiguous. The ambiguity comes from the distance between the event and the metaphors used to explain the events that caused the image to be taken in the first place. It is this fluidity and the fact that the image can be used and viewed in any number of different ways that "virtualizes" it (Grau 1999a, 1999b).

A claim can be made that the image has no ontological validity unless and until the archival, metaphorical, and virtual qualities of the image have been fully explored. This moves the process of interpretation beyond the "first" look of an image and requires a shift into the labyrinth of metaphor. This process in no way removes the image from its emotional impact. In fact, a significant part of the communication process remains silent, without words, and is not dependent upon the discourse that is applied to the image. There will always be both tension and contradiction between what is said and what is experienced with images. I would locate the creativity of viewing inside this tension. This is as much a struggle with language that seems inadequate in relation to what has been seen as it is a struggle with the ontological validity of what has been pictured or created by photographers.

Figure 1.10 is a photograph of Auschwitz that was taken in 2002 by the photographer Judith Lermer Crawley. It is a multilayered visualization of the prisoner's barracks and smokestacks. Is it a more realistic depiction than figure 1.3? On the surface, that would seem to be the case. I would claim that although Crawley shot this on location, the photo moves far beyond the parameters of the camp itself and invokes a generalized view of all such horrific symbols of war and death. In that sense, time is both irrelevant and at the center of the photo. The image virtualizes the past and negates a simple or direct look. To "site" this image is to drag it from the past into the present and back again. It is to both identify with horror and disavow the flood of memories that the image engenders. The photo can play as flexible a role as the spectator desires, and this can lead to its undoing—to irrelevance. Alternately, the activity of viewing can be brought into a process of visualization and discursive richness, which means engaging with the image in many different ways and

FIGURE 1.10 From the exhibition *About Auschwitz* (Judith Lermer Crawley).
Used by permission.

not allowing that first look to be the only reference point for the experience. This means that the trauma of the event itself recedes into the background as the image becomes "virtualized." The struggle of interpretation, then, is between the virtual status of the image and knowledge of events, history, and language.

 Chapter 2 explores the movement from images to visualizations and the resulting creation of virtual, image-based environments. Digital images are in many ways a practical solution to the dilemmas that I have been describing in this chapter. As more "intelligence" is processed into image-worlds, the question of the boundary between humans and images becomes ever more complex. At the same time, digital worlds are very much about the integration of images into every aspect of human activity, and therefore they underscore the importance of understanding how images think.

CHAPTER TWO Imagescapes, Mind and Body

The Meaning of Existence

Everything except language

knows the meaning of existence.

Trees, planets, rivers, time

know nothing else. They express it

moment by moment as the universe.

Even this fool of a body

lives it in part, and would

have full dignity within it

but for the ignorant freedom

of my talking mind.

— Les Murray, "The Meaning of Existence"

In chapter 1, I explored some central cultural assumptions about images, how images communicate, and why images are often assumed to be the *source* of a communications process when they are actually a middle ground for intervention and interpretation by spectators and creators. I used some photographs to make the point that the middle ground between images and subjects is where the process of communications gains its character and meaning. Now I would like to explore another aspect of this process. When viewers interact with images they engage in an activity of visualization that is similar to the *reverie* that music listeners drift into when they "listen" to a song or a symphony. I want to stress that this is not a passive activity and that, as I mentioned in the last chapter, the notion that viewing or listening is passive has contributed to a profound misunderstanding of what "interactivity" means in the digital age.

In this chapter, I also deepen the examination of the move from images to imagescapes in an effort to broaden the cultural view that is held of pictures and photographs as well as the roles of participants and viewers. The term *imagescapes* does not just suggest spatial metaphors. Rather, it provides a way of mapping the relationships among a variety of different processes, all of which are also located in time—not only the time of viewing or the time of experience, but the combined time of creation and interaction. The gaps among creativity, viewing, and interpretation are not as broad as might appear to be the case. There is no moment of interaction that is not also a moment of creativity, and this is perhaps the most important link between creative people and their audiences. This is why I prefer reverie as a way of thinking about spectatorship because it brings the multiplicity or the multimodal nature of image and sound-based experiences at all levels into the foreground of analysis (Bergson and George 1956).

Reverie in relation to images is not very well understood in large measure because of an inherent bias about eyes and vision, a bias that tends to think about seeing as a far more precise activity than it ever is or could be. There is a further cultural narrowness about the crucial role sound plays in image-based communications processes. Spatial metaphors about images tend to fix the aesthetic and formal organization of meaning, as if the experiences of being a spectator were not an evolutionary or dynamic one. Part of the reason reverie is so important is that images remain imprisoned by the realities of mediation and screens even as the middle ground of which I have been speaking allows spectators to break out of that straightjacket.

The most sophisticated of virtual reality installations relies on the use of mediated screen-based technologies and then proposes a more active response (which is why the term "navigation" is so often used to describe the experience of being an immersant). Three-dimensional worlds built through the use of computers and experienced with head-mounted displays allow for the sensations associated with touching and feeling objects to be replicated through sensors, gloves, and acoustic and magnetic input devices. Yet, and this is the extraordinary thing, even with all of the mediators and technologies that are used, imagescapes remain places that encourage direct, unmediated experiences. I would like to suggest that the reason these processes remain so powerful is because the modes of interaction are varied enough that different people with different needs and perspectives will nevertheless find some place for themselves inside these heavily constructed spaces. This is largely because imagescapes have enough fluidity that meaning is never just a function of what is in images, what has been intended, or what has been constructed for the purposes of display. The combination of reverie, empathy, and the need to give meanings to sight encourages the process of visualization.

There are many metaphors used to support not only an attachment to but also a dependence upon images and the worlds that they make possible. Most of the metaphors in the list below are dependent upon the technology of image creation in a variety of media. The list speaks to the complex performances of meaning that various forms of visualization engender, particularly within image-worlds.

- Images as windows
- Images as mirrors
- Images as entertainment
- Images for learning
- Images as exploration
- Images as excitement
- Images as information
- Images as truth
- Images as lies
- Images as immersive
- Images as presence/absence
- Images as dreams
- Images as traces
- Images as shadows

- Images as artifacts
- Images as notations

Crucially, it is the many ways in which images "materialize" metaphors that gives them such transformative power. Image-words are about creating a context for embodiment, although it has been common to consider images as sites of disembodiment. The distance of spectators from images is one of the reasons that embodiment is possible. To be at a distance means that some very basic problems have to be solved. These include whether and how the metaphorical world can be experienced and how to give meaning to a variety of physical sensations.

The challenge is how to give body to vision and hearing even though acts of viewing and listening are such fundamental human activities. What, after all, does it mean to be moved to tears by images? It is clear that image-worlds extend and enhance existing forms of embodiment, a major reason, I would think, for their attraction (Woolley 1992; Turkle 1995). I explore these issues in greater depth in chapters 3 and 4, but for the moment I would suggest that the many metaphors in use for images are the result of the symbiotic relationship humans have with them. The metaphors are also evidence of the need to clarify the interdependence people have with image-words.

The metaphor of images as windows onto and into worlds that could not otherwise be seen has remained very powerful even in the digital age (see figure 2.1). Yet, what does this window depict? The anonymity of the landscape and location is as important as the image itself. Perhaps, images provide people with the very plasticity that the act of looking at a scene cannot supply.

One of the questions I am concerned with in *How Images Think* is the knowledge that all viewers need to understand and experience the vast and complex imagescapes that are encountered on a daily basis. This may seem to be a transparent issue, but I consider it to be a crucial as well as complex cultural concern that needs exploration. The reason for this is that viewers have ceased to be spectators in the traditional definitions that have been used for this term. To some degree, spectators have "evolved" beyond the parameters of viewing in the sense of distance and separation, "the images over there"—to living within the confines of a world where images in the broadest sense intersect with the real at all times.

To be within images is not to be suffocated by them; rather, images are vistas on the brilliance of the human imagination, and perhaps this is

FIGURE 2.1 Window at dusk (Ron Burnett)

why images are simultaneously loved, desired, and feared. Immersion in the image-world is simply part of what it means to be human and is perhaps the best example of how pivotal to human activity and self-definition image-scapes have become in the twenty-first century.

Content and Compression in Image-Worlds

In this chapter I approach the many levels that make up this image-world as if the layers were evidence of a living archaeology. Imagine the hundreds of layers that constitute this world and then imagine slicing through them. Each layer is relatively stable, living, and metaphorically speaking, breathing and contributing to the overall structure of the image-world. It could be said, at

Screens become portals to new ways of seeing and understanding.

Instantaneous connections bring lightness to the flow of ideas, information, and images through space and time.

It now takes violent storms on the sun or earth to disrupt the movement of images and ideas from one place to another.

Geography is as important as it always was except that a new definition of place has been added to the meaning of nation and community.

Images have gone from surface to depth.

least in Western cultures, that viewers have spent much of the twentieth century trying to learn how to become comfortable with this environment. Yet, a general cultural unease remains central to the ambiguous relationship viewers have with images. Television, for example, has generally been viewed as a distraction, entertainment in the sense of the trivial, the unimportant. Many people pride themselves on the fact they do not watch television and assume that those who do are overly dependent upon the medium for entertainment and information. These metaphors of subservience are very powerful. They are often linked to the idea that television overwhelms viewers, hence the notion of the spectator uncritically accepting everything thrown his or her way.

Most forms of image production and creation have been treated in a similar manner throughout the twentieth century. It will be important to challenge this attitude in large measure because it has so heavily influenced not only the production of images but also the thinking behind what it means to create interactive image-based environments (Benedikt 1992).

Photography was already a well-developed medium at the end of the nineteenth century. But moving images were not, and the combined effects of rapid industrialization in the West and the increasing importance of a variety of communications technologies meant that cinematic images became part of the popular imaginary well before there was any understanding of why they were attractive in the first place. The cinema became universal far more quickly than anyone anticipated it would (Burnett 1991). However, the critical and theoretical exploration of the cinema, a literature of critique and analysis, only emerged with great force in the latter half of the twentieth century (with a few notable exceptions).

The same problems repeated themselves with television and other media, and, most important for the present, with the rapid move to digital forms of production and creation. As more and more forms of image production have arrived on the cultural scene and as images have become vehicles not only for the communication of meaning but for

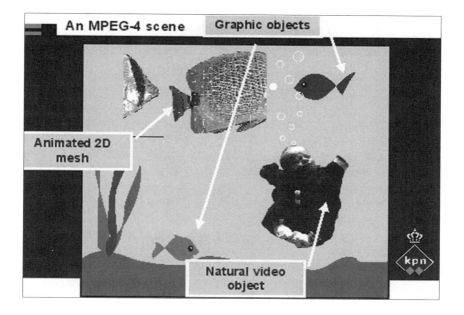

FIGURE 2.2 Image compression—MPEG 4 (Rob Koenen). (http://mpeg
.telecomitalialab.com/documents/ic_tutorial/rob/ppframe.htm)

the creation of environments, the problems of developing critical discourses
to understand these phenomena have grown.

This raises questions about the movement of images from their con-
ventional locations into the far more complex environment of the computer.
To what degree are the images on a computer screen similar to or different
from the images on a film screen? What do compression technologies do to
conventional notions of information and image? This is a fascinating issue,
since compression is actually about the reduction of information and the re-
moval through an algorithmic process of those elements of an image that are
deemed to be less important than others. The more compressed, the more
that is missing, as data is eliminated or colors removed. The reduction is in-
visible to the human eye, but tell that to the image-creator who has worked
hard to place "content" in a particular way in a series of images and for whom
every aesthetic change is potentially a transformation of the original intent.

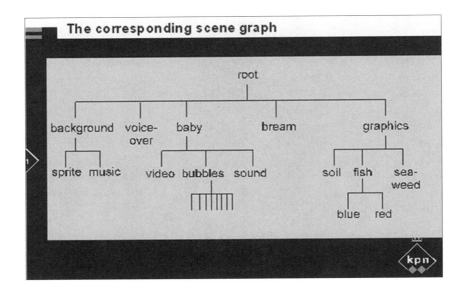

FIGURE 2.3 Corresponding scene graph for image compression (Rob Koenen).
(http://mpeg.telecomitalialab.com/documents/ic_tutorial/rob/
ppframe.htm)

Compression technologies like MPEG-4 are designed to facilitate the communications of images that are used in games, mobile multimedia, streaming video, and digital television. This means that nearly all aspects of the future use of images will employ some form of compression, which is distinctly different from the analogue properties of screen-based environments. Compression is but one feature of the many subtle transformations that are taking place in the communication of images. More importantly, these transformations are also about a shift in the ways in which meaning is constructed within digital media. There *is* a difference between compressed and noncompressed images. It may well be that compression as a process is the single most important characteristic of digital images and what distinguishes the digital from the analogue.

Here is part of the sequence generated to "represent" the relationship between animated and nonanimated images compressed for the express pur-

pose of reducing the amount of information communicated across a network. Any assumptions about the similarity between computer-based image generation and conventional assumptions about the cinema, for example, should be dispelled by this example (figure 2.2).

The images have to be deconstructed in order to be reconstituted. This example (figure 2.3) looks a great deal like a linguistic diagram in which a sentence is broken down into its syntactic and semantic elements. The compression process is as much about mathematical abstraction as it is about the generation of images. The combination of algorithmic formulae and image generation decisively alters what is meant by images.

The relationships that normally defined the projection of images or the ways in which they were printed have also changed dramatically. These changes are as much about "content" in the traditional sense of that word, as they are about a new sense of what it means to "design" images for the purposes of communicating meaning (Barry 1997).

In the digital world "form" is largely determined by compression and the transformation of image sequences into information. The conversion of images into information makes them far more adaptable, flexible, and changeable. The irony is that in the analogue television world a camera transforms what it captures or shoots into electrical signals, which are then transmitted to videotape for recording. A further conversion from electrical signal to frames means that the human eye can be tricked into thinking that information has become image—data has moved from the electrical to the concrete.

I have discussed the transformative impact of the move from the analogue to the digital in such detail because, for the most part, there is a tendency to assume that images remain constant. In other words, the move from the analogue to the digital doesn't change the basic fundamentals of communication using images. However, in the analogue world images are not information in the sense that they have become bits and pixels in the digital world. In fact, some serious questions need to be asked about the role of aesthetics and design as the distinction between images and information blurs into pixels, lines, and rates of compression. Further questions must be raised about what happens to images that are products of programming processes and have been generated inside the virtual spaces of a computer.

Daydreams, Reverie, and Images

This brings me back to reverie and the rather complex process of engaging with imagescapes. For better or worse, one of the crucial guiding cultural as-

sumptions about viewer-image interactions is that a causal relationship exists between what is shown and what is experienced. Images are thought about as both the site of meaning and the reason why viewers have certain experiences and not others. Images, it is assumed, are the place where the exchange begins. In contrast, reverie is about the interplay among thoughts, daydreams, listening, and viewing, and it is part of a continuum into which some images fit and others don't (Crary 1999). The activities of viewing are a creative engagement with all of these levels without necessarily privileging one or the other. The continuity of experiences here means that imagescapes are just one element in a continuous flow of exchanges that are never discretely separate (Johnson 1987).

Most moments of viewing or listening simultaneously interact with daydreams and thought processes. Viewers, in a metaphorical sense, move into images and outside of them. The experiences seem to be embodied and disembodied at the same time. Viewers are separate from the images and yet deeply concerned with experiencing them. This multiplicity of levels allows for and encourages a mixture of imaginary and real emotions—perceptions and reflections on what has been seen, understood, or experienced. It is possible to inhabit the worlds that are viewed, and, just as quickly, it is possible to step outside, all the while interpreting each phase and thereby generating others. The experience of imagescapes is not just about taking in what is there; it is also about creating a dynamic interrelationship that continuously evolves in much the same way that human consciousness is never static or fixed.

Reverie is about "giving in" to the viewing experience, being entertained, as well as being able to recognize the extent to which one has to be in the "mood" to confer so much power to images and sounds. Being in the mood, feeling ready, settling down in one's seat or one's sofa, are ways in which viewers create and maintain the ground upon which the viewing process develops. Conscious and unconscious processes interact—there are no visible boundaries, just a circular continuum of entry and exit points largely defined by the "need" for images and the pleasure and pain that images bring. I see these many levels of interaction as poetic, as images move from the realm of the objective into shared spaces of reverie and imagination. This is why these experiences need to be talked about using a model of shared intelligence and collaboration. Image-worlds are sites of exposition but also places of perpetual interaction, and it is this (among many other elements), which pushes the entire process toward reverie.

Imagescapes and Bodies

The imagescapes generated by simulation, computer games, digital cinema, and popular culture need to be explored in order to comprehend more fully the intersections of culture, experience, and identity. These analyses will be dependent upon a reimagined sense of the importance of images to the meanings and experiences that make up everyday life. The integration of image-worlds into the fabric of human identity has implications that go far beyond the images themselves. I am making an ontological claim here that connects technology and the production of artifacts within technospheres to the human body in a far more holistic fashion than is normally the case.

Discussions of images and their influence usually take place within the humanities and social sciences. It would be just as rare for a physicist to undertake an analysis of popular culture as it would be for a cultural analyst to study the mathematical basis for quantum theory. I am not suggesting that such crossovers don't take place. Rather, the distinctions between disciplines are deeper than that and are centered on the perceived differences among social and cultural phenomena, and biology and nature. In other words, bodies are, to varying degrees, material and can be studied from within the seemingly firm foundations of the sciences, while culture is more of a product of this process than its progenitor. This debate has been present within Western culture since its inception. But, as I mentioned in the introduction, it has particular relevance now when the distinctions between reality, the material world, and human bodies are being challenged by digital scanning technologies that seem capable of imaging the body in hitherto unimaginable ways.

The brain is a biological construct, part of an organism, and although imaging devices have provided extraordinary insights into the operations of the brain, magnetic resonance images are seen as windows into the operations of the mind. I would suggest that there is a relationship between the ways in which the brain is imaged and the efforts within popular culture to "depict" the body, mind and the brain (e.g., in the film *Fantastic Voyage* (1966) a group of scientists are miniaturized and travel through the arteries of a man who has a blood clot in his brain). This seems to be a leap that devalues the "hardness" of the neurosciences. Yet, I believe that a film like *Fantastic Voyage* is evidence of a circle of cultural metaphors that say a great deal about the links between cultural phenomena and research in the biological sciences. The links here are about the production of images and the various imaginary and real viewpoints that humans have of their bodies.

What is the difference between images of the human body produced through magnetic resonance and images produced by cameras? At first glance, this question may seem to be absurd. The purpose of a Magnetic Resonance Imaging (MRI) is to provide pictures of the insides of humans. But the reality is that magnetic resonance images have to be reconstituted by computers in order to be seen. "The use of computer displays, specifically picture archiving and communication systems (PACS), has become essential for the radiologist to cope with this increasing array of images with extended gray-scale range" (Uttecht and

This point will become even more significant in the context of three-dimensional visualizations and the use of scanning devices to "picture" the insides of human beings. (Scanning in three-dimensions will increase the complexity and modes of circulation of body-images.) This circle of cultural metaphors influences the "interpretive" strategies of radiologists who look at the visualizations that are produced through scanning technologies (Shapin 1998). (See chapter 6 for more details on this issue.)

Essentially, I am talking about the ways in which knowledge is produced and context is clearly as important as output. At another level, the knowledge that is gained from brain scanning, for example, remains image-based. In that sense, nearly all of the qualities, frailties, and inherent ambiguities of images are not eliminated by the claims of biological verisimilitude. The actual equation of scan with cognition (e.g., there is a part of the brain involved in making it possible to see and understand images) cannot map the cultural, class, or gender content of sight and perception (Waldby 2000).

However, a melding of the insights of cultural analysis with the neurosciences might make it possible to comprehend the transformation of biological activity into cultural mapping and human identity. The common misunderstanding of an MRI is that an image of the body is generated through the process. Rather, MRIs produce images of the body that are represented as a series of slices, and radiologists have to know how to interpret the results (although they are aided by software that generalizes from the scans of thousands of other bodies): "The capacity to acquire many MR images at higher sampling densities and with multiple contrast types has evolved rapidly in clinical radiology. The human capabilities to view, integrate and interpret these vast quantities of multidimensional images and maps in a timely manner have been challenged to maintain parity with acquisition capacity" (Uttecht and Thulborn 2002, 73). In other words, a great deal of training is needed to interpret magnetic resonance images in a manner that would be consistent with the desired results, and even then there are many possible ambiguities that can arise.

There is no prior moment in which the images of the brain preexist their inclusion into a system of values that have very specific cultural and social anchors. This means that however physical or objective the results of a brain scan may be, the scan must "fit" into a set of preexisting and quite normative assumptions about consciousness (Edelman 1989). Not only do the images have to be spoken about, they remain open to interpretation, if not misinterpretation. A brain scan is as much about cues and traces as it is about possible biological states. The scan never preexists all of these elements. Rather, scans are about bringing the elements together and developing a coherent and potentially empirical analysis of the outcomes of the process. It is this interdependence of culture and nature that magnetic resonance images exemplify.

Adapting to Images

Although this discussion raises questions about the "realism" of images, it is not my main concern. Scans clearly have an empirical value. The issue is the relationships among specialists, technologies, and interpretation. It is essential not to put interpretation to the side, as if the images as well as the process transcend the potential pitfalls of less empirical approaches to research. What is at stake here is the definition of context, that is, the place within which embodied humans cast a wary eye on their own creative and scientific endeavors.

Gerald Edelman (1989) deals with the relationship between organism and context by referring to the "density" of perceptions—the many parallel, sometimes contradictory levels at which interactions take place between organisms and their environments (255). For Edelman, the challenge is to describe processes that precede the move into language, although he knows that thinking is ongoing and that the brain, language, and thought don't work in some sort of mechanical sequence. For my purposes, as I suggested earlier, images are as important as language in forming and activating biological processes. By this I mean that consciousness and the links among perception, conception, and the electrochemical interactions of the brain are as dependent upon images as upon memory and language. To this must be added not only the ability to perceive the world but also the ability to construct internal images at a variety of different levels. There is a far more intimate relationship

Thulborn 2002, 73). In other words, the authors are reporting on the difficulty of translating and interpreting all of the information produced through imaging processes that are not the direct result of conventional camera-based approaches to capturing images of the human body.

among internal image processes, perception, and imagescapes than is usually assumed.

In this context, the markers for an effective scan are quite conventional. An experienced eye will see things that a novice might not. This moves the issues back into the realm of interpretation and away from simple notions of scientific veracity, but it also raises issues about the semiotics of internal "views" of an organism. A scan that reveals a blocked artery seems to indicate a simple and transparent symptomatic expression of disease. The "signs" are clear. Yet, a gaping hole remains between blockage and the history of the individual, their genetic background and the speed with which the blockage will lead to crisis. The image, in other words, is only part of the story. I have referred to scanning both in this chapter and earlier because MRI's and CT scans challenge many assumptions about the body and what is meant by seeing. A long history of scientific illustration preceded the introduction and development of scans, and the relationship between scientific illustration and photography, in general, has not been given the attention that it deserves.

I discussed part of the answer in chapter 1; image-worlds are inherent to every activity pursued by humans. Another part of the answer is the primacy of vision in everyday life, not just the act of seeing, but the complex manner in which sight comes to stand for consciousness. At the same time, as more and more technologies direct themselves toward enlarging and extending the range of visual experiences, the process of human adaptation to those technologies grows ever more complex. Technological innovation may drive the capture and transmission of images, but has far less to do with the various and often eclectic ways in which humans interpret and recreate what they see than is assumed by social and cultural critics. The globalization of image exchange and transmission means that questions of adaptation, use, and interaction need to be approached with great care. Stephen Jay Gould (2002) frames the debate on adaptation as follows: "Adaptation may be viewed as a problem of transforming environmental (external) information into internal changes of form, physiology and behavior" (157). Of course, Gould is referring to evolution in the Darwinian sense. Adaptation should not be misunderstood as something that happens over the short term. This is precisely why I suggest that the use of images is one of a number of processes active within humans as part of their makeup. Another way of thinking about this is that, it would be impossible to talk about evolution without also talking about human imagination. Yet in the neurosciences, for example, the human imagination remains a mystery as well as a challenge (Edelman 2000). What is it that pushes human biological activities to transcend their mechanical, chemical, and elec-

trical origins? Can some of the answers to these issues be found through analyses of what humans do with images?

I am working by inference from the observation that no human society has ever existed without the creative externalization of internal images. This gives an ontological status to images because humans could not exist without *both* their dreams (evidence of the complexity of internal images) and the externalization of consciousness into pictorial forms. Ironically, this history links MRIs, for example, to all of the previous efforts to understand the internal workings of the human body.

Humans speak with words and images. Language and image are inextricably bound together, but neither can be traced in an exact way to some point of origin in the brain. In other words, however strong the desire may be to explain the relationship between biochemical processes and human consciousness, a good deal of what happens occurs in an autonomous fashion out of immediate reach of introspection or scanning technologies (Pinker 2002).

For example, the gap between seeing images and experiencing what has been seen is a very large one. Sight is transformed into subjectivity in much the same way that internal images are a platform for the imagination, little of which can be explicitly linked to the seemingly concrete specifics of vision. This is why reverie is such an important concept. The demands of viewing and thinking about the experience, as well as making it meaningful, are so multilayered that a distinctly human kind of openness is required in order to make the entire process work.

Reverie is often referred to as "suspension of disbelief" with respect to viewing films and television shows, reading novels, listening to music, and so on. But the process is more complex than that. Reverie is one of the foundations for all of these activities, one of the fundamental ways in which humans are able to activate the relationships among their own thoughts and daydreams and the requirements of viewing and listening experiences. Reverie permits and encourages empathy, which is a strong emotion and has often been confused with identification. Reverie is also about unpredictability, which is one of the core reasons why an intersubjective relationship can be developed between images and viewers.

The reader will notice that I have attributed subjectivity to images. Rather than sustain the subject/object distinction here, I am more interested in the circles of continuity that link images to viewing and experience and that are responsible for a middle ground of comprehension and reflection. Images don't operate in an autonomous fashion outside of the relations established between their various modalities and the humans who interact with them.

Internal and external images meld together as soon as they interact, just as thought and language are fundamentally inseparable for the speaking subject.

Some images are essentially depictions of the external properties of objects. However, image and object are not equivalent, and whereas the latter has an existence independent of the observer, the former is inevitably bound to the subjective space of viewing and interaction. Distinctions between internal and external are less relevant since images are an inevitable part of seeing and thinking, just as sounds cannot be separated from the listener.

Metaphors of conveyance are an excellent way of thinking about these distinctions. Whereas an object has an autonomous character (the screen in a cinema), the images projected onto screens exist in relation to their role as media of communications. The distinctions between screens and spectators are obvious. What is less clear is how images could exist *without* being seen, just as dreams cannot be dreamt without the dreamer. One of the most important features of imagescapes is that the *relationship among viewers and images* means significantly more than the actual status of the images themselves. Relationships are about process, and process cannot be reduced to the characteristics of images outside of use and interaction. I realize that what I have just said favors a pragmatic approach to the communications process. As Umberto Eco (1997) has so brilliantly argued, the pragmatics of interaction cannot be separated from what humans do with language and images.

It is an irony, then, from the founding moment, not only of photography's invention, but also its development into a mass medium, that the central issue has always been whether the realities, objects, and/or subjects depicted were congruent with the output, that is, the image. Yet, it is precisely the pragmatics of the communications process that allows viewers to situate meaning and relate to messages. My use of the term "image" is centered on the performative relationship among viewers, sight, and comprehension. When I speak of pictures or photographs, I see them as parts of this continuum, not as separate empirical entities.

Depiction is therefore less important than interaction, process, and the interpretive judgments brought to the *scene* of images. The beauty to me of this argument is that it values discourse about images as much as the images themselves. In this context of relations of interaction, it becomes very difficult to talk about images *as if* they were objects and therefore outside of the continuum of experiences that link seeing and understanding.

The computer game *Myst* provides a good example of what I mean here. The sensations of entering the game and its images are fundamental to its

operations. But what does it mean to say *enter the game?* Entry in this case refers to a series of imaginary loops, which are ironically at the heart of the quest within the game itself. Resolving the game and achieving a result mean nothing other than having followed the quest to its conclusion. The passion to solve the problems set by the game is as much about the game's internal structure as it is about the performative relationships developed through using a computer to engage with the game. At all points, the game is about shared intelligence—about the intelligence that went into its construction and the intelligence of players. Once again, this is a continuum that is not bound to intelligence in one of the parties to the exchange but to the intersubjective context of engagement, a collective and hybridized space of interaction.

It is in this important sense that one can begin to talk about *How Images Think,* not literally of course, but as a function of an engagement that will not succeed without the agreement of all sides to the exchange (Llinás 2001). I am not making a claim here for anything close to the complexity of human thought in objects. I am suggesting that it is precisely the strength and depth of human thinking that frames the interconnections humans create between internal and external images. And I am suggesting the distinctions that differentiate internal and external images are what drive the fascination humans have with the images they create and view.

Relations of meaning and communication drive the process of interaction in image-worlds. The relationships between subjects and objects cannot be predicted by their individual characteristics. There is always a process of hybridization at work that frames how meaning circulates through the use and abuse of subject/object relations. But to varying degrees hybridization produces a result that is greater than the parts. Intelligence moves around and enhances the thinking process beyond the boundaries of either image or subject. In fact, as I discuss later in this book, what is described as virtual reality (and the reason "reality" as a term is linked to "virtual") is evidence of the power of this hybridized space of intelligence, exchange, and communications.

A good example of this process of hybridization at work is the manner in which someone like Britney Spears can become popular to the point of being worshipped (although she is now far less popular than she was—it is a similar cultural activity in reverse). How else can one explain the intensity with which popular cultural heroes are absorbed by their fans and then rejected? There is no more disarming a set of images than thousands of people screaming and yelling at the "sight" of one of their iconic stars. This enthrallment is ultimately a fascination with the boundaries and excesses of images. It is a fas-

cination with the paradoxes of engaging with someone, something that can "never" be there in the sense of presence, fully present. A tremendous amount of energy has to be "willed" into place in order to believe that a rock star is actually mine and that I own his/her songs, body, and image.

This is one reason that fans are so aggressive when they come close to the stars they admire. There is a sudden breakdown of fantasy, dreams, and internal projections. That is also why Elvis imitators (and many others) actually have an audience. At a minimum, it seems better to have a tiny fragment of the real person, exemplified at most by clothes and makeup than to have nothing at all. It is as if there were a need to bring the fantasies to life, but only to the point that they don't threaten either the ideal Elvis or the everyday life of his admirers.

This is a balanced pas de deux around which people dance to tunes that are both private and public. The star is brought to life, always virtual, inevitably an abstraction. She is caught in a loop that nevertheless transforms images into sites of desire and loss where the forces of hybridization work to contain and explode the boundaries of subjectivity. (These ideas were brilliantly explored in the film *Being John Malkovich,* directed by Spike Jonze, released in 1999. The star of the film, John Malkovich, is physically internalized by one of the characters who also happens to be female. The resulting chaos reveals what occurs when viewers become what they desire.)

The viewer of images is also potentially a raconteur of daydreams, visions, thoughts, and insights. To glance at an image is the first of many steps from sight to mind to action and back again. The loops are endless without a beginning or an end to the process of interpretation and understanding and to different forms of social and cultural practice. There is not a pure moment of seeing somehow divorced from all of the memories and thoughts that circulate within the human mind. A web of complexity sustains images over time and through history. The next chapter explores the relationships between the virtual and the real in greater depth in order to deepen the arguments about hybridization, adaptation, reverie, and subjectivity.

CHAPTER THREE Foundations of Virtual Images

In this room of open prediction, facts flash like
a headland light. The search flares burst around
you where you stand, lost in an information fantasia:
tangled, graphical dances of devaluation, industrial
upheaval, protective tariffs, striking shipbuilders,
the G7, Paraguay, Kabul. The sweep of the digital
now beyond its inventors' collective ability to index—
falls back, cowed by the sprawl of the runaway
analog. . . . Data survive all hope of learning.
But hope must learn how to survive the data.

— Richard Powers, *Plowing in the Dark*

This chapter explores the historical and contemporary ground upon which notions of simulation and virtual imagery have been built. I use examples from photography, film, computer technology, and three-dimensional installations to explore why the virtual is perceived to be so different from the real. There is clear and sustained continuity of connections between the real and the virtual that is evidenced in the history of the various pictorial traditions of Western culture (Grau 2003). These connections are the foundations upon which information moves from data to visualization. The connections are also the base upon which the process of hybridization sustains its strength. As I mentioned in chapter 2, virtual worlds are about the dissolution not of reality, but the *assumptions* that go into subject/object relations. Virtual worlds are an expression of the many ways in which humans solve their conflicted relationships with the machines they have created and the vast technological infrastructure that many societies now support.

Known and Unknown

The photographic, moving, electronic, and digital images filtering into and through every aspect of daily life do not simply refer to or reflect a *known* world. Instead, they exemplify the continuous points of intersection and struggle among knowledge, imagination, and creativity that people in Western societies engage with everyday. The contrast between the known and unknown has been one of the underlying, foundational concepts governing the role of art and literature in Western societies. This central trope has also been essential to definitions of scientific research as more and more of the natural world has revealed itself at the microscopic and subatomic level.

In fact, if the arts and sciences share anything at the beginning of the twenty-first century, it is the legacy of making a great deal of what has been invisible about the world and the way people live in it, visible. From cosmology, physics, chemistry, biology, and geology to artistic experiments that change the genetic makeup of animals, to the ways in which history is pictured and narrated, definitions of reality have undergone a sea change. Previously inaccessible characteristics of the human body, the fossilized record of animal and human activity, models of the universe and time, have changed, and with these changes a major revision of what is meant by "reality" has occurred (Camus 2002).

In fact, conventional definitions of what is real and not real are anachronistic given the complexity of what has been discovered about the operations of the natural universe and the sophistication of what has been created by hu-

mans at the technological level. This point is important because in some respects current cultural distinctions, both in theory and practice about what is real and what is virtual, no longer apply with the same force. In other words, new definitions are needed that will encourage and support the development of a more complex view of what it means to engage with reality and its virtual extensions. This is of particular importance with respect to images, which are now so capable of being transformed as well as acting in a transformative fashion that conventional explanations for their role no longer apply.

A crucial feature of this change is the move from images as purveyors of meaning to images as contingent spheres of influence, temporally driven places and spaces as opposed to objects for viewing.

To think of images in terms of the spaces they occupy and the time of interaction with viewers brings the environment within which images operate into the foreground. In other words, images need to be thought of in broader terms as one part of a larger number of "installations" that make up a continuously evolving built environment of great cultural diversity. This is part of the reason why architecture has become such a significant discipline over the last ten years (Carpo 2001). Architecture, both as discipline and practice, creates the contingent spaces (among others) within which images operate. The World Wide Web is built on an architectonic model. Even the notion of home entertainment centers is based on theatrical metaphors with large televisions replacing screens with a variety of multimodal image and sound-based technologies. In all of these instances, the boundaries of knowledge about the role of images are being pushed to the point where the real no longer exists without some reference to imagescapes.

A recent project in Melbourne, Australia, is a good example of what I am discussing here. Federation Square is a massive development project in the center of the city. It has buildings devoted to art and media as well as public squares and commercial venues over a twenty-acre site. The scale is enormous and the design is experimental. One of the walls on the site acts as a screen for a continuously changing succession of light forms. The performative aspect plays a dramatic role because the light form is driven by a series

Video artists like Doug Aitken now develop their narratives and situate their images within installations. This not only changes the site of projection, but also effectively responds to the breadth and influence of images beyond their "normal" location within monitors and on single screens. Aitken uses a variety of environments for his installations with the result that his images attempt to sculpt space through

a video aesthetic. One of his central goals is to create visual landscapes that can be experienced beyond the parameters and constraints of conventional viewing. Another video artist, Gary Hill, removes the cathode-ray tubes of televisions from their cabinets with the result that the entire object becomes an image. These two examples represent just a small sample of experimentation that is responding to the ubiquity of images and the slippery ground that connects technology, the virtual, and the real.

of robotic mirrors that are in turn hooked onto a computer. The computer scans Melbourne's airways for radio waves, and the computer then translates the radio waves into different mirror positions. As a result, it is unlikely that the configuration will be the same on any given day. Contingency has been taken to its extreme in this example, but the combination of design, digital technology, and architectural sensitivity is the site within which a more elaborate image-based and performance-oriented process can take place (see figure 3.1).

As I mentioned in chapter 2, a more performative model framed by the social context of communications needs to replace conventional notions of representation. Contingency in this context refers to meanings that are not solely located either in images or viewers but in a set of relations created by the context of interaction, a process I have referred to as visualization and hybridization (Rorty 1989).

Another good example of this can be found in peer-to-peer (P2P) networks, which are about contingent forms of interaction largely dependent on the performative context of enunciation and expression using various technologies, languages, and images. At another level, P2P networks are a response to the increasingly complex and multilayered supposition that knowledge and information are one and the same. As I mentioned in chapter 1, the confusion between information and knowledge is centered on a more metaphysical notion of interconnection. It seems that what matters most is that the connections are there, and if knowledge can be gained from them, so much the better. (See chapter 7 for more details on P2P networks.)

Within P2P contexts (such as the informal news gathering groups wirelessly connected through portable computers during the anti World Trade Organization demonstrations in Seattle in 2000), information circulates and changes at high speed. The mere fact that there is an image of an event doesn't necessarily suggest that information or even intention has been communicated. The fact that there is a vast network of connected computers does not necessarily mean that communications are actually taking place. The test of whether information has been exchanged and whether knowledge has grown from the exchanges can only be extrapolated from the use to which that

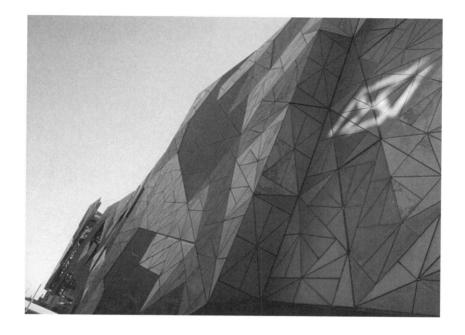

FIGURE 3.1 Federation Square, Melbourne, Australia, 2002 (Ron Burnett). By permission of Peter Davidson, architect.

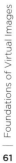

knowledge is put or the context into which the information is placed. (Affinity groups both developed and grew out of the demonstrations in Seattle.)

I do not mean to suggest that contingency and performance lead to a kind of arbitrary relativism (Habermas 1984). Certainly, there are dangers in proposing that interaction, not the exchange of information, drives networked connections. I am suggesting that as a sphere of influence, networks create the "possibility" of interaction and exchange of information and meanings. Possibility in this instance means as many failures as successes. It also means that users, viewers, or participants in the process can take greater control of the interchange and, in fact, can move around in a continuum of creativity, communications, navigation, and participation. (For a contrary view, see Castells 1996.)

Microcultures

This may also explain the extraordinary proliferation and influence of what I will call *microcultures,* places where people take control of the means of creation and production in order to make sense of their social and cultural experiences (See Schuler 1996 for a discussion of community networks.) Every major street in the cities of North America, Asia, Africa, and Europe unveils this seemingly endless cultural and social productivity (Manuel 1993). Any number of diverse influences can be brought to bear upon an evergrowing population of smaller and smaller constituencies that are driven as much by the need for community as they are by the technology that enables them to communicate (Mohammadi and Sreberny-Mohammadi 1994). The appearance of the Xerox™ machine in the 1960s and 1970s is one of the pivotal examples of the important influence of new technologies on this phenomenon. Xerox copies enabled small groups to communicate with each other and with other potential readers. The process of copying was a precursor to new methods of disseminating information and ideas. This is most fully expressed through the zine movement and P2P communications systems that I examine in greater detail in chapter 7.

These communities are not dependent on national boundaries. Some of them are horrific and violent. Others are found in community centers, the basements of houses, schools, and universities. Many are on the Internet, communities entirely defined by virtual interactions such as those devoted to particular rock groups, computer games, or the cinema. These communities produce images, texts, and sounds that cannot be analyzed outside of the performative and local space in which they operate. This means

that representation is far less important than experience and the *time* of performance. This exemplifies what postmodernists understood some time ago, that cultural expression no longer relies on the traditions of authorship to which humanists and artists have grown accustomed since the Renaissance (Newman 1985; Bolter and Grusin 1999).

Interestingly, it is the players and creators of computer games who have understood this change most fully. I explore this point in greater detail in chapter 8. Computer games are crucial to an understanding of the cultural and social transformations that this book is examining. In fact computer games presage a dramatic realignment of *sources* of creativity (Schleiner 1998). The phenomenon of open source programming (Linux) at the operating system level and the prevalence of hackers who change, if not transform, computer games suggest that the microcultural movement is a built-in part of the digital age. (This argument could also be extended to the extraordinary rise of autodidacticism as a legitimate mode of knowledge enquiry and acquisition.)

Microcultures make it possible for a small cinema with twenty-five seats to become part of a cultural movement. The network extends the capabilities of existing physical, virtual, and community spaces into a realm of communications that by definition has no clear boundaries. It is this that transforms everyday phenomena into potential sites of creativity and exchange because any aspect of the built or natural world can be colonized for multiple purposes, and any number of hybrid activities.

At the same time, so many variables come into play that it seems as if information, communications, and understanding were the same. In a digital world, all three are bound together in sometimes unusual ways. Clearly, information under certain circumstances can be close, if not equivalent, to knowledge. Knowledge is, on the one hand, a subjective state produced through self-awareness and self-reflexivity. On the other hand, knowledge also points toward an objective, systematic, and often verifiable body of facts. Information is the raw material that people use to understand the issues with which they are concerned and the problems they want to solve. More often than not, information produces a series of encounters, clashes, and conflicts, all of which *extend* into potential spheres of knowledge and understanding.

One of the best examples of this is the contested interpretation of images from news broadcasts. The images never provide just the right amount of information to come to clear and sustained conclusions about events. Quite the opposite, the images are a testing ground for debate and disagreement. Part of the problem is that the images make it appear as if con-

flicts could be visualized, and this may not, in fact, be either their purpose or the outcome of the experience of viewing them.

Visualization cannot be predicted from images, nor is it clear that information is a predictor of knowledge acquisition. There may be no clear explanation of why some images work and others don't, and this raises important questions about whether the way images communicate can be based on conventional notions of human interaction.

Although the power of images often seems to be self-evident, what is less clear is the manner in which viewers relate to what they see. The full force of personal and public history comes to bear on the process of visualization. For example, if you have visited the Vietnam Memorial in Washington, know or have known veterans, or been an antiwar activist, the interaction of memories, images, and stories are part of a generative process. You "make" the photos and memories of the Vietnam War work for you, and they become an example of the intensity with which the process of visualization enframes viewing and is in turn related to experience and knowledge.

Can history be envisioned through images? I would suggest that photographs from all wars *test* the very ground upon which images can be used and understood and raise further questions about the nature of information within image-worlds. In order to deal with these issues, I explore the relationship between information and visualization in greater detail in what follows.

Information Rechanneled

In the 1830s, Charles Babbage invented the analytical engine, which was a brilliant precursor to the modern computer (Shurkin 1996). Babbage set the scene for a different conception of information and how it could be gathered, stored, visualized, and communicated. Babbage's machine was powerful in conception but almost impossible to build (Swade 2000). His timing was just a bit off. But the importance of Baggage's experiments were that he set the stage for thinking about information, including what it means to process information in a more efficient and economical way.

The term "computer" was already in use then, but it referred to *people* who worked on mathematical problems and calculations particularly in relation to shipping and navigation (Grier 2001). Individuals employed in these roles ended up making many errors, and the errors often had a disastrous effect on the movement of goods and people. Babbage therefore did not just invent a machine; rather, he signaled an important attitudinal change in looking for accuracy and correct information by using technology. He wanted to

eliminate errors through mechanical means. This conceptual leap was one of the building blocks in the development of complex computing environments and in the growing importance of visualization for human communications.

The other crucial issue was how to "visualize" information. It is more than a coincidence that Babbage's work coincided with the invention of photography. It is significant that the acceleration of devices for "capturing" the look and feel of the world paralleled the increasing use of images to communicate the results. It is equally significant that the 1950s, which were among the most fertile years for the development and growth of computer technologies, were also the period in which television became a mass medium. The connections between photography and Babbage as well as computers and television are a reflection of a particular *zeitgeist* that envisioned the role of images as performative tools of information exchange and not just as aesthetic objects for display. These links among visualization, technology, and information were at various times central to the rapid growth of instruments like the telescope and the microscope (Hankins and Silverman 1995; Stafford and Terpak 2001).

They were also the site of conflicts about truth and distortion with many questions being raised about objectivity, vision, and reality. Although the telescope is now thought of as a device that enhances human vision in order to "see" beyond what normal vision provides, it was originally met with great disapproval. This had as much to do with the mediations between reality and human vision that it introduced, as with the new information provided. (The familiar case of Galileo's punishment by the Church because of his discoveries about the universe aided by the telescope says a great deal about this issue.) It also had to do with a crucial characteristic of image-based communications that for the most part leaves a great deal out of the relationship between its constituent elements. Mediation introduces distortions, which is a *valuable* way of recognizing both the power *and* frailty of communicative interchanges, but mediation can also be used to make claims about truth and the actual role of information within particular cultural contexts.

Ironically, as various information technologies have grown in scope and importance during the last century, mediated environments have become more and more complex. For example, telephones increase contact between people while also sustaining disembodied forms of intercommunication. At the same time, conventional concepts of embodiment are transformed by the use of phones. This contrasting and quite ambiguous problem—phones make it possible to communicate more while transforming actual human-to-human contact—points toward some of the ironies as well as contradictions of tech-

nology-mediated environments. It could be argued that telephones increase the likelihood that communicators are imagining each other's bodies—projecting the physical into an imaginary space and perhaps even enhancing incomplete notions of what each party to the communication looks like. It could also be argued that phones extend voice and body into a shared space that has a set of unique qualities and characteristics that cannot be explained by conventional notions of communications or embodiment (Ronell 1989).

This shared space is part of the continuum that I mentioned earlier. There is nothing mysterious about this space. When two people communicate over a network, they reshape not only what they say but also how they interact. With time, these transformations also change other forms of contact. This loop of interactions has no beginning or end point. In fact, it is also possible that the intensity of telephone communications increases the likelihood of more interpersonal contact. Within a continuum of the sort that I am describing, the technology enables sharing in often unpredictable ways (Carey 1989). The irony is that the technology also increases the need for more visualization to occur. This pressure has resulted in an extension of the phone system into a text-based instrument (electronic mail) and then further into visual form, ranging from videophones to faxes to the Internet and visual chat spaces.

In all cases, the visual reappears to bring concreteness to the shared space of communications and information as well as creating more levels to the interactions. When people speak of information overload, for example, they are actually referring to the increasing complexity of this shared space. In order to understand how visuality and information operate, I will explore the ways in which the virtual and the real become part of a continuum that actually heightens the intensity of the participatory space of communications, creativity, interchange, and visualization.

The Continuum of the Virtual and the Real

In the middle of the 1970s I read about the invention of the Altair, which was essentially a kit to build a personal computer. I built one, but I really did not know what to do with it. What I remember most is that it had a lot of flashing lights. At about the same time, I purchased a small holographic kit with a laser. The three-dimensional images that came out of that small beam of light were breathtaking. In 1983 I witnessed the introduction of the Lisa computer by Apple. In 1985 I purchased my first Macintosh 512, and using a primitive digitizer and my large and rather cumbersome camcorder, I watched images move from the camera to the computer. I was particularly overwhelmed when

FIGURE 3.2 "Katie," digitized from a camcorder (Ron Burnett). Originally published in *Copie Zero* (Montreal: La Cinémathèque Québecoise, 1985).

I stilled the video image and printed it out on my dot matrix printer. Figure 3.2 is that first still.

The key to figure 3.2, is the resilience of the eyes, nose, and mouth. The face is flatter than it should be because the printer could not produce enough dots to properly shade the shapes and contours of Katie's expression. This image is like a drawing, albeit a mechanical one.

To varying degrees, the Macintosh that I learned to use in the mid-1980s quickly turned into a tool for imaging and for my videocamera. It was not easy and the software was not great, but digitization became an everyday practice for me, particularly moving images from the camcorder into MacPaint, which was a precursor to Photoshop.

The use of these technologies is an example of the cultural fascination with visualizing worlds and of the effort to augment the potential of vision with machines. According to Douglas C. Engelbart (1962), "By 'augmenting human intellect' we mean increasing the capability of a man to approach a complex problem situation, to gain comprehension to suit his particular needs, and to derive solutions to problems" (1). Englebart developed a brilliant set of insights into the potential for computers to both extend and enhance the imagination. However, mass-produced image-based media had been developing this process for over seventy-five years. In my view, augmentation allows for increasingly complex levels of visualization to the point where images, for example, are experienced as if mediation is unimportant.

My use of digital technologies thrust me into a space of invention and transformation—a space of illumination made possible by the excitement of the new and the sheer wonder at the many ways in which images can be moved from one context to another. I am still amazed at the appearance of moving images on my computer screen and to this day remain as fascinated with the Web as I am with conventional television. There is something fluid and dynamic about the movement of ideas and images across a computer screen. In the cinema, that movement has to be printed onto celluloid. In video, tape must be used. However, in a computer, images, texts, and sounds are really a set of electrical charges. They are bound to time and, for the most part, can be altered. Anything that resides on a computer can be changed from its original form, and this is perhaps why hackers are both feared and viewed as heroes. Hard copies have not disappeared, but their reference points are fluid and sometimes unpredictable computer memories.

This is part of the reason why information may not, as a term and concept, adequately describe the movement of ideas, thoughts, languages, sounds, and images into the complexity of networked connections. It is this

that links the virtual to the real with both reciprocally altering the other. It may also be why images are treated in such an ephemeral manner. IBM recently developed a memory chip using nanotechnology that can hold 25 million printed pages on a surface the size of a postage stamp. What have those pages become? Are they a representation of a massive amount of information or a subatomic reinterpretation and transformation of the written word?

Nevertheless, I would claim that "knowledge usually entails a knower" (Brown and Duguid 2000, 119). Therefore, the amount of information compressed onto a chip remains inert until it enters into a relationship with readers, viewers, or users. This inertness combined with the fluidity of the outputs points to the strength of the continuum that links reality to the virtual.

Another way of thinking about these issues is to return to questions of vantage point and determine a position from which to witness the flow of information from a small chip to people's use of the information. Since 25 million pages are not visible when they are the size of a postage stamp, one can only know if the information is there by using available technology to access it. Still, it remains unclear how information that is compressed can be unpacked without discarding a great deal of it. All of these increasing levels of abstraction further challenge one's capacity to engage with the relationships among meaning, memory, and expression. They also raise serious issues about the efficacy of visualization and the potential to "envision" information.

One of the challenges of having so much information available in a form that cannot be seen is that "data" no longer has the meaning normally attributed to the simple flow of information. The visualization process has to be sensitive to aesthetic and formal issues of such complexity that data extraction becomes as important as the information itself. In fact, the preservation of information in a form that can be accessed will eventually require three-dimensional environments in order to make sense of the overwhelming complexity of coming to a clear vantage point about what is important and what is not important.

In addition, so much of the information used on a computer is temporary (that is the definition of random access memory or RAM) that what is preserved may only be a small proportion of what has been worked on. As many users of computers know, too little RAM means that the computer will not operate quickly or even permit much creativity, which is why the hard disk is referred to as the place where memories are permanently stored. That permanence can easily be corrupted. Anyone who has been through many gen-

erations of software and hardware knows how much is lost and how much information becomes inaccessible.

The challenge of preserving information will require a completely new approach to the notion of the archive, a challenge that is being taken up by libraries and museums. At the same time, cultural definitions of popular memory will also be challenged by the increasing complexity of the mediations among events, their interpretation, and the medium used to compile, remember, and express what has happened.

When the computer becomes a personal archive for all of the images of a generation (moving and still), the questions of storage, retrieval, and cataloging will become even more pressing. What will have to change is the way in which users relate to the information they are collecting. This means that new concepts of memory and retrieval will be needed as well as new kinds of imagescapes. In this case, intermediaries will generate virtual environments for the storage of precious memories that will be accessed through land-based and wireless networks.

Images will increasingly become the major means of recording not only the personal histories of individuals but also the ongoing relationships that people have to their own archival information. In that sense, earlier analogue images will become the markers for historical change, for the ways in which the continuum of image, identity, knowledge, and information circulate and have circulated in the past. This continuum creates and makes possible shared spaces that are not necessarily medium specific. This is why artificial distinctions between the virtual and the real no longer have much power. It is to this issue that I now turn in chapter 4.

CHAPTER FOUR Imagescapes as Ecology

The real significance of computing was to
be found not in this gadget or that gadget,
but in how the technology was woven into the
fabric of human life—how computers could
change the way people thought, the way
they created, the way they communicated,
the way they worked together, the way they
organized themselves, even the way they
apportioned power and responsibility.

— Mitchell Waldrop, *The Dream Machine*

In this chapter, I return to the issues of vantage point, but this time with respect to virtual technologies. The trope of virtual reality has captured the popular imagination. In so doing, it has reinforced another crucial idea that this chapter explores, the creation and maintenance of digital ecologies. I use the term *ecology* in reference to the indivisible nature of human-machine relations and the interdependence of humans on the technologies they create. Ecology does not necessarily mean harmony or an ideal balance of forces and energies that sustain the connections between humans and machines. Rather, ecology is a term that suggests the many interrelationships that people develop between each other to engage with the communities of which they are a part. The technologies they use are simply one constituent of a complex system built up over time and are an inevitable part of the process of connection that makes it possible for communities to exist (Nardi and O'Day 1999).

The movement from the analogue to the digital is about the transformation of one type of information to another. This process also anticipates the cultural move from the real to the virtual. The analogue era felt comfortable with representation, with the ability to relate the real to markers and signs that humans could translate from one experience to the next. The virtual era will have few of those concerns because so many of the images that will be created will be the products of human interaction with complex digital devices. Unfortunately, the terms *real* and *virtual,* as they are now used, may not make it easy to understand these fundamental transformations and in particular the vantage points needed to comprehend the continuum that links the real and virtual.

Virtual environments use a graphically-driven photorealistic approach to overcome the distance between what is being pictured and what is being experienced. As I mentioned earlier, this struggle between distance and proximity is fundamental to nearly any image-based experience and is the basis upon which most images become virtual. Irrespective of whether the experience is based on two-dimensional screens or three-dimensional simulations, there will always be some distance between the images that are seen and the viewer who is looking. This will only change if images become physical and sculptural objects or if the bodies of viewers become holographic.

As I have suggested earlier, images are virtual because they are distant from the spectator or user but are experienced as if that distance could and, in some instances, must be overcome. This is not a bipolar relationship. There is a constant struggle, ebb and flow between wanting to possess images *as if*

they were real and the knowledge that they can only be experienced at a distance. Part of the impulse to create virtual environments is an effort to recover human agency in relation to this conundrum of the visual. The argument in favor of virtual reality is that the participant is immersed in what he/she sees. Consequently, the participant is more likely to take control of the experience. It is unclear whether or not more control is in fact possible. Users and/or spectators enter an arena of struggle that pits them both for and against the imagescapes they encounter. Immersion is not solely a function of letting go. It is a sign of the struggle between human expectations and viewing.

This is precisely why experiences within imagescapes are contingent and shared. The distinction here is between the notion of message and receiver. In a contingent and shared environment, it is not clear where and when the message begins and to what degree meaning has been shared. Rather, meaning circulates in so many different forms and through so many different media that no one message can be isolated from the other. This mixture is volatile enough that users, spectators, and navigators enter a continuum of relationships from which they cannot be extricated. At issue is the notion that messages exist in separate spaces and can be abstracted from their context in order to be better understood. It is precisely one of the characteristics of digital environments that boundaries of this sort disappear.

In twenty-first-century terms the virtual is often referred to as artificial—spaces, experiences and events that do not exist. Many analysts, who use the term *virtual reality* pejoratively, describe virtual environments as if they were cut off from the world and not an integral part of everyday experience. But if all images are, to varying degrees, virtual, then a different set of issues needs to be explored. For example, the movement of images and data all over the world in real time means that human identity can no longer be localized in a simple or direct way. The capacity to watch and experience the news from everywhere and the "idea" that time (and different contexts) can be shared contributes to the intuition that these events are not being lived within conventional definitions of time and space. This intuition is also driven by the concept of instantaneous transmission and communication. Immersion in the experience of other societies without having to be there is part of what makes the experience virtual.

Interestingly, virtual experiences rely on inferential thinking. They do not so much make the real come to life as they create an awareness of the many different planes on which perceptions of the real depend. One of the best examples of a virtual experience is a sound compact disc (CD) player. One may infer that a particular CD will play a certain sound and that inference will have

a great deal to do with the experience. The properties of that inferential process are not physically apparent either on the CD or even when the CD disappears into the player. In other words, the act of listening begins within a virtual space of expectation devoid of sensory stimulation yet flush with internal dialogues and feelings. The laser that helps to generate the sound is invisible. The electric current that energizes the music, gives it a shape, and broadcasts it is also invisible. Much can go wrong here, but faith in the virtual makes it possible to believe that once turned on, the CD player will produce sound.

To varying degrees then, virtual experiences are about surrogacy and the ways in which human beings engage with and comprehend the realities and visualizations that they create. Surrogacy falls into that ambiguous sphere of closeness and distance, control and loss of control. The music comes from a very distant studio and as a result of processes over which the listener has little control. It is what the listener does with the experience that makes a difference. Closeness is created by use, interaction, and the context of listening. In fact, an argument could be made that the technology is ultimately not that relevant because its functions and role can be so heavily transformed, if not recreated, by the very people for whom it was designed.

This is why music sampling was initially viewed with disdain and why Napster was seen as such a threat. As audiences recreate original forms of expression, they deny the power of surrogacy without necessarily limiting the role of the virtual. They also mold the technology to fit a set of expectations that are not commensurate with what the technology was designed to do. These activities are about taking control of the virtual experience; control may be even more important than content or technology (Seiter 1999).

Until now, I have been talking about the virtual using vision and the act of seeing as a central feature not only of what people do with the technology but with respect to what the technology is meant to provide. What about the other senses? The beautiful colors of television do not come close to the swish of my hand through seawater. Images of the ocean cannot compare to the sounds and smells, the rush of sensations that often overwhelm me when I walk along some of the beaches that I have visited. In other words, there is a difference—not so much between reality and image, but between the senses and within the sensorial organism. These may not be oppositions; they are certainly not simple binarisms.

The various senses that humans have slide around and collide with each other. Human bodies integrate or at least keep control of these "parts" and follow the way the parts interact. Images are not foreign to this endless process.

They are an integral component of everything that one could define as sensual, which is not to say that images are equivalent to human senses. Rather, "to see an image" does not necessarily mean that the "it" is outside of or beyond the human body—no sooner seen than a part of the "seer."

These relationships between sight and body sustain themselves around the perceived necessity for images and the simultaneous and often desperate desire to jump outside of the frame and find a place that has the "look" and "feel" of the real. Of course, there is a difference between the touch of water and a picture of water. But the differences are at best defined by a continuity that can never be marked by a slash or the simplicity of opposition.

In much the same way, Western culture has approached the experience of nature as if landscapes, for example, were the expression of activities beyond the control of human beings. Nature is the innocent precursor to what humans do to it. Yet, the pristine look of the land, the majesty of the Rocky Mountains exists in relation not only to the use of it but to the transformation of the viewing experience through language and the senses. There is not necessarily a conceptual or physical distance between the images used to describe the mountains and the mountains themselves, nor need there be one (McCarthy 2001).

How distant is figure 4.1 from the original moment in which it was taken? Is that question relevant anymore? How visible are the transformations that have brought this photograph onto this page? The photograph was shot using a Sony Cybershot Camera and transferred to iphoto on a Macintosh G4. It was then moved into Photoshop and enhanced using a variety of filters. Anyone familiar with Photoshop knows one click will transform an original. What is the history of the filters (Maeda 2001)?

The modernist notion, so central to cultural assumptions about how images work and how image and reality are divisible, creates levels of separation that turn on themselves. The category of the real somehow stretches the boundaries of nearly everything, yet the category of image does not. Images provoke and disgust even as they seduce. There is revulsion even as human bodies reach out and are transformed by sight and the seen. People dance in clubs, watch films, and shoot video as image and body, as symbol and sensate beings. Images are not so much the foundation upon which these processes are built, as they are the expression of so many of the physical sensations that are felt when words and emotions somehow and rather mysteriously match and when images express as much about that matching as they do about the real and the ineffable.

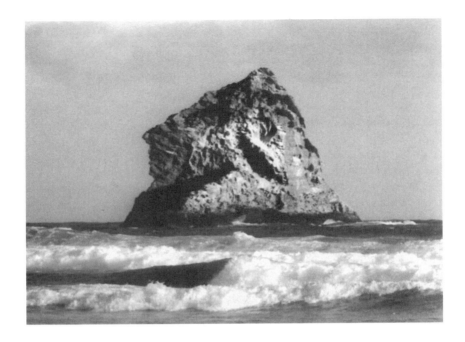

FIGURE 4.1 Seascape (Ron Burnett)

At no point do any images hover beyond or outside of these rather wondrous and often momentary cultural and social interactions. Humans are as much *within* images as they are creators of images. They coexist with what is pictured and build hypotheses about the future and past through visualizations. It is in this sense that images are an expression of various levels of intelligence—images are visualizations of thinking, feeling, seeing, and knowing. It is almost as if their seeming autonomy were a fantasy that has to be constructed in order to avoid the high degree of integration experienced in the use and viewing of images.

Within human-image relationships there is a strong attraction to and an equal fear of mediation. Images are seen as opaque or transparent films *among* experience, perception, and thought. Arguments that overlook how mediation, images, and experience are unified generally marginalize both the inventiveness of projection and the creative dominance of the imaginary. They do not anticipate the continual way in which humans reinvent the very process of invention itself. The difficulty is that images fly by either on screens or as projections, which makes them seem beyond the grasp of viewers or users. The "virtual" seems to submerge viewers even more inside a mental and physical space, powerful and persuasive enough to overcome any resistance to its synthetic character. It is possible to create a simulation that will place a viewer inside the Vienna train station in 1938. This can be done using a rather cumbersome virtual reality helmet or inside a virtual reality cave with screens, gloves, projectors, and computer-driven sensory devices that respond to the movement of immersants. A less immersive experience could also be generated using a desktop computer. Participants might be able to navigate around the train station and watch it depart. Yet virtual "spaces" are abstract spaces (Biocca 2001). Their elements have been programmed to carefully represent Vienna's main train station in 1938. The trick and the wonder are that a set of abstract elements can come to look and feel as if they were "duplicating" the reality of another period. But the issue of what happens within this space is as open to interpretation as any experience in imagescapes. Immersion does not privilege images more than before; rather, it simply takes images to another level. It is important to remember that immersion is only possible if the immersant *agrees* to participate.

Does the resolute stillness and silence of the images discussed in chapter 1 preclude the immersive experiences that I have just been describing? I think not. In fact, immersion may just be another level of empathy, another way of discovering more entry points into the meaning of visually driven, sensuous experiences. The strength of human imagination is the crucial arbiter in all of this and the basis upon which virtual experiences gain their credibility.

In the 1960s, a short animated film entitled *Cosmic Zoom* was made at the National Film Board of Canada. The film has since had many imitators. It shows a boy in a boat in the middle of a lake. The camera zooms away from the boy, zooming and zooming until the camera appears to be in the clouds, then outer space, and then some distant planets of the solar system. Suddenly, the camera stops and reverses direction. It moves past the planets, the moon, the sky, onto the arm of the boy, and then closer and closer to his skin. A mosquito alights on his arm and sucks some blood from the boy. The camera moves into the blood, then into the body, inside cells, and so on. This exploration of the inner and outer is premised on perspective, vantage point, the viewer's ability to see the big picture within the small one and to recognize how details are connected to details in a vast chain of meaning that is circular and never ending.

Cosmic Zoom is also an exploration of time and space, both psychological and sensorial. It is an attempt to picture the way history can be constructed through images. Crucially, *Cosmic Zoom* transforms its animated sequences into a series of visualizations that anticipate the efforts by digital artists and technicians to explore the body and physical environment using computers. In the process, the film also explores the relationships among history, point of view, and the biological, material basis of human existence. Clearly, at the time, no one had seen the planets from the perspective that the film offers nor had humans traveled into the body to the degree suggested by the animation.

It is reality itself, as history and story, that is being explored through a jump in logic made possible by the film. History becomes part of a dynamic loop that is always unfinished but is very much the product of human creativity. As I have said, the advent of MRI machines has made it possible to reconstruct three-dimensional images of the human body. *Cosmic Zoom* anticipates this possibility and creates a different sense of the ways in which individual and more public forms of history can be pictured. This is the case with all animation, but it suggests something important about the manner in which history can be recreated within imagescapes and the expansive possibilities of virtual image-worlds.

David Bohm (1987) suggests a metaphor that is quite useful in describing historical processes and that applies with even greater emphasis to images. He speaks about history as "enfolding" (9–10). This suggests that history is not about a linear relationship among a set of different or connected events. Rather, historical events fold back onto each other creating a chain of inter-

connected fragments that are synthesized differently by different generations. Michel Serres (1965) discusses history in the context of time as multitemporal, polychronic, "multiple pleats" that intersect in predictable and unpredictable ways (60).

Polychronic and enfolding processes reveal and hide connections until a more profound understanding is created of how all of the layers intersect. The "lightness" with which humans carry all these rich images, perceptions, and ideas suggests an ability to bear the weight of operating in a universe that honors the distinctions among the real, images, and the virtual while simultaneously embracing their contradictory relationship (Calvino 1988).

In some senses, the modernist notion that images lie, and the postmodernist presumption that it does not really matter whether images are true or whether they lie, cannot account for the depth of the ambiguities I have been discussing. Images and the sounds that accompany them are forever caught in a space that has no fixed location—simultaneously a part of what is depicted and alienated not only from the truth but also from depiction itself. This relationship is defined by the tensions that exist between different interpretations of the same objects, experiences, or events. Again, without some sense of history and vantage point, the danger is that all sense of location and specificity will be lost.

I do not believe that the social and cultural context of Western societies is burdened by these contradictions. Humans have the capacity to expand their understanding of the world around them, and this is as infinite as the language used to describe and respond to lived experiences. Mine is frankly a utopian vision of what I have in a previous book described as a phantasmagoria (Burnett 1995). The notion that images are caught by their lack of fixity and location is at the heart of what I have been discussing with respect to shared spaces. The absence of clear anchors and foundations is what makes images so fluid, and, in a metaphoric sense, *Cosmic Zoom* is an exploration of the many variables that can be generated when neither the image nor what it depicts are the sole arbiters of meaning.

Imagine the moment in 1634 when Johannes Kepler suggested that humans would need to place themselves mentally on the moon in order to understand the planets and earth's position among them. From there, people might be able to "see" the earth, its roundness, and its character as a part of the solar system. The perspectives drawn from that "position" were, of course, as imaginary as Kepler's own understanding of the earth itself, but this did not prevent the construction of many speculative theories about the cosmos and the place of humans in it.

Now jump to the extraordinary images of the earth taken by the Apollo astronauts from their perspective orbiting the moon in the 1970s and the equally beautiful television images regularly taken from the space shuttle of the oceans and continents of the earth. The jump is still a mental one, but now it is anchored in images *from* the moon and from the shuttle. The difference is that the images are accepted without worrying about perspective or vantage point. Comfort is taken from the fact that the view is not an imaginary one (which is one of the reasons Ron Howard's *Apollo 13* worked so well as a film) even though it is unlikely to be a view that anyone will ever experience firsthand.

This poses serious problems for definitions of what is real and what is virtual. It is a paradox that the images from the space shuttle are not that different from the animations in *Cosmic Zoom*. Yet, *Cosmic Zoom* was made during a period when satellite imaging technologies were very primitive and when pictures of the universe came from telescopes and other less direct imaging devices.

For the last two hundred years, every form of popular and literary culture has explored the relationship among machines, space and time travel, and the human condition. The cumulative impact of that history is at least part of the reason that *Cosmic Zoom* has such a powerful impact, but it is also why it cannot be viewed in isolation from its cultural history. In fact, as animation has become more sophisticated, the dividing line between different kinds of images with differing sources has changed. These increasingly blurred relationships among artifice, images, and reality are producing expressive forms that move outside of the conventions of viewing that have been used by humans for centuries (Harris 1999).

Cyberspace

An argument can be made that, at a minimum, televised images from the shuttle bring viewers closer to the vantage points needed to "see" the world. As I have suggested, the need for this type of vantage point has become more important in the digital era. Do fans worry about the location of the "Backstreet Boys" when they listen to their music? Television shows come to spectators from remote locations, but that is not the pivot for how they are understood or why they are viewed. Films are made in Hollywood, but they could be shot in Toronto, Vancouver, Sydney, or New York. Stories drive films forward more than location. E-mail moves from continent to continent in an almost constant dissolution of location. The Internet itself stands as an ex-

ample of this profound shift from location to something more general and perhaps far more psychological and imaginary. There is widespread fear this loss of place will have an impact on human identity and negate or reduce the importance of local communities. However, I believe the opposite is actually the case. The Internet has led a variety of cultures to find the measure of their connections to other societies, while also foregrounding the need to maintain and strengthen their own communities. A simultaneous sense of distance and proximity are needed to understand place. The location of a particular community on a map is a distant yet necessary point of departure for the various definitions that can be made of the local. The map is not the territory, but it is crucial to the visualization of geographic settings.

Walkmans, Discmans, and MP3 players are examples of an embodied process. Music is placed in the ear and the "effects" of stereophonic sounds are experienced in partial isolation of the surrounding environment. The power of this technology is its ability to immerse listeners in a total experience. The need for vantage point seems to disappear and with it the need for the specific, the local, even the indigenous. This is not so much about loss as it is about momentary shifts from one level of experience to another.

In contrast, raves have become an important expression of the range of cultural activities that audiences participate in as they struggle with the role and effects of technology upon them. Raves are the antithesis of Walkman culture and yet are paradoxically dependent upon the knowledge and experience these technologies provide. Raves are a profound point of contact between material reality and the experiences of dematerialization. Embodiment in this context becomes a tool of expression and a basis upon which new forms of community are created and an antidote to dematerialization. This is accomplished through immersion in highly sexualized and physically complex environments. Raves go on for many hours and "ravers" often dance through the night in order to bring the physical and the imaginary closer.

The combination of physical exhaustion, drugs, alcohol, and the closeness of so many people to each other creates a sense of community that is unlike anything that could be constructed in a digital space. To be at a rave is to surrender to the process and music, which is relentless, pounding, and physically overwhelming. The continuity between the Walkman and raves is in the intense desire to overcome the distance separating listening from body movement—to translate the reverie of engaging with music into a creative, communal, and physical experience. That said, the rave scene is also about creating an underground space, an alternative to mainstream forms and a challenge to conventional notions of interaction in public contexts (Fritz

1999). These contrasts are fundamental to the shifting currents of activity made possible when a history of embodied experiences rubs shoulders with virtual environments.

The interaction of the virtual and the real and the manner in which they have formed a continuum reflects my own belief that Western culture has shifted its concerns and resources from images as representations to images as tools of mastery, visualization, and control. This shift portends an entirely different universe of communications and understanding. Images are no longer used solely to reflect on the world. On the contrary, images have been transformed into linguistic, emotive, and embodied instruments that guide individuals through their experiences of nature and culture. In this sense, cyberspace is far more than just a "space" created and maintained through digital technologies. Cyberspace, which incorporates networks of communications and various forms of cultural, scientific, and political activity, is a trope for a new kind of human interaction. Clearly, this affects both the definition of locality and the meaning of community but also the role and impact of imagescapes on the process of communications.

Virtual Mediations

One could find oneself in an endless circle of questions about the virtual and real, since they seem to contradict each other at first glance. This is why the concept of mediation is so important. In neither case is the relationship between the virtual and the real an opposition. Simply put, the real and the virtual are dynamic interrelated phenomena that intersect in the language humans use as well as in the activities they pursue. Borrowing from Bruno Latour, there are a series of human practices that make the virtual, real, and the real, virtual. These practices (like skiing in a virtual reality environment) are so heavily mediated that the challenge becomes disengaging many of the elements that make these experiences possible in the first place (Latour 1994).

Skiing in a virtual installation has enough of the qualities of skiing itself that any analysis will have to be based not only on the medium but also on the mediations that make the installation effective. These range from the physical platforms used, to the software that tracks the movements of the skier. The mediations include the location of the machine, the experience of the skier, and the size of the screen as well as the myriad of other factors that contribute to the state of mind of the player.

It should be remembered that the term *virtual* "was used in optics at the beginning of the eighteenth century to describe the refracted or reflected image of an object" (Woolley 1992, 60). The refracted or reflected image is *not* the object, but is part of a continuum that binds images, objects, and subjects together. The virtual is reflection or refraction that has no direct need of a real object. This is one of the most important characteristics of any artistic work. This is also what is exciting as well as frightening about simulation as it extends the power of the imagination to place people into unknown and fantasy-driven worlds (Lenoir 2000).

The known world can be rebuilt as information or data without necessarily referencing something tangible. The Coliseum in Rome can be reconstructed in a virtual space using architectural mapping to complete its missing sections. Ancient Pompeii can be "visualized" in three-dimensional environments, even though the archeological ruins of Pompeii only exist in fragmentary form. Although the worlds that can be built inside computerized spaces are mathematical constructs, they provide users with "visions" that are at best refracted instances of numbers that have been ordered in a particular way. The abstraction of the codes behind virtual images challenges conventional notions of how images are produced let alone viewed. It is this coding that distinguishes digital constructions from works of the imagination although the aesthetic forms that they use mediate both and contribute to their impact (Thacker 2001).

Imagescapes as Ecology

It is 1498. Leonardo da Vinci paints, constructs, and presents *The Last Supper.* In 1995 copies of it appear on the Web. Leo Steinberg (2001) captures the essence of da Vinci's method in the following passage:

The common view of Leonardo's Last Supper as a revelation of human nature and a feat of dramatic verisimilitude perpetuates two dominant attitudes of the nineteenth century—its secularism and its enthusiasm for scientific statement. The latter called for precise representation and demanded that a statement be consistent with what it means, but that it be inconsistent with alternative meanings. Hence the aversion to ambiguity, and the assurance that Leonardo's outstanding artistic creation must be forthright in meaning as his anatomical drawing or his didactic prose. (P. 13)

The appearance of *The Last Supper* on the Web is not accidental, but it is evidence of the extraordinary and sustained involvement of Western culture with images. Generally, the extent to which history and the history of images are folded into every action and thought governing human activity is often underestimated. This underestimation is linked to a misunderstanding of how a variety of visual forms move into and out of the world of human events and practices. For example, as *Cosmic Zoom* predicted, images of the human body have been enhanced through the use of tiny cameras which can be used to "picture" the inside of a colon or stomach. Computer simulations can reconstruct every part of the body and put it in view as never before. As I have mentioned, scans now probe the body, lessening the distinctions between inside and outside.

Subjectively, images of the human body are sustained by a variety of strategies that include the pictorial and often rely upon popularized versions of body functions that have been visualized within medical research and mass culture. Of course, the body is never fully pictured, fully available or completely understood. Rather, the trajectory from the empirical reality of the body to the ways in which knowledge of the body has been gained is as dependent upon biology as it is upon culture, myth, and folklore. These images do not circulate without connections to a far more complex imaginary, metaphorical, and cultural world built on the foundations provided by the history of images in general.

Steinberg points out that da Vinci painted *The Last Supper* during a period of time when there was a general "aversion to ambiguity" within pictorial traditions. As da Vinci's mural circulated through a variety of periods, traditions, and contexts, it became increasingly ambiguous, contested, and often rejected. These transformations are now fundamental to how images communicate, and they happen far more quickly than in Leonardo's time. This may be one of the most important characteristics of the digital age, but it is also very confusing. If ambiguity is not only built-in but is fundamental, are understanding, exchange, and communication possible or even desirable? It is in the character of the continuum I have been describing that interaction and understanding happen as much by design as by accident. The communications process is therefore far more unpredictable than might seem to be the case. This is heightened by the many different images and sounds that compete with each other for the attention of viewers and users.

Da Vinci's work is an attempt to bring a particular spiritual history into concrete, bodily form. Ultimately, it is a metaphysical portrait of the divine. However profound da Vinci's faith may have been, his was essentially an ex-

ploration of an image space and the relationship of truth to religious practice. Da Vinci attempts a semiotic reading of *The Last Supper* through the references he uses, such as clothes, the setting of the scene, gesture, *and* a pictorial actualization of the event.

The image stands over time as one of the key iconic representations of Jesus and the events surrounding his betrayal. The image has been reproduced so many times that it has taken on a mantle of truth that obscures its origins. Da Vinci, after all, painted the event by referencing other images, texts, and assumptions about the past. The mural is therefore an already layered representation full of the folds of history that Michel Serres describes. Many different historical periods are present in the mural in a summary fashion, but its most important characteristic is that the work has sustained its sacred quality into the twenty-first century. The restoration of *The Last Supper* took many years, and the mural has become as important to the event that it depicts as the event itself.

Yet what is crucial to the impact of the mural is the presence of the "body" of Christ. Over time, even the shadow on a cloth can become the focus of debate and contestation. The idea and reality of presence can be achieved through a shadow as long as it has some of the properties of an image. This may well be the clearest way of understanding the nature of the virtual and the power of its impact on viewing. A claim can be made that *The Last Supper* bids viewers to enter its world. After all, da Vinci could not have known the events surrounding *The Last Supper* directly. His immediate knowledge was largely derived from religious descriptions and mythmaking.

He built his simulation so that it would fit into the preconceptions of the Catholic Church as well as popular notions about the death of Christ. He recognized and played with the strengths of artifice and style, all in the name of a carefully thought out notion of what would now be described as photorealism.

The irony is that all images, including da Vinci's image of *The Last Supper,* only come alive through this process of engagement and viewing. The *source* of the realism is not the mural itself but a shared space that all parties to the viewing and display of the mural have agreed to. The agreement spells out the rules for accepting not only the mural's virtual construction, but also the virtual space that has to be inhabited in order to accommodate the assumptions of the mural. Here, I am using virtual as a metaphor for myth as well as for images in general, which are sustained as much by a hypothetical connection to the real as they are by the attempt to actualize myth and history.

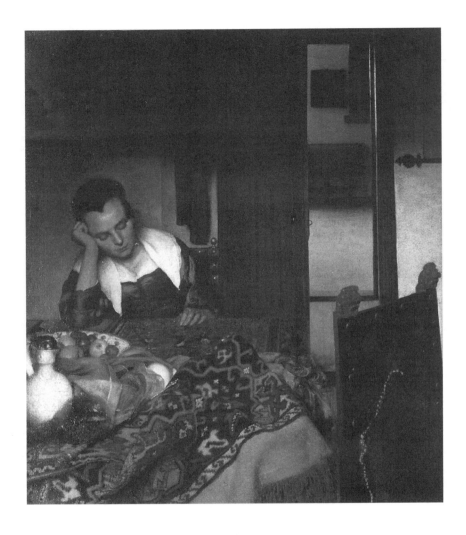

FIGURE 4.2 Johannes Vermeer, *A Girl Asleep*. (http://www.cact.Caltech.edu/~roy/ vermeer/hug.jpg)

Camera Obscura

Some years ago I happened upon *A Girl Asleep* by Johannes Vermeer. It was reproduced on a postcard. The card was propped up in the corner of a small shop full of paraphernalia, crafts, and a variety of objects from old cameras to a spinning wheel. The store smelled quite musty but had the charm of a New England home devoted to the memories of the owner, all of which were for sale. *A Girl Asleep* appears in figure 4.2 in a new version as a 72-dpi reproduction of a photograph—seventy-two dots per inch, which suggests that the image in figure 4.2 is virtually without weight and presence. (Sixteen hundred dots per inch would still not bring the reproduction close to its original brilliance.)

The "lightness" of the image tells a story in itself because the left-hand side of the painting is "lit" through the contrasts between shadow, wall, table, and face. Weight is as much a function of the image as it is one of the pivots for how paintings work. I was attracted to the image because of its mystery. What is the source of interest here? Could it be the very banality of the scene? Or is this a celebration of form, shape, and style? Is its lightness related to what it depicts or is that my interpretation? Is the painting a still life? And what makes it so calm?

I have deliberately chosen Vermeer because he used a camera obscura to paint his subjects and scenes. Vermeer's impulse to work from one image to another doubles the mediating layers with the aim of heightened realism. At the same time, his painting is also a study of a woman's state of mind. Her state of mind can be extrapolated through her position and look, both of which can best be represented through gesture and color. None of these elements are photorealistic. Instead they are expressive and carefully nuanced in order to exceed what the camera obscura may have made available. The artifice at work here moves far beyond the parameters of realism in order for Vermeer to succeed in giving some life to his subject. In the same way, viewers also move beyond the boundaries of the painting and confer upon it a variety of interpretations, which become the responsibility of the spectator and may have little to do with Vermeer or the woman in his painting. The ability to engage with this process is the product of many years and many generations of apprenticeship in viewing flat canvas surfaces and making sense of their meanings and genealogy (Steadman 2001).

I also chose Vermeer because his exploration of light and materiality in painting and his concern for accuracy and detail has provided modernism

FIGURE 4.3 Ananova: Virtual anchor. Used by permission.

with one of its most important foundations, the assumption that there is a link between images and what they depict.

This assumption has also become crucial to the ways in which digital environments are conceived and developed. The fundamental premise of linkage means that some features of the real are always present in digital versions. Thus, the virtual news anchor Ananova (figure 4.3) is made to look and act as if she were more of a substitute than a real individual. At the same time, her existence is given validity by the events that "she" covers.

What is the relationship between her look and that of any other news anchor? The visible presence of artifice in Ananova is similar to the documentary impulse of the news. This gives great credence to the idea that images are as much about representation (the way that a scene is depicted) as they are representations in and of themselves. This impulse, which in the world of art suffuses surrealism and realism and forms the basis for abstract expressionism, treats the painted canvas as a material example of desire and intention as well as reception. It is also one of the foundations for the use of images within digital environments and is fundamental to theories of human-computer interaction (Replace painted canvas with computer screen.)

I would like to conclude this chapter by returning to a central concept in this book—images are never representations in the sense exemplified by that term, nor do they simply represent the intentions of their creators. The minute an image finds a spectator (i.e., from the moment its creator casts a wary eye upon his or her creation), the "object" is no longer the main focus. As a consequence, viewers are in a middle zone between seeing, materiality, understanding, and feeling.

This middle zone forms the shape and produces the boundaries for simulated experiences. Simulation is a way of accessing intentionality by entering the world of artifice and living within its confines. This suggests that simulation is about ecology, and the virtual is as fundamental to human survival as is the real. Ananova merely represents one of the outcomes of a long process of cultural apprenticeship in learning how to interpret images. She is neither a perfect nor imperfect version of someone else. Ananova is a hybrid whose features model a variety of different facial and body types. She is neither an idealization nor a real person. The struggle here is with discourse, ways of describing and interpreting images. This struggle has been a continual characteristic of human-image relations.

To varying degrees, therefore, images have always been an ecological phenomenon. They have formed an environment. As images have become increasingly prevalent through mass production, they have redefined human

action, interaction, and subjectivity. These shifts will require different models of analysis and critique as well as reinvigorated ways of thinking about history. Although Vermeer painted well before the invention of photography, I would like to reclaim his painting as an example of this new ecology. My own use of ecology is related to the work of Regis Debray (1996) and the foundational work of people like Gene Youngblood (1970), Italo Calvino (1988), Bruno La-tour (1999), and Michel Serres (1995).

A Girl Asleep has traveled a long and circuitous route into this book. Its size, depth, and color have been altered to fit into the print medium. However, can it be mapped back onto the original? Should it be? What happens when there are no markers for the source, no way of relating the image to its origins or its history? Figure 4.2 was taken from a Web site, which means that it may actually be closer to some kind of authorship and intention than the postcard. A new author has taken control of the painting and redefined the context for its presentation.

Perhaps reproduction is about empowerment and new forms of authorship which is why the Web is so puzzling to copyright owners (Lessig 1999). Vermeer is an historical trace moving from one context to another. As with many artists from different periods of history, Vermeer repetitively disappears and regenerates in a struggle of control and loss that has little to do with his paintings and much more to do with the changing role of art and the changing context of viewing. In both the Vermeer and da Vinci examples, mass reproduction has altered not only the nature of painting but also the role and aura of Vermeer and da Vinci's works as cultural artifacts (Benjamin 1968). The content, authority, and origin of the works have also changed. This fluidity is part of the movement of art into the realm of communications systems and new networks of distribution.

The distinction I am drawing here is central to the orientation of this book. A work of art, like a painting, does not start its life as an image. Rather, it gains the status of image when it is placed into a context of viewing and visualization. This has implications for definitions of interaction and for the relationships between viewers and creators. Interactivity is only possible when images are the raw material used by participants to change if not transform the purpose of their viewing experiences.

Interactive practices in the digital age are generally described as a function of what can be done *to* images. Interaction is also talked about as if it were a new process. Rather, interaction is fundamental to the creation of audiences. For example, an audience cannot change the ways in which a film tells its stories. However, this has little to do with what audiences are capable

of doing to *themselves* as viewers. Interaction is about subjectivity and creativity. It is about visualization and interpretation—as much about the creativity of artists as it is about the potential creativity of viewers. In arguing for this focus on the role of viewers, I am trying to deepen assumptions about the workings of cultural artifacts.

Clearly, some works of art beg for audiences to fill in the gaps left open by artists. Creators like Jean-Luc Godard, Samuel Beckett, Jackson Pollock, John Cage, and many others structure their art to reflect precisely on the cleavages, breaks, and discontinuities that images make possible. At the same time, these artists know that viewers will make the difference. They know interaction is what entertainment is based on, just as the pleasures of viewing are also dependent on an audience's ability to generate and contribute to the richness of the experiences they have. In the next chapter these issues are discussed in greater detail in the context of immersive and simulated practices.

CHAPTER FIVE Simulation / Viewing / Immersion

Real-world biochemistry was far too complex
to simulate in every last detail for a creature
the size of a gnat, let alone a human being.
Computers *could* model all of the processes
of life—but not on every scale, from atom to
organism, all at the same time.

— **Greg Egan,** *Permutation City:*
Ten Million People on a Chip

Any effort to understand the complexity of concepts like cyberspace, virtual reality, and simulation needs to connect with popular culture and particularly computer and video games. It is not only the often repeated bonds between writers like William Gibson and images of cyberspace that are important, it is the depth and breadth of cultural activities driven by the desire to inhabit virtual and imaginary spaces that needs to be examined. As images move from two-dimensional surfaces into three-dimensional installations, the "content" of the experiences will largely be determined by the orientation and direction taken by popular culture. If the Graphical User Interface (GUI) presently defines the look and feel of desktop computers, then it is likely that holographic images will become the basis for three-dimensional information and data worlds. Personal avatars will enter, write, explore, and experience a variety of interactions with people, stories, and communities.

The "picture" of that world has already been generated in television shows like *Star Trek* as well as the cinema of George Lucas, Stephen Spielberg, and many others. The paradox is that the terrain of cyberspace is not physical, but it combines fantasy, projection, and the senses—an interplay that redefines what it means to inhabit real space and time. However, the artificial nature of these environments has made it seem as if simulation and virtual reality were illusions. This has resulted in rather superficial complaints about the world turning into Disneyland and artifice becoming the foundation for the real (Baudrillard 1990, 2001).

Rather, it is these slippages that make it possible for the real to be enhanced with the result that viewers, users, and audiences are constantly shifting their roles and in the process redefining what it means to engage with their identities and the social context of which they are a part. Cyberworlds can be thought of as third-person image-spaces, that is, environments that come to participants *as if* they could be converted into first-person experiences through an investment in them. A great deal of time and energy has to be put into transforming image-spaces into personal encounters. This is the work of viewers, users, and participants.

The Playdium in Vancouver, Canada, is a good example of an environment of virtual games and simulations, one of many that have sprung up around the world in recent years. Playdiums are the realization of the desire to experience virtual spaces through a collective and community engagement. Children ride motorcycles and speed down dangerous highways. Adults box with larger than life figures on a screen. There are areas devoted

to guns and baseball. One entire series of games is centered on snowboarding and skiing. There are hang gliders, airplanes, and, of course, a restaurant and pizzeria. The Playdium is situated in a shopping center dominated by giant cinemas and a Rainforest restaurant that simulates the sounds, smells, and tastes of tropical regions of the world. The restaurant has live parrots and employees who show children the tricks that the parrots have been taught. Many stores sell paraphernalia from the movies as well as toys and clothes derived from television shows and rock bands. Nearly all of these artifacts are either image-based or derived from images—signs of the imagination at work and the power of popular culture to transform and metamorphose everything it touches.

For the most part, the games in the Playdium are sensitive and responsive to users and viewers. The games may not be an ideal form of interaction, but they move beyond the conventions of cinema and television spectatorship. Human-computer interactions become the potential basis for an altered experience of the real, give a heightened sense of the virtual, and provide a genuine example of how the real and virtual are inseparable. Simulated games trigger a major struggle between creator and participant. Games are very personal experiences. There is little focus on the authors of games—they are seen as products of studios (like Electronic Arts) rather than individuals. The struggle for the player is with the fantasy of taking over and controlling the game.

It often seems as if control were elsewhere, either in the narrative, the characters, or the hill that has to be skied down. The challenge is to determine the scenario, develop a strategy, and solve the problems and blockages (Wolf 2001). The desire for a secure adventure that is also challenging with puzzles and questions has always been a part of playing games. Virtual spaces increase the variables in an exponential fashion and make the suspense of playing all the more intense. This is why simulation moves games and image-based experiences to another and more complicated level for players and users (Murray 1997).

Mapping Simulation

Simulation is about mapping different realities into images that have an environmental, cultural, and social form. This is a very material activity, and although computers are the main technology, the creation of a simulation is like sculpting in space. Commonsense notions of cyberspace and simulation suggest a lack of materiality but many of the distinctions of the analogue age no longer apply.

Presumably, the creation of a virtual oceanarium means that it does not contain any "real" fish. However, as the gap between virtual and real decreases, the question becomes what has been *learned* in each environment. In other words, the "presence" of real fish may not contribute to anything tangible anyway because "real" aquariums are about looking through windows at fish in containers; in other words, aquariums are about mediated experiences that cannot be framed by the simplicity of the opposition between the real and the virtual.

The Virtual Oceanarium is about *degrees* of simulation, performance, and depiction, not about an either/or situation based on a conflict between the real and unreal. It is about learning from a variety of imaging experiences irrespective of the origins of the images themselves or the origins of the objects under examination.

Simulation and virtual worlds appear to operate on their own. They seem to be the product of machines that can act without the intervention of human beings. Over time, this feeling of autonomy has become an important element in the relationship that humans have with the digital machines they use. However, this sense of autonomy was also an important impulse in the creation of analogue machines, such as timepieces. As clocks and watches became smaller and smaller through the course of the eighteenth and nineteenth centuries, the presumption arose that the accuracy of the timepiece was the result of its autonomy from human interference. Underlying this concept was a notion that humans were weaker than machines and therefore more inclined to making mistakes. This remains a convenient way of abstracting the relationship between the production of technology, human creativity, and the ways in which machines are used. This is at the heart of an ambivalent and sometimes contradictory relationship between machines and humans.

As machines have become more and more capable of autonomously reproducing through refined software programming, their sophistication has led to a steady accretion of fear that machines will take over human activities and undermine what it means to be human (Noble, Bullock, and Di Paolo

2000). However, this may be an overly deterministic point of view. Increasingly, a central characteristic of the digital age will be the autonomy of computers, but this may actually increase the need for qualitative thinking about the goals humans have both for themselves, their machines, and the communities of which they are a part.

Autonomy is part illusion, part reality. Throw the electrical switch and the machine will grind to a halt. Cut a wire and the computer will malfunction. Machines and humans remain as interdependent as they ever were with one major difference. As more intelligence is programmed into machines, they increasingly become part of a *dialogue* about achieving particular goals and results. They are less about traditional notions of functionality. This means that as the human-machine dialogue becomes more complex, the image of the dumb machine or the dumb robot will recede into the background. As digital devices become smaller and more portable, their inclusion as partners in everyday experiences, in the everyday challenges with which humans engage, will shift from the periphery to the center. This has already happened with cell phones. Intelligence will become increasingly a matter of sharing and collaborating. No one device or individual will hold all the keys to different bodies of information and knowledge.

One of the most important characteristics of the "virtualization" process is the fact that most of what happens in virtual worlds occurs in front of screens and is image-based. Western culture is effectively redesigning and deepening the meaning and uses of images as well as what it means to be human. To see whether this claim is valid I have been exploring the differences and similarities between analogue and digital forms of communication and investigating whether the evolution of analogue modes of communication into digital forms has altered how humans interact with both images and machines.

The networked world makes extraordinary use of analogue and digital forms of communication. Without belaboring the point, are analogue and digital systems that different? If they are, how so? Ultimately, the value of the difference between analogue and digital is that it allows some distinctions to be drawn between different modes of communication and to frame the particular characteristics of digital communications in a new light. Anthony Wilden (1972) has a very useful explanation of the differences:

An analog computer is defined as any device which "computes" by means of an analog between real, physical, continuous *quantities and some other set of variables. Examples of the analog computer thus include a number of*

common devices: the flyball governor, the map, the clock, the ruler, the ther-
mometer, the volume control, the accelerator pedal, the sextant, the pro-
tractor. The digital computer differs from the analogue in that it involves
discrete elements and discontinuous scales. Apart from our ten fingers, the
abacus was probably the first digital computer invented. Pascal's adding ma-
chine, the Jacquard punch-card loom, and Babbage's difference engine are
further historical examples. Any device employing the on/off characteristic of
electrical relays or their equivalents (such as teeth on a gear wheel) is a digi-
tal computer. (P. 156)

Wilden makes the point that although a thermometer is an analogue device, it can communicate to a switch that will turn a furnace on or off. This is a characteristic of digital processes. Here, the analogue and digital work together. Keep in mind that much of the ambiguity of analogue and digital forms of communication results from the fact that human interaction is neither simple nor binary.

What would happen if an individual were to ask a computer to be vague? Could a software program be written that makes a point of producing ambiguous statements? The answer to both questions is yes and no. There is not much room for vagueness when 1's and 0's are the basis for moving information through the chips and processors of computers. But there can be a great deal of vagueness when a user works with the technology. The contextual space created does not depend entirely on the technology but on the relationships developed through usage. In this sense, as long as there are humans to use them, digital technologies will never be devoid of analogue problems and challenges.

It seems clear, nevertheless, that the immersive potential of digitally generated images is so great that the impact over time will be to "rewrite" what analogue experiences mean. There is no better example of this than the increasing effectiveness of simulated spaces for every kind of imaginable purpose from training pilots and astronauts to virtual reality (VR) labs investigating the use of the technology for medical purposes like remote treatment. Eventually, to varying degrees perhaps, everyone will experience simulations of one sort or another. The experiences may come from home computers, televisions, or newer and more portable large screen installations, but digitally mapped and constructed worlds will provide some continuity from the digital to the analogue and back again (Manovich 2001). Although it is unlikely that the grammatical principles of human language will change, the pragmatic use made of texts and speech will alter over time (Snyder 1998).

Simulated and virtual spaces are mapped with a coding process that makes many different assumptions about the relationships between "code" and reality. The examples of technologies dependent on code are endless, from cars to Playstations to airplanes to bank machines to traffic signals and medical equipment. This ubiquity means that the challenges of understanding software development are more crucial than ever. Yet, for the most part, software is used rather than created, and this has important ramifications for users and participants.

The opaqueness of "coding" and the skills needed to create software are out of reach for the vast majority of people. Imagine a situation of "illiteracy" with respect to language that is so widespread most people would not even have a rudimentary understanding of the grammar of their mother tongue. This is the reality most individuals face with software. It is also why simulation as a process and experience seems to be such a threat. To play in this world is to play by rules established by others, and, inevitably, this is a conferral of power to specialists.

"One would expect a 45-million-line program like Windows XP, Microsoft's newest operating system, to have a few bugs. And software engineering is a newer discipline than mechanical or electrical engineering; the first real programs were created only fifty years ago. But what's surprising—astonishing, in fact—is that many software engineers believe that software quality is not improving. If anything, they say, it's getting worse. It's as if the cars Detroit produced in 2002 were less reliable than those built in 1982.

As software becomes increasingly important, the potential impact of bad code will increase to match, in the view of Peter G. Neumann, a computer scientist at SRI International, a private R&D center in Menlo Park, CA. In the last fifteen years alone, software defects have wrecked a European satellite launch, delayed the opening of the hugely expensive Denver airport

There is a need to analyze the relationship between the modeling of the real through images and codes and to compare that with interpretations of what the codes generate. This poses a serious problem for analysts and critics of simulated environments. It is not enough to transpose the tools of literary or film criticism to simulation. Nor is it the case that simulated images are necessarily the same as conventional images. New discourses need to be invented and more thought has to be put into the languages used to interpret and describe virtual spaces.

For example, most simulations run on programs that have the ability to adapt to the user. The range of adaptations is actually quite high, and this introduces a level of unpredictability to the human-computer relationship that takes it beyond the

for a year, destroyed a NASA Mars mission, killed four marines in a helicopter crash, induced a U.S. Navy ship to destroy a civilian airliner, and shut down ambulance systems in London, leading to as many as 30 deaths. And because of our growing dependence on the Net, Neumann says, "We're much worse off than we were five years ago. The risks are worse and the defenses are not as good. We're going backwards—and that's a scary thing" (Mann 2002, 22). This is the Achilles' heel of digital technologies. It is an inherent limitation of cyberspace. My own sense is that these weaknesses are like pleats in the supposedly solid world of computers. As many opportunities as problems are created by the complexities of software development.

parameters of code itself. Simulations are often ambiguous in the sense that quite often the outcome of the encounter cannot be known until the game has been played or the experience completed. This lack of predictability could be the source of untold creativity. Instead, engineers put a great deal of time into "fixing" the systems so that they will be even more predictable. Yet, this makes it seem as if the virtual were far more secure and solid than it could ever be, which is why none of the system software used for computers is ever without flaws.

In a recent issue of the online journal CTHEORY, Jeremy Turner interviewed Myron Kreuger who in 1973 pioneered the term *virtual reality*. In response to a question about the loss of physical integrity in virtual environments, Kreuger (2001) said the following:

It is true that today's virtual reality provides very limited tactile feedback, almost no proprioceptive feedback (as would be provided by walking on a sandy beach or on rough terrain), rare opportunities to smell, and little mobility. However, it is just getting started. Criticizing a new idea because it is not yet fully realized seems unreasonably impatient. On that basis, the Caves at Lascaux would never have been painted because we did not have a full palette and could not animate in three dimensions.

Kreuger's comments are significant. They not only suggest how early the work in virtual reality is and how young the experiences of simulated spaces are, but they relay the extent to which the elements that make up virtual worlds still need to be developed. At the same time, Kreuger makes it clear that an emphasis on the visual is ultimately not what virtual environments are about. It may be the case that VR will eventually be truly immersive and multisensorial. This will challenge the meaning of the visual in Western cultures. But this is unlikely to happen until users can write code or develop their own strategies to create the virtual spaces they are interested in experiencing. Software development has to be taken out of the hands of specialists.

At another level, Chris Crawford, who is a veteran of game design, discusses the fundamental differences between optical reality and perceptual reality in a short article entitled "Artists Against Anatomists" (Crawford 2002). He proposes that a basic difference exists between optical reality (images produced by machines) and perceptual reality (the human experience of seeing). He suggests that efforts to create images that are "photorealistic" miss the point. More realism doesn't necessarily mean better communication. More realism also doesn't mean a better relationship between audiences and images. This is a crucial insight. The distinction between the optical and the perceptual is perhaps less clear than Crawford suggests, but the emphasis on the construction of photorealistic virtual environments misses the point about the complexity of human interaction with images and sounds.

Interactivity will not be achieved through effects but as a result of experiences attached to stories (Pesce 1998, 2000). Narrative in all its forms cannot be produced through the simple application of technology. Interactivity is as much about awareness as it is about fantasy. Even the most sophisticated science fiction writers know that the worlds they are creating refer back to the worlds of their readers or viewers.

The Playdium puts some aspects of the real back into the experience of images and simulations. As a result, virtual reality experiences become more process-oriented than oriented toward the end result. Virtual experiences also take a great deal *away* from reality, yet at the same time can bring participants to the point of seeing in a new way with no direct connections to the conventions of the everyday. There are not many discursive or critical tools for dealing with this unstable ground which is part of a continuum that incorporates the real into the virtual and vice versa. There are even fewer interpretive approaches available to account for the profound shift in orientation required to accept and engage with images that try to draw spectators into the very fabric of the screen and beyond.

Often, a rather superficial notion of interactivity is incorporated into discussions of simulation. The assumption is that skiing down a hill on a platform that moves in response to the player means the player is "interacting" with the screen. From a behavioral point of view that seems to be the case, but interaction needs to be judged by the interpretations that players make of their experiences with the game. The notion that there is something artificial to the experience masks the ongoing creativity of participants who are the final arbiters of what will work and what will not work.

Kreuger (2001) makes the point that "humankind has always inhabited a conceptual universe that is every bit as important to it as the physical world. Language, symbols, myths, beliefs, philosophy, mathematics, scientific

theories, organizations, games, sports, and money are completely abstract dimensions but as much a part of our humanity as rocks and trees." As the simulations become more complex, the notion that simulations are just copying something else or replicating another reality will become far less significant in evaluating the experiences. The construction of more layers of the virtual world means that the edifice will become larger, more solid and less solid at the same time. This is as much a recipe for chaos as it is for creativity and suggests the need for a constant process of construction and deconstruction.

Consequently, should one be overly optimistic about the Playdium? Will people look back nostalgically upon this era of nascent virtual emporia? Alternately, is there something romantic about snowboarding in front of a screen, sweating, screaming, laughing, and finally failing or succeeding? Could this be the source of a new kind of adventure of the spirit and mind and a new reference point for early twenty-first-century history?

These questions seem to be difficult to answer because present-day culture is feeling its way through simulation as an experience and immersing itself in the paradoxes of the real and the virtual. At the same time, history is being made and modern culture is constructing an important frame of reference for future reflection. Why are these worlds being built? Moreover, what kinds of expectations are there about their role in defining the viewer's relationship to images? What are the implications for traditional approaches to image construction and interpretation?

The irony is that photographs of the nineteenth century now look as if they represent the history of that period. In the same way, paintings have come to represent history or at least the traces of the past as seen through the eyes of artists who may never have thought they were leaving behind a historical legacy. Could it be that the Smithsonian will quickly move to preserve the simulated games now being played because they are markers of the needs and desires of contemporary humans in Western societies? Will reference be made to computer games like *Sim-Cities, Myst,* or *Riven* as examples of fairy tales in early twenty-first-century society? Do the power and the pervasiveness of simulation suggest something significant about human identity, need, and evolution? Does this suggest that a new definition of what it means to be human will be needed (Hayles 1999)?

Technology is not just about using and developing new tools. Technology also enables humans to model their environments in new ways and create the foundations for different ways of thinking. Technology is as much about cognitive change as it is about invention and the creation of physical devices. This is perhaps one of the most important lessons of the digital age.

The merging of humans with their computers and the augmentation of human abilities are not about the construction of cyborgs, a metaphor that suggests a dystopic rather than utopian outcome to human evolution. It will take years of collaboration and intermingling for a radically new vision to emerge from the very early stages of interdependence that are presently being built in the relationship humans have to digital technologies.

Ethnography of the Virtual

How can the experiences of virtual spaces be explored? Personal descriptions and testimonials provide at least some basis for the analysis of the virtual, and the coordination of comments among a variety of different people is helpful but not necessarily as accurate or broad as might be needed. The many different pitfalls of relying upon ethnographic as well as first-person commentaries about any cultural or experiential activity have been well documented (Marcus and Fischer 1986; Clifford 1988). Again, this is not to suggest that value cannot be drawn from ethnographic explorations of viewer experiences in differing contexts. Rather, it is to propose that the conclusions developed from these observational and analytic tools often end up making claims about digital, simulated, and immersive experiences that do not move beyond behavioral or phenomenological levels of observation. At the same time, artists who create virtual worlds have stepped into the breach and, as Char Davies (qtd. in Gigliotti 2002) suggests, developed a sophisticated discourse to explain what they are doing:

For a long time, I have been interested in conveying a sense of being enveloped in an all-encompassing, all-surrounding space, a subjective embodied experience that is very different from the Cartesian notion of absolute, empty, abstract, xyz space. As an artist, I am interested in recreating a sense of lived, felt space that encircles one with an enveloping horizon and presses closely upon the skin, a sensuous space, subjectively, bodily perceived. Some might interpret this as a uterine or womb-like space. Perhaps the desire to recreate, to communicate this sensibility, my sensibility, of such space is because I am female: I would leave that up to interpreters of my work. I think it might have more to do with having spent so much time alone in nature. (P. 64)

The following two examples (figures 5.1 and 5.2) are from the work of Char Davies and exemplify the extraordinary autonomy that can be devel-

FIGURE 5.1 Char Davies, *Forest Grid.* By kind permission of the artist.

oped in virtual worlds. Although participants have to wear head-mounted displays (HMDs) to see the images, the impact of Davies's design is so powerful that questions of interiority and the boundaries between dreams and reality are breached in a tumultuous fashion. Davies's installations lay bare the contradictions of virtual spaces. On the one hand, her work is so highly mediated that it is unclear how artifice, experience, and participation can be untangled. On the other hand, the power of Davies's creations is such that the experiences are more visceral than intellectual, more about testing the limits of perception, body, and thought than they are about recognition or gazing. In fact, Davies has constructed these spaces as environments for reverie with the one caveat that participants cannot evade the trajectory of images she has created or redesign their experiences by following a route different from the one Davies makes available.

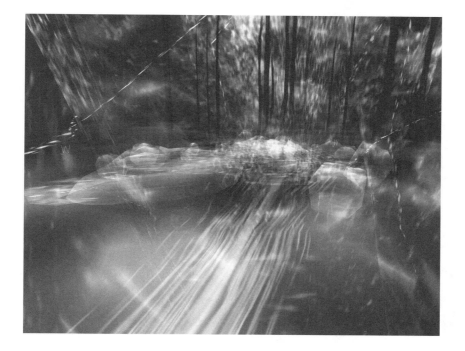

FIGURE 5.2 Char Davies, *Forest Stream*. By kind permission of the artist.

At another level, there is no simple inductive link between the complex experiences of virtual image-based environments and how they are processed and thought about. What I want to avoid is a narrow binary relationship between viewer and screen where responsibility is laid on either side. As a contrast, Davies's images and words suggest a much more symbiotic relationship among immersants and virtual worlds. Davies is looking for explanations that bring viewer and screen/image together as pictured in figures 5.1 and 5.2. The result could best be described as an open space that combines the characteristics of images and viewers and *binds* them into a shared framework. In other words, the mediated character of virtual images and virtual spaces means that, just as with language, there is no easy way to separate the manner in which the images operate from the manner in which they are ex-

perienced. My argument acknowledges the weight that must be placed on the combined role played by images, language, thought, and self-reflection in any context but with particular emphasis on the evolving importance of virtual experiences and the ways they are changing how participants interact with image-worlds.

At the same time, the experience of images is a very personal one. Surveys and ratings of different old and new media that try to access that personal space provide very little information, other than a broad sweep of likes and dislikes as well as patterns of behavior and choice. Recourse to claims by creators, marketers, or publicists provide inadequate markers for the complexity of viewing habits. What is left are a series of conjectures and hypotheses about the impact of images. This in itself is not necessarily a bad thing, but it is a weakness of analysts of images and the claims made by creators, authors, and critics. Some distinctions may have to be drawn here between claims about what immersive and virtual experiments provide, and hypotheses about the subjective experience of being inside image-generated spaces.

Most of the important digital phenomena that have developed over the last twenty years were in gestation for many years. They appear to have become important overnight, but were actually thought about in the 1950s and 1960s. These phenomena range from the World Wide Web to virtual reality, computer-aided augmented reality, and immersion. However, what was not understood in the middle of the twentieth century was the extent to which these technologies would be taken up and the breadth of change they would engender. The concept of computer networks had been worked out in detail by 1958, and important notions of augmented reality systems and the programming needed to achieve an improved relationship between computers and humans had been developed by the mid 1960s. J. C. R. Licklider, who was one of the most important people in the development of computer technology and very concerned about human-computer interaction, said in 1960: "[Humans] will set the goals and provide the motivations. . . . They will formulate the hypotheses. They will ask questions. They will think of mechanisms, procedures, models. . . . They will define criteria and serve as evaluators, judging the contributions of the equipment and guiding the general line of thought. . . . The information-processing equipment, for its part, will convert hypotheses into testable models and then test

the models against data. . . . The equipment will answer questions. It will simulate the mechanisms and models, carry out the procedures, and display the results to the operator. It will transform data, plot graphs. . . . [It] will interpolate, extrapolate, and transform. It will convert static equations or logical statements into dynamic models so that the human operator can examine their behaviour" (Waldrop 2001, 176–177).

One of the most important characteristics of the digital revolution has been the unpredictability of the wholesale importation of computers into everyone's daily lives. Licklider developed the framework as well as some of the actual coding to make the technology work, but he recognized early on that users and developers would take the technology much further than he had anticipated. In fact, the history of computer technology is nonlinear and characterized by a sense of unpredictability. This produces fear and a sense that an infrastructure is being built that will overtake humans and destroy their individuality and uniqueness. Virtual environments now bear the brunt of this anxiety because they work so well. It would be my contention that these fears are no different than the hesitation expressed when photography and cinema came onto the cultural scene in the nineteenth century. Most important, the telephone was perceived to be as much of a threat as virtual reality technologies are now, an irony given the ubiquity of telephones in most cultures of the world (Standage 1998).

Immersion in CAVEs

Many of the comments about immersion and the suggested differences between traditional and new media have centered on the claims that have been made about virtual reality CAVEs (automatic virtual environments) and installations. CAVEs provide immersants with a sensory experience that is not the same as, but is akin to, what used to happen in theaters with Cinerama screens in the 1960s. Cineramas were traditional theaters that were transformed by wide screens, and the films were shot with multiple cameras and shown using multiple projectors (figure 5.3). Shots using the point of view of riders on various vehicles provided spectators

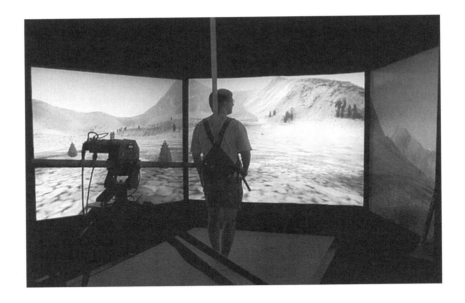

FIGURE 5.3 A typical CAVE installation at the University of Utah. Used by permission. (http://www.cs.utah.edu/research/areas/immersive/locomotion.html)

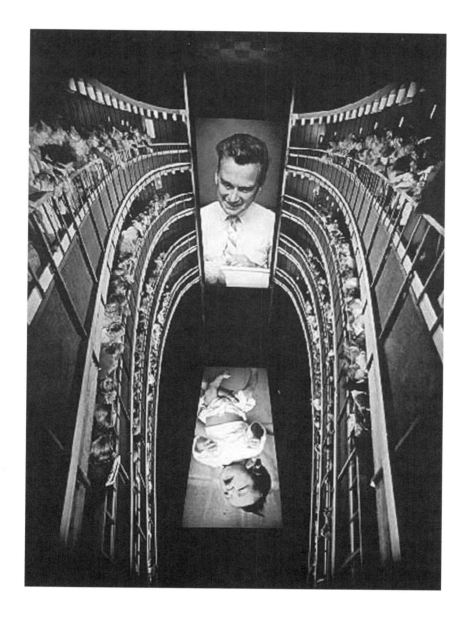

FIGURE 5.4 Labyrinth: Expo 67 (National Archives, Ottawa)

with a physically unsettling and quite realistic experience of traveling through space. It was common for viewers to get vertigo and feel nauseous.

CAVEs take the concept of Cinerama many steps further because computers exercise control over the environment and because participants or immersants move around in CAVEs in response to the movement of images and sounds. Part of the impact is created through filtering mechanisms that isolate people from anything else but the images. The most important elements are the variables that can be introduced. Images change in response to what immersants do, and this sensation of interaction makes it appear as if the images were malleable and responsive.

Of course, even in the most sophisticated of installations, the variables are not infinite, and, consequently, processes of interaction can only operate within the limits set by the programming. However, the presence of sensors adds to the feeling that the machines generating the images are capable of any number of interactions and that can keep participants "playing" for a long time. As Kreuger suggests, one of the outcomes of experiments in CAVEs is that participants will soon be able to "telecommunicate" using a variety of augmented reality systems bringing people and environments that are distant from the user into close contact. As figure 5.3 suggests, this will be an enhancement of the relationships that participants have just as the telephone is now indispensable to what is defined as communications in society.

CAVEs are also similar to some of the experiments mounted at different world expositions, like Expo 67 in Montreal. At Expo 67, the National Film Board of Canada created an immersive experience by using a number of large screens in an enclosed space. In fact, the screens were so large and high that it was very difficult to escape their impact and people had to watch the screens from different levels, as the illustration in figure 5.4 shows. The "Labyrinth," as it was known, was a precursor to IMAX cinemas, which also "immerse" viewers much as CAVEs do but remain screen-based in the more traditional sense.

A further experiment at Expo 67 was designed by the Disney Corporation and involved a 360-degree visual experience. Fifteen hundred people crowded together in a room surrounded by nine large screens. According to Jeffrey Stanton (1997), "Nine projectors, concealed in the space between the screens, projected a completely circular image, while twelve synchronized sound channels enveloped the audience in sound."

Therefore, it should come as no surprise that CAVEs are an extension of many of these experiences. The difference between CAVEs and many of

these early experiments is the infrastructure needed to make the CAVE work. It is possible to reach even further back to experiments with magic lanterns, the camera obscura, eighteenth-century panoramas, and circus environments that used mirrors, images, and sounds to achieve an immersive effect. Clearly, there is a lineage to the research and practice in this area that is as fundamental to technological development as it is to artistic experimentation.

Popular culture has been obsessed with heightened immersive experiences ever since the first roller coaster rides were invented. Adding movement to the experience of being in an immersive environment has a long history. To add movement in a CAVE, locomotion devices have to be used to heighten the effect of the simulation. Motion was also used in the Disney experiment. The history of experimentation with visual interaction in virtual spaces is also steeped in experimentation with moving platforms and other mechanical devices.

"Locomotion interfaces are energy-extractive devices that, in a confined space, simulate unrestrained human mobility such as walking and running for virtual reality. Locomotion interfaces overcome limitations of using joysticks for maneuvering or whole-body motion platforms, in which the user is seated and does not expend energy, and of room environments, where only short distances can be traversed. Their use yields realistic navigation and engagement in modeled worlds and an enhanced sense of spatial layout" (University of Utah Computing Science Department 2002).

"The intention in this experiment is to create a 'synthetic' experience that mimics what it might be like to walk in the space that is depicted. One of the goals is to have a realistic experience of turning and translating for accurate updating of locations in the environment. In return, manipulating the display variables will lead to a greater understanding of how humans perceive and navigate through space" (University of Utah Computing Science Department 2002).

All of these different strategies of image depiction are interrelated. In the case of virtual reality, the presumptions of change and immersion are greater than ever before. Research in this area combines cognitive approaches with engineering and computer science (Van Dam 2001). Many

artists have also entered this realm and make a variety of assumptions based on their own experiences and the comments of others. David Rokeby is particularly sensitive to the contrast between the human sensory system and what is provided by the technologies of virtual reality. Rokeby suggests that the interfaces for immersive experiences are neither as rich nor as developed as the human sensorium: "Our sensing system involves an enormous number of simultaneously active sensors, and we act on the world through an even larger number of individual points of physical contact. In contrast, our artificial interfaces are remarkably narrow and serial even in the multimedia density of sound and moving image" (1996).

The various prostheses that are used to support the relationship between subjects and virtual spaces suggest a great deal about the technologies but may not easily provide the analytical tools to make claims about what is experienced (Brahm and Driscoll 1995). When Rokeby talks about sensory systems, he assumes an understanding of the cognitive relationships among perception, action, and thought. Chapter 6 details the problematic appropriation of research in this area by both artists and computer scientists. For the moment, scientists know far too little about cognition, the brain, human emotions, and the mind for many of these claims to stand up to detailed scrutiny (Lakoff 1999).

This has not prevented locomotion interfaces from being developed for VR CAVEs and for increasingly complex simulations to be created for everything from medical imaging to learning how to fly an airplane or a spaceship. The use of head-mounted displays (HMDs) increases the power not only of the participant but also of the various images that can be seen. As Piekarski and Thomas (2002) suggest, graphical objects can be visualized using HMDs, but they do not define visualization:

Augmented reality is the process of overlaying and aligning computer-generated images over a user's view of the physical world. Using a transparent HMD placed on the viewer's head, an internal half-silvered mirror combines images from the LCD display with the user's vision of the world. By combining this display technology with a wearable computer, it is possible for the user to walk outdoors and visualize graphical objects that are not normally visible. (P. 36)

The difficulty with what Piekarski and Thomas say here is that the knowledge engineers who build and maintain immersive systems "assume that thought and action are isomorphic" (Forsythe 2001, 53). In other words, they assume

that visualization is one of the outcomes of using HMDs without the intellectual and methodological tools needed to examine if that has in fact happened. As Forsythe (2001) suggests, "To knowledge engineers, 'knowledge' means explicit, globally applicable rules whose relation to each other and to implied action is straightforward. Knowledge in this sense is a stable entity that can be acquired and transferred" (53). This issue is not simply a difference of opinion between engineers and social scientists. The lack of concern for the social and cultural implications of immersive experiences means that the ways in which they are built and used is conceived of through a limited model of human subjectivity. This depletes the potential richness of interaction and reduces the future potential of virtual reality environments.

In an HMD, one sees a combination of images and objects. However, the mediated image remains and still poses issues for what is meant by *perception* and *experience*. Part of the problem is that images are generally about ambiguous forms of presence and absence. Images have always been fluid metaphors for how viewers deal with their proximity and distance from events, people, and objects. This is why the shift to immersive simulations appears to have dramatically overcome the normal distance between human sight and the sense people have of themselves as viewers.

Ironically, it is also why so many new technologies and new media have been criticized for being artificial rather than extensions of existing mediums of expression that allow the exploration of new image terrains (Baudrillard 1990). In addition, for Baudrillard (1996) the virtual is described as "something that doesn't happen" as if mediated experiences negated or reversed the relationships between the real and the artifactual.

These experiments with immersion bring the questions of direct interaction with virtual and real worlds into question and raise important issues of where the dividing line is between different levels of experience in image-worlds. Rather than thinking about oppositions here, virtual images need to be approached as one of many *levels* of experience for viewers. Viewing or being immersed in images extends the control humans have over mediated spaces and is part of a perceptual and psychological continuum of struggle for meaning within image-worlds. Thinking in terms of continuums lessens the distinctions between subjects and objects and makes it possible to examine modes of influence among a variety of connected experiences.

Continuums are about *modalities* of interaction and dialogue. In fact, continuums are built through analogue processes, which require subtlety and shading in order to be understood. This is the irony of new media and new technologies for image production. They create the conditions for experien-

tial relationships, conditions that cannot be reduced to the discrete characteristics of the digital. To varying degrees emotions will always be the purview of sensate beings irrespective of the power of the digital world (Stone 1995; Turkle 1995).

This central issue and the degree to which digital technologies try to embody what humans do are evidence of a misunderstanding about the boundaries and levels of complexity that make it possible for humans to *experience* the world around them. A generally reductive approach to technological devices and objects is one of the reasons for this error. As I mentioned earlier, this comes out in the popular assumption that technologies produce objects that are just tools. But the implications of this approach go far beyond the notion that technological objects exist purely as a result of their use or functions.

If the computer I used to write this book were simply a tool, then its impact on my writing style and approach to argument and thought would be transparent. It is easy to draw the conclusion that there is no difference between my work on a keyboard and what I would have done had I written this book in longhand using pen and paper.

And yet there are distinct and important differences. Among the key ones (with respect to Microsoft Word) are

- the manner in which documents are formatted;
- assumptions of correct spelling and grammar (the poet e.e. Cummings would have had red lines under every word);
- the way in which content is perceived on screens and the impact of the movement from keyboard to screen (What does it mean to type at the speed of thought? Or is the thinking process changing to type at the right speed?);
- the screen as text and code, with the latter not visible and yet a determining factor in the ability of Word to move type from the computer to the printer;
- Word documents as multimedia productions. (Bolter 1991)

These are only a few of the many ways in which a digital technology like word processing alters the environment within which writing takes place. I am not talking about tools but processes of far greater complexity. At one extreme, it is possible to suggest that an investment in the functionality of Word indicates an almost mythic belief in the transparency of computers to the use that is made of them. At another extreme, it is clear that any dependence on

Word is about much more than its efficiency or the efficacy with which Word makes it possible to write.

Perhaps the most important facet of this (inter)dependence is the role of memory and archiving as strategies for mapping authorship and writing. This is very much about power and control, the ability to manipulate large amounts of information and write in a context where that information can be classified and categorized (Ryan 2001). The "space" of writing is now partially defined by the size of the screen that is used and the ability of the writer to work with large bodies of text that are interrupted by their framing. This moves (or transforms) the written word from its material and historical base (i.e., paper) and from its conventional role as marker for the process of thinking and/or feeling into a broader, even more fragile environment. The fact that any "piece" of writing can now be converted into an e-mail message or a Web page or can become the base for a multimedia production shifts the written word from a solid to a fluid base. This has been recognized in discussions of hypertexts and hypermedia, but not fully understood as an integral part of the recasting of technology from tool to constituent element of a more complex and broadly based ecology (Landon 1997).

Yet the role of human emotions, the subtlety of human intuition, and the complexity of human consciousness cannot be replaced by digital technologies. In chapter 6, I examine the relationship between machines and humans in order to explore more fully the argument about the continuum of linkages among technologies and the ecologies they create.

CHAPTER SIX Humans ———— Machines

Suddenly, as a result of discontinuities or
critical thresholds characteristic of the
coevolution of knowledge, the computer
has emerged as a tool of choice for observing
and simulating the infinite complexity of life,
of society, and of the ecosystem—and above all,
as a tool for acting on it.

—Joël de Rosnay, *The Symbiotic Man*

The Brain Sees, but Does the Mind Understand?

As the epigraph suggests, Joël de Rosnay (2000) goes further than most futurists in his discussion of the transformative impact of computers on everyday life:

This hybrid life, at once biological, mechanical, and electronic, is still coming into being before our very eyes. And we are its cells. In a still unconscious way, we are contributing to the invention of its metabolism, its circulation and its nervous system. We call them economies, markets, roads, communications networks, and electronic highways, but they are the organs and vital systems of an emerging superorganism that will transform the future of humanity and determine its development during the next millennium. (Pp. xii–xiii)

This is an extraordinary statement; there are elements to what de Rosnay is suggesting that must be examined with great seriousness. He is beginning to talk about merging human biology and the way it functions with digital technologies organized by the programming systems that govern them. As a result, Western societies are developing, albeit tentatively, a completely different understanding of the body and thinking about the relationships humans have created with the many devices that surround them (Resnick 1997).

De Rosnay does not simply collapse technology and the human body. This is not his purpose. Rather, and more important, he understands the connections that bind people and technology together. The links that have been created—the webs that join people, their environment, governments, cultures, economies, and, most important, technologies—remain at the heart of a new understanding of what it means to be human (Campanella 2000).

In making this statement I am aware of its many pitfalls, not the least of which is that there is no clear way of anticipating the outcome of the changes presently being experienced. However, there is no doubt the convergence of biology and technology means that conventional definitions of human identity and subjectivity will undergo a profound alteration. (See Fukuyama 2002 for a negative evaluation of these changes.)

Much will have to be learned about how to discriminate between differing definitions and explanations of what it means to be human. Most importantly, baseline assumptions about reality will have to change to reflect the integration of image-based virtual worlds into everyday life. These developments are also part of a paradigm shift that is dramatically altering the boundaries, orientation, and emphasis of many academic disciplines (Stock 2002). Richly endowed strategies of research about the interrelationships among the sciences, arts, and humanities are becoming important parts of a new

research agenda that is being pushed to define what connects and sustains the digital with the biological (Casti 1997).

For example, the neurosciences examine the biological basis for human thought and, at the same time, have to explore the social context for human behavior, since both are so directly interrelated (Pinker 2002). Experiments in the neurosciences extrapolate results from language-use simply because language is one of the foundations for the biological makeup of the brain (Paittelli-Palmarini 1980; Edelman 1992). The crossing of disciplines is necessary because the brain is being studied in order to understand how it represents knowledge and information as well as to more fully comprehend what happens when it becomes diseased or injured. Yet there is no concrete way of being sure that "representing" is what the brain does, nor can a simple window be opened onto how information is processed inside the trillions of connections that the brain uses in order to function effectively (Edelman and Tononi 2000).

Interestingly, as I mentioned in chapter 1 as well as in the introduction, the ways in which the brain fires during certain activities is only visible through imaging devices. These devices are themselves the product of a cultural context that makes assumptions about pictures and the translation of pictorial elements into readable data about the body (Baigrie 1996; Waldby 2000). What does a diagram designed to describe the electrical patterns in the brain reveal? Does a physician's analysis of an MRI linger in the space between interpretation and empirical deduction? There is an assumption that the link between the diagram and brain function is a direct one, but it may well be the case that culture is being mapped onto the brain and vice versa in an attempt to provide physicians with a vantage point for research and analysis. In all of these instances, the research has to draw upon a variety of assumptions about truth in order to be effective.

Imaging of the brain can provide pictures of the connections between different parts, but imaging cannot provide details of what Gregory Bateson (1972) has so aptly described as the set of differences that makes relations between the parts of the mind possible: "The interaction between parts of mind is triggered by difference, and difference is a non-substantial phenomenon not located in space or time" (92).

Difference is not simply the product of processes in the brain. Thought cannot be located in one specific location; in fact, difference means that the notion of location is all but impossible other than in the most general of senses. Bateson goes on to ask how parts interact to make mental processes possible. This is also a central concern in the work of Gerald Edelman, particularly in the book he coauthored with Giulio Tononi where they point out how the

neurosciences have begun to seriously investigate consciousness as a scientific "subject." (Edelman and Tononi 2000, 3). Edelman and Tononi (2000) summarize the challenge in this way:

What we are trying to do is not just to understand how the behavior or cognitive operations of another human being can be explained in terms of the working of his or her brain, however daunting that task may be. We are not just trying to connect a description of something out there with a more scientific description. Instead, we are trying to connect a description of something out there—the brain—with something in here—an experience, our own individual experience that is occurring to us as conscious observers. (P. 11)

The disparities between the brain and conscious observation, between a sense of self and biological operations cannot be reduced to something objective; rather, the many layers of difference among all the elements that make up thought can only be judged through the various strategies used to understand subjectivity. In response to this, Edelman and Bateson disengage a series of cultural metaphors that cover up the complexity of consciousness. For example, when information is assumed to be knowledge, an input/output model is generated to explain the relationship between experience and understanding. The issue is not only that these relationships are more complex than allowed for, it is that the long historical struggle to explain human thought stands as a comprehensive narrative of what can and cannot be achieved by research in this area. Mechanical and nonmechanical models of mind have provoked scientists, philosophers, linguists, and artists to wage a continuous battle for centuries, but the arrival of imaging tools makes it seem as if at least part of the conflict has been solved.

Although it is impossible to "see" thought, the appearance of electrical activity in one part of the brain seems to provide the kind of topographical concreteness that eluded researchers before the arrival of scanning. Yet the paradox here is that thought remains as opaque as ever simply because language is the best way of understanding, in the most subjective of senses, whether thinking has actually occurred. And although the location of "talking" can be pinpointed in the brain, there is no location for content especially in brains that have not suffered from an accident. The distributed nature of consciousness makes it difficult to reduce its complexity to a model, which is why it will be very difficult to create a machine with a mind (Sommerer and Mignonneau 1998).

There is a useful metaphor that explains difference and information processes as they apply to human awareness and perception. The metaphor

comes from the cinema. When viewers watch a film, the black dividers between each frame have a large influence on the movements viewers see. The difference between each frame, however miniscule, effectively produces the possibility of motion. The black dividers exist, but spectators do not see them. From the point of view of the audience, they are irrelevant to the experience of watching a film. The information is built through the differences between the frames, but that set of differences has no immediate or concrete substance.

It is hard to think of information without ascribing a certain "weight" or "substance" to the process of exchange and interaction. In the same way, it is difficult to "think" of the mind creating many of its rich possibilities through actions that may not have a quantitative character. It is even more difficult to envision mind, using theories that do not locate "effect" or "affect" in specific locations in the brain (Horgan 1999).

Yet the desire to "picture" what happens inside the mind remains locked into models of representation that are for the most part idealizations. This is not necessarily a contradiction—after all, much of the research in the sciences and social sciences works from hypotheses, and these are often based on idealizations (Kuhn 1962). However, with respect to the brain and to questions of mind, great care must be taken in the translation of model to reality through idealizations that are fundamentally quantitative in orientation.

The reader may well ask what relevance a discussion of mind has to the study of digital forms of cultural production. The central issue is how to distinguish between the living and nonliving. Some researchers are embracing the idea that a computer might one day be able to replicate human thought (Kurzweil 1999). Yet research into the brain and mind is in an early phase of development. This is the case even though humans have always been fascinated with how they think and what differentiates the brain from the mind. The difficulty has been in establishing a research agenda that does not make too many claims and does not become overly deterministic in orientation.

As computers become increasingly capable and more sophisticated, the relationship between the living and nonliving will have to be mapped so as to explore and explain the dividing lines between the artificial and nonartificial. What webs of interconnection are being constructed to blur the boundaries among biology, technology, and human thought?

Human consciousness cannot be duplicated inside a machine, although this does not preclude the possible duplication of many aspects of the human body in machinic form. At its root, the idea that the mind can somehow be replicated arises from a fundamental contradiction. The as-

sumption is that evolution will end and that the interaction of mind, machine, environment, and biological forces has an absolute center that can be duplicated. This is somewhat similar to the notion that the brain has a representation of a human inside of it that controls waking and sleeping activities, perception and dreams. If anything has been learned from the work of Charles Darwin and more than a century of research on evolution, it seems clear that the process of change is a neverending but very slow one. Each time the infrastructure of knowledge changes, the human capacity to understand the world and the place of humans in it changes. This may well be an infinite process. Even the recent decoding of the human genome, which seems on the surface to provide a map of the biological organization of humans, cannot be seen in isolation of all the environmental, social, and cultural factors that influence human development (Carruther and Chamberlain 2000).

What happens when humans compare themselves to the operations of a machine? Are they inevitably going to find themselves in the weaker position? The answer to this question will not be found in any inherent lack of power. The simplicity of the opposition between humans and machines can lead to paranoia and fear. Yet it remains the case that machines are an integral part of definitions of human subjectivity. If the impulse to compare humans to what has been created is dispensed with and an integrative approach is accepted, then it is likely that humans will be able to explore the implications of what they *share* with machines and computers. At the same time, hard questions need to be asked about the process of sharing and the granting of greater autonomy to digital technologies. This is perhaps the first time in human history that a technology has been invented that could redefine what is meant by being human. Great care must be taken in the exploration of this new territory.

The melding of silicon with biology has taken a step forward, thanks to recent advances by the IBM research center in Zurich and the University of Basel. In the April 14 Science, *the researchers report that they constructed a biomolecule sensor based on an array of miniscule silicon piers—each thinner than 1/50th of a human hair. Each fingerlike cantilever is coated with a different short DNA molecule that will bind only with complementary DNA strands added later (*Scientific American, *July 2000).*

As this passage suggests, the intermingling of silicon and biology is a matter for research, but questions still persist about what this actually means. I explore this central issue in greater detail in what follows.

Thought Machines

Machines attract and repel humans. Although human beings are surrounded by many different machines and rely on them everyday, they are viewed with a great deal of skepticism. (See Kurzweil 1999 for the utopian outlook, and Coyne 1999 for a more historical and critical overview.) At the same time, the desire to automate the world and efforts to link humans and machines have always been a part of the arts and sciences, and have been foundational to the cultural and economic development of Western societies. What happens, however, when machines disappear from "view" into the background and nevertheless retain even more of their importance? This is the world of cyber-space, but it is also the world of images. It is a place in which contradictory feelings about cyborgs have not prevented Western societies from engaging with cloning and a variety of complex reproductive technologies. In other words, as the "Borg" in the television show *Star Trek, Voyager* would say, "Resistance is futile" (Davis-Floyd and Dumit 1998).

Digital technologies bring with them many attendant dangers, including the assumption, if not the reality, that humans no longer control their own destiny. This need for control is bound up with a series of cultural and moral worldviews that regard machines as the antithesis of what it means to be human. There is a "natural" and negative "gut" reaction to the idea that machines may have more power than humans do. This was recently played out to its fullest in the chess encounter between the powerful computer (Deep Blue) built by IBM and Garry Kasparov, the chess grandmaster. Deep Blue lost the first series and won the second. Consequently, the demarcation lines between humans and machines became fuzzy, and questions were raised about the human brain, its capacity, and the ability of machines to match, if not exceed, human thought processes.

Efforts to create artificial intelligence are largely dependent on the power of computers and their capacity to retain and use information. Artificial intelligence is a metaphor for information processing and modeling. The assumption is that as new information is introduced into the computer, it will be capable of processing new information into the existing models that have been part of its operations. To some degree, the hope is that the computer will be able to use enough of its 'intelligence' to move beyond the limitations of the information it has received and to develop predictable as well as unpredictable outcomes. To some degree, the more autonomous the computer, the more it 'feels' as if there is intelligence, especially if the programming process allows the computer to effectively work on its own. Nevertheless, computers

remain very dependent on what has been inputted into them. How can one judge whether or not autonomy has been achieved?

According to David T. Stork (1997a), "Humans are exquisitely good at pattern recognition and strategy. Computers, on the other hand, are extremely fast and have superb memories but are annoyingly poor at pattern recognition and complex strategy. Kasparov can make roughly two moves per second; Deep Blue has special-purpose hardware that enables it to calculate nearly a quarter of a billion chess positions per second."

Stork's comment explains very little about the "intelligence" at work here. Rather, the fact that Deep Blue is capable of anything is largely the result of collaboration among humans. The same collaborative process is what characterizes computer-human relations. The question is from which vantage point can humans make the decision that their machines are intelligent? At this stage, the computer certainly cannot make that decision. Judgments about intelligence will be determined by knowledge of what has been programmed into the computer. And for the most part, there is no clear understanding of the relationship between programming and intelligence.

The history of exploration into artificial intelligence, which has its roots in post–World War II research into cybernetics, has had a profound effect on how Western culture thinks about computers and their potential, as well as the human mind and its potential. The effects have also been pervasive in the cognitive sciences and in the resulting concepts that have been developed for human subjectivity as well as in the way metaphorical maps have been created to explain the human mind (Helmreich 1998; Hayles 1999).

As I have mentioned, the problem is that research into the brain and consciousness, research straddling the boundaries among the neurosciences, cultural theory, and the mind, is in its infancy (Moravec 1991, 15). At the same time, many of the claims that are made about the mind seem to circle around metaphors that transform the mind into an apparatus (Churchland 1995). This cultural impulse tries to turn thought processes into a series of mechanical activities. It is the machine, so to speak, returning to haunt its creators from within. Yet the choice to equate the mind with a computer, for example, results in a series of assumptions about the relationships between programming and knowledge that are not verifiable. In what appears to be an endless circle, software is built to try to grasp processes that more often than not are within the realm of human consciousness. The beauty, as well as the irony of this process, is that it creates and then sustains its own mythological and scientific infrastructure (Pinker 1997, 59–148).

Among the most serious problems of a mechanical view of the mind is a disavowal or lack of concern for the body and the integrative relationship between feelings and thought (Damasio 1999). Nevertheless, I would argue that a new ecological foundation for cultural production, experience, learning, and the activities of communications is being created. It will be necessary to explore the implications of this fundamental transformation and how the integration of the digital and the real have converged to create a new identity for human beings.

One of the most important characteristics of this new ecology is that computers have the capacity to talk to each other. Communications networks to some degree are about autonomous relationships developed and maintained by machines with connections that are generally sustained without too much human intervention. Of course, machines do not literally speak to each other. They do communicate although the assumption is that humans mediate the interchange. However, a great deal takes place that is not governed by humans even if they may have been the progenitors of the interaction.

Some important questions need to be asked:

- What does it mean to talk about the computer as if it were a machine?
- Do references for the word *machine* come from another era?
- Is a computer just a smart television screen?
- Is it a smart combination of analogue and digital components to produce the illusion of intelligence?
- What does it mean to attribute human qualities to the screen—to the computer?
- What does it mean to talk about the memory of a computer?
- Is the distinction between human and machine a nonstarter?
- Does the distinction between humans and technology contribute to a lack of understanding of the continuous interrelationship and interdependence that exists between humans and all of their creations?

What happens when a computer automatically recognizes the speaking voice of a user and then transfers that information to another computer for verification? Does the machine listen and then communicate? Is this just a matter of terminology—the use of words like "listen" and "talk"? In a general sense, computers are referred to through a series of anthropomorphic metaphors that both personalize and enlarge their role as "agents" for exchange. This is perhaps why the information that circulates through a computer is seen in more personal terms than other devices. It is also why the attribution of intelligence moves along a consistent line even when machines fail in their duties.

Can a machine feel pain? This question has been explored in the literature of science fiction and film. The answer is not as easy to formulate as the question. What are the boundaries between humans and nonhumans? If the issue were a simple one, easily divisible into parts with humans at the center, then it is quite likely that machines would have played a far less important role in human development than they have. A better question might be, can machines eat, digest, and excrete? Suddenly, the superficiality of the attribution of intelligence to machines becomes apparent. This still does not explain the need to anthropomorphize machines. It may be that even the question about the digestive system is part of the same circle of debate (Casell and Vilhjálmsson 1999).

On the one hand, computers are related to as if they have no bodies. On the other hand, when a hard disk crashes and wipes out its "memories," it also takes something from the humans who may have used it. The problem is in the distinction between machine and human. The simplicity of this binary opposition generates its own set of conundrums because there is no answer to what increasingly becomes a tautological loop. Machines are created by humans: they are simply part of a connected set of relations, albeit ones that require different tools and modes of interaction. There is a reason humans transform machines into surrogates, and it is simply because they could not survive without them. Machines act for people and with them; consequently, a measure of humanity is conferred upon them. This is a natural outcome to the process of creating a world in which machines are partners with humans in every aspect of daily life. Ironically, as machines become more autonomous and act upon the world without human interference, the already existing links that connect humans to their machines will be drawn ever tighter (Latour 1996). Perhaps the distinctions between technological innovation and human-machine interaction have from the start been built on differences that do not exist.

Telephones, as I mentioned earlier, are one of the best examples of the interdependence of machine and human, a connection that by its very nature encourages humans to become cyborgs, even as they resist the notion of interdependence. At another level, it also seems clear that the distinctions between artifice and nature, between the artificial and the real, have by degrees become far less important than the very definitions made of life itself. In addition, those definitions are being challenged, in no large part because humans have so heavily linked themselves to the seemingly autonomous activities of computers but also to many other technologies.

There isn't one correct way to approach this complex topic. Nor must one assume that there is any linearity to the relationships that people develop

with the machines they use. The interaction between machines and humans has become far more complicated over the course of the twentieth century and into the twenty-first century. This doesn't mean that the contradictory relationships humans have with machines has lessened in intensity. Computers have become increasingly more powerful as well as more intricate and bewildering. In the process, the computer has changed from a tool to the foundation upon which a new information ecology as well as environment is being built. This position is most persuasively held by Bruno Latour and developed in great detail in his book *Aramis or The Love of Technology* (1996).

As an early user and programmer for the World Wide Web, I continue to be fascinated with the speed and intensity of its growth as a medium. The impulse to create a Web page and to maintain it is about the design of a new landscape for human expression. Landscapes, in this context, become more than just a physical phenomenon. The Web makes it possible to envision and then interact with different worlds. This transforms the computer from a device with a screen into a portal, a gateway, an entry point into a series of lived experiences that are not constrained by the protective shell of the computer box. This is why there is so much fascination with three-dimensional worlds. Will it be possible to touch images? Or will the nature of touch change to suit the digital spaces that participants enter into? For example, hasn't sight already been transformed to accommodate the presentation of films in a theater? Aren't film screens among the most limited of mediums for experiencing images? Yet spectators willingly throw aside the contradictions of theatrical space in order to experience the pleasures of cinematic storytelling. It is the environment of culture and cinema that makes all of this possible and plausible. That environment is largely defined by what goes on outside the theater including the star system, Hollywood, and television. In the same way, digital environments are about the intersection of a wide variety of activities that include education, learning, scientific experimentation, cultural production, and research, robotics, business and government. At this point, it would be inconceivable to run any of the operations mentioned above without the aid of computers; in other words, for better or worse, an ecology has been put in place.

The challenge is that computers now have many different uses, but they remain dependent upon programming principles that have not changed for forty years. In addition, the interior workings of computers remain, for the most part, opaque to users. This is why computers are dealt with as if they are "other" to humans, as if they are unapproachable and can only be understood through use.

Can a Neuron Think?

Thus far, I have been exploring a number of issues that deal with the human connection to, and dependence upon, digital technologies. Computers and machines in general play more than a significant role in Western culture; they are among the essential foundations of society. Intuitively, one feels that this is somehow wrong. There is a residual sense that human beings are superior to the machines they invent. The problem is that the superiority of humans is not in question. Rather, as humans strive for more knowledge, computers will inevitably be one of the pivots for a collaborative approach to problem solving.

I am not talking about a value-free universe here. The desire to develop new technologies is governed in large measure by enlightened self-interest as well as altruism, and at other times by greed and the desire for power. This universe of conflicting values needs to be explored. The goal is not to come to some easy resolution of the ambiguous feelings humans have about machines but to examine the richly layered tapestry of relationships they have *with* culture and technology. One philosophical or scientific framework will not explain why all these relationships actually work. A multidisciplinary or transdisciplinary approach is needed in order to understand the impact of technology on daily life.

The fact that computers do many things seems to suggest that they have intelligence. But a large measure of what is described as intelligence is derived from a self-reflexive understanding of thought processes. People understand intelligence from a very subjective point of view. They know little about how the electrical and chemical activity of the brain translates into intelligence. They do know that they are capable of incredible mental feats. For example, language use is just one of many activities engaged in for which researchers have a fragmentary understanding. There may well be a part of the brain that deals with language, but as Edelman and Tononi (2000) point out, it is likely that the complex processing of information of this sort is distributed throughout the brain. This means that it takes millions of interactions

among neurons across networks connected in millions of predictable and unpredictable patterns for a simple sentence to be formulated. Ironically, one can only hypothesize that the sentences so produced actually relate to the thought process (Ramachandran and Blakeslee 1998).

The capacity to define and explain consciousness is largely dependent on hypotheses, which is why there are so many conflicting explanations. It is also why the intersecting fields of philosophy of mind, neurosciences, and the study of computers have attracted such a large following. Irrespective of whether conclusive evidence is found about how the mind works, the existence of computers has raised many important questions about human thinking. However, intelligence in the broad sense, and very much in the human sense, cannot be built or constructed. Some aspects of the mind can be reproduced, but are generally limited to specific kinds of reasoning and mechanical command structures. Computers cannot emulate what humans are capable of doing with their imaginations or even with their daydreams.

The answer to the question "Can a neuron think?" is an ambivalent one. The brain generates a vast number of interactions between neurons. Within that almost incalculable mix of events, memories and connections, thought emerges. The various translations of the brain's operations, including the use of language, can only hint at the complexity of the biological processes that make thinking possible. In this sense, the comparison between computers and the brain seems to be extremely reductive.

What interests me is why anyone would want to pursue this type of connection in the first place. Part of the answer to these debates will be found in the ways in which modern culture frames the arguments between the artificial and the natural. The desire to recreate the brain in a mechanical form is grounded in generalizations about human thinking. These generalizations are founded on a hierarchy that places human thought above all other biological activities, including the body.

This is one of the underlying foundations of modernism. Before the Age of Enlightenment, intelligence was a God-given quality imbued with spirituality and dependent on validation from religion and adherence to religious values. As humans have recreated the natural environment in their own image, they have also redefined the meaning of nature. Humans live within a fabricated world that mirrors their history as well as their desires. This is a world of such extreme heterogeneity that no amount of quantification will exhaust its possibilities. Paradoxically, computers are built upon a system that is first and foremost quantitative, so there is a tendency to assume that human activity mirrors that type of functioning.

Objects and sounds as well as images and signs surround everyone, providing evidence of the world in which people live and the cultural and physical environment humans have created. This phantasmagoria of expressions, representations, machines, and the built environment, at once architectural, archaeological, and anthropological, is not, as many have argued,

> The evidence for the integration of artifice and nature is everywhere. As early as 1994, "Surgeons put an electrode array into the eye of a blind patient, and while delivering small, controlled electrical pulses, asked what he could see. 'Well,' replied the volunteer patient, 'it was a black dot with a yellow ring around it'" (Frontiers 1997). Recent efforts have become even more sophisticated with the insertion of silicon chips into the eyes, capable of communicating with the brain. An electronic circuit has been developed that mimics the wiring of the human brain. The circuit is built on a silicon chip. This does not mean scientists are any closer to reproducing the brain in electronic form. But it does suggest that they will continue to find many different ways of creating machines that try to emulate the operations of the human body.

disembodied data floating in a sea of information. History is inevitably more than the sum of the discourses generated to explain the past. To varying degrees, in the early years of the twenty-first century the distinctions among culture, artifice, and the material world have been left far behind. Paul Carter (1996) says it well:

We may say, 'But we walk on the ground,' yet we should be aware of an ambiguity. For we walk on the ground as we drive on the road; that is, we move over and above the ground. Many layers come between us and the granular earth—an earth which in any case has already been displaced. Our relationship to the ground is, culturally speaking, paradoxical: for we appreciate it only in so far as it bows down to our will. Let the ground rise up to resist us, let it prove porous, spongy, rough, irregular—let it assert its native title, its right to maintain its traditional surfaces—and instantly our engineering instinct is to wipe it out; to lay our foundations on rationally-apprehensible level ground. (P. 2)

The modern world mediates experiences so heavily that what is natural and cultural have become interlaced and profoundly intertwined

(Schama 1995). I do not subscribe to the notion that this is an artificial environment dominated by what humans have made of it. On the contrary, I believe the infinite play of meanings that language and culture have made available to human beings will never be exhausted by nature or by human activity. In this sense, humans will always struggle with the "idea" of the natural even as they use a variety of tools to interpret and master the cultural phenomena that make up their experiences of everyday life. In other words, there is no need to engage in reductive and often unproductive oppositions between nature and artifice.

The act of engaging with a virtual landscape, for example, is profoundly embodied. Participants use their imaginations and energy to push at the boundaries of their perceptions and to make their bodies respond to what they are looking at. To ski down a virtual hill is exciting because of its own particular character and not only because it is somehow close to the "real" thing. Here, the language of description, (and the psychological as well as discursive processes that encourage humans to use the term *virtual*) affords the chance to recognize and to celebrate immersion in the world irrespective of whether it is virtual or real. Ironically, poets have been trying to say this since humans first made use of words to transcribe their thoughts and hopes. As the great American poet Theodore Roethke (1966) so aptly put it:

When I stand, I'm almost a tree.
Leaves, do you like me any?
A swan needs a pond.
The worm and the rose
Both love
Rain. (P. 78)

Humans are almost, but never quite, the tree, yet they are able to imagine and speak about that which doesn't seem possible and to envision worlds that don't exist. And between what may be and what cannot be lie the domains of images and sounds, those extraordinary vehicles for a new materiality that help invigorate the imaginary worlds of people every day of their lives.

I must stress that for me virtual spaces are sites of exploration. I feel like a voyager who has come upon something very new, and yet I struggle to articulate what that means. I am perhaps like the early viewers of photographs who were at the same time enthralled and repelled by the seduction of still images. Nevertheless, the spectators of the middle of the nineteenth-century did not come to photography naively. Nor have I come to the digital world bereft of the tools that I need to understand and inquire into cyberspace. I

I have been struck by the *weight* behind the process of digitization as opposed to the weightlessness of information. So many complex systems have to be created and maintained for the digital environment to survive and flourish. This weight has an impact on discussions of technological change and human identity in the twenty-first century. In this context, does there need to be discussion about the creation of a *new* kind of human being? Will avatars be the new storytellers? Is this just the tip of the iceberg in the shift from nineteenth century notions of humans to twenty-first century experiments with cloning and bioengineering? This is as much a question about the present as it is a question about the future (Serres 1995).

have been schooled by decades of media and cultural experiences.

I grew up as television was making its way into people's lives and have remained, as I was then, fascinated by the power of images and sounds communicated through screens and projection. In the same way, nineteenth-century viewers were surrounded by a plethora of images painted onto their walls or canvases as well as by the many new ways of designing public and private spaces from vast exhibitions to panoramas. As Walter Benjamin (1999) has so wonderfully described it, Europe was awash with sounds and smells and sights, because the groundwork was being laid for popular culture in the twentieth century.

His description of the growth and development of arcades in France reads the way one might describe virtual emporiums devoted to games of simulation. A good deal of what he has to say about arcades anticipates what twenty-first-century culture is trying to achieve with the networked environments that are now being built. Internet-based environments offer the opportunity to explore shared spaces with other people (in much the same way as the world exhibitions of the 1870s in London and Paris)—a set of interactions as complex as the encounters between consumers in nineteenth-century Europe. The level ground Paul Carter describes has become so layered that new ways of seeing and understanding will be required to comprehend how all the levels interact or how they got there. This will be even more important in the exploration of the impact of new media upon Western culture and all the assumptions of interactivity that have come with it.

What Telephones Have Done . . .

As a convenience, but often out of necessity, distinctions are blurred between the nonliving material world and the subjective experience of what it means to be alive and embodied. In the previous chapter I raised some preliminary questions about phones. Here I explore the importance of telephones

in greater depth. It is clear that from the earliest days of its invention, the telephone has been used to connect and enhance the meaning of communications between people. Think of those evenings devoted to a telephone call to a friend or a lover, moments as real and important as face-to-face encounters. I have often had the sense that the voice on the other side of the line has traveled through my ears into my body. There is the further sense that the conversation has encouraged an intimacy *particular* to the medium of the telephone itself. In fact, something unique *is* going on. The telephone is not simply a tool of communication or exchange. It is one of the primary vehicles used to develop vocabularies of interaction. As telephones have moved from fixed locations to the world of wireless connections and as those interconnections have become essential to human activity, the very status of the telephone as an object has changed. Even when telephones are talked about as a technology, this does not capture the very palpable feeling that telephones have become fundamental to everyday life and to expectations that people have of their relationships with one another.

Although a large percentage of the world's population is just beginning to gain access to telephony, every country that has become wired has found that the use of telephones increases rapidly, and there is an almost immediate positive impact on local and national economies. The most recent example of this is China, which has taken up wireless technologies at a pace that far exceeds what is happening in the West. China is a good example of how communications technologies like telephones accelerate economic growth by permitting companies and individuals to be in constant contact with each other. In a general sense, telecommunications services open up the possibilities of Internet access, mobile communications, and an increased awareness of economic activities elsewhere. China's telephone industry has grown astronomically since the late 1970s. There is a significant correlation of this growth with economic gains in what is now one of the world's largest economies.

When I telephone a friend or a business acquaintance, I anticipate a response, even if it is an answering service. Furthermore, I know that my message will be listened to and that I am likely to receive a return phone call. Yet this is both an ambiguous and multilevel relationship. There are so many intervening layers to the phone call. These range from the phone company which controls the quality of the connection, to the satellites and cables that reflect, refract, and channel my conversation from one place to another. The technological infrastructure needed to sustain my voice in space and time, such that it will arrive at a desired location, is both complex and mundane.

Yet that infrastructure can never be displaced, nor can I recreate it. It is a living, breathing apparatus supported by thousands of workers. Humans are as attached to the apparatus and its wires as the wires are to themselves. Infrastructures should not be dismissed because they are silent. The electrical wires providing them with energy go about their tasks twenty-four hours a day, heartbeats neither counted nor thought about unless they fail.

Layers: At one point, during an early and more creative phase in Cuban filmmaking after the revolution of 1959, a series of didactic films were made about such topics as electricity, telephones, tractor building, and creation of machine parts. The films traced an industrial process that remained obscured for most people. Suddenly, there was some visible evidence about the complex "bricks and mortars" activities underlying the elaborate ways in which human beings recreate the environments they live in. Nothing can be manufactured nor disseminated without infrastructure. Malcolm Gladwell has brilliantly unveiled the building blocks of cyberspace and electronic commerce in the same way as the Cuban films

In some ways, the telephone appears to be a plain, if not mundane, example. As I asked earlier, how can one move away from the culturally dominant idea that objects, the nonliving, are just simple additions to the activities of humans? Marshall McLuhan responded to this issue by describing technology as an extension of human beings, as if people extended themselves into space because they could talk to each other from different locations (McLuhan 1994). This is only partly correct. The telephone is still left "out there" as something to be grasped and incorporated. The notion of extension still makes it seem as if the machine were *other* to the humans who use it. Clearly, *incorporation* is a better term to describe the breadth and extent of human-machine relations. Incorporation works both ways. And incorporation is, in my opinion, an ecological term.

Robots

McLuhan (1994) also said the following: "Since all media are fragments of ourselves extended into the public domain, the action upon us of any one medium tends to bring the other senses into play in a new relation" (267). He observed, "With the telephone, there occurs the extension of ear and voice that is a kind of extra-sensory perception" (265). McLuhan relies on the idea that the telephone remains a "thing" to be used. Yet a great deal separates the telephone from its original purpose because all forms of communication are pragmatic in orientation, irrespective of whether the technology is used or not. The technology is integrated into users' lives and bodies,

changing its role and function. This is the true meaning of incorporation.

This reinforces the idea that people are, and have been, cyborgs for a very long time (Haraway 1991). This was brilliantly explored by Stanley Kubrick in *2001: A Space Odyssey* and led to an extended analysis of the impact of computer technology in the recent book, *HAL's Legacy: 2001's Computer as Dream and Reality* (Stork 1997b). In the late 1990s, the Sony Corporation created a robotic pet dog (AIBO) and even used terminology to suggest that the dog was a "real" dog.

did for the industrial process. Cyberspace incorporates much of the same infrastructure as has been built for most forms of cultural and economic activity; only the goals are different and the effects have been more broad based (Gladwell 1999).

Meet AIBO. He is smaller than he looks. He walks in a very awkward fashion and yet has many of the qualities of a pet. The manufacturer Sony cannot keep up with demand. He is made of metal and is obviously a primitive precursor to a more elaborate robotic construction. AIBO sees, does not smell, and is merely a toy. Yet it "feels" as if "he" represents something new.

I cannot help feeling that AIBO symbolizes the human yearning for attachment, for a meaningful social context and some sense of control over the world. AIBO is no more than a projection of the desire to manipulate both living things and objects. AIBO can be programmed to learn, and soon AIBO will learn how to recognize people and develop a variety of habits. In other words, AIBO will evolve.

The feeling that AIBO is close to a living dog makes it attractive, because objects are not meant to play that role and because nonliving things become exciting when they act in unpredictable ways (Menzel and D'Aluisio 2000). The brilliance of the robot dog and the inventiveness of all software is that a great deal can be programmed into robots. The programming and the design, however, cannot be used as predictors for what people will do with the technology. This fissure between intention and use is at the heart of Hal's operations as a computer. It (or he) cannot understand the gap between himself and humans, and therefore Hal, the computer, ultimately fails to achieve its goals. As Marvin Minsky wrote in the early 1980s, there is no point in trying to create a program that will anticipate all of the uses people will make of it (Minsky 1982).

For a variety of reasons, there are replicas everywhere. Mechanical copies of dogs, robots that look like humans, and toys that speak. Baby dolls cough, laugh, and cry. Some of the robots bark, run, and retrieve balls. The recent exploration of Mars by the Mars Pathfinder, which is a very sophisticated robot, best summarizes the intensity of this move toward replication

Humans ———— Machines

and robotics and is a wonderful example of what I have been discussing in this chapter. As it trundled around examining the earth and rocks on Mars, Pathfinder remained under the control of humans. It was more than an extension of the eyes, ears, and hands of millions of viewers. Although the interaction felt like it was happening in real time, it was delayed by distance and the computerized translation of what the robot was seeing. In one extraordinary moment, Mars became a "living" system and a place with history, bound to human beings by links in a way that had never been possible before. The robot was worried about and related to as if "it" were alive even though its eyes revealed a landscape that could only be grasped by an act of imagination. It became possible to live "inside" the robot for a short period and when it finally fell silent, there was a profound sense of loss.

These phenomena, centered on artificial replication, are about the slippery borderlines between biology and machines and are an elaboration of the human desire to extend the boundaries of the mechanical world into the very tissues of what is meant by human nature. The challenge here is fundamental. Machines and humans have always shared tasks, events, and experiences. The filters that separate humans from their mechanical creations is very thin indeed. As the biological, mechanical, and electronic worlds merge into new definitions of life itself, modern culture is entering a period that will be characterized by rapid evolutionary pressures. These pressures will redefine the rhythms of history and allow people to move beyond the conventional explanations that society has developed about the relationships between machines and humans.

Will the next step be to use a dog's body as a receptacle for robotic implants and to create a hybrid of flesh and metal? Is a new scientific configuration being developed that will effectively wire flesh to networks and turn biology into an adjunct of computers (Warwick 2000)? There is a hint of this to come in genetic engineering and nanotechnology. The decoding of the human genome is a further step in the deconstruction of what it means to be flesh and blood. Cloning is only one more example of the shift from biological processes over which humans have no control to full elaboration and control over the genetic blueprint.

Think for a moment of the hundreds of thousands of people who have been conceived through a variety of techniques of reproduction that go far beyond the parameters of what would have been considered normal even thirty years ago. The idea that conception can take place outside of the womb remains both radical and evidence of a profound shift in the ways humans think about biology and control of the body.

Ironically, so much of what happens in the human body is not in anyone's control. Reproduction itself is an activity without a master. There is no such thing as a perfect genetic blueprint, which explains why no one person is exactly the same as his or her neighbor. There is a common myth that as an embryo develops in the womb, its genetic heritage provides instructions to grow in a particular way. How are the instructions entered and acted upon? Is there a manual from which information is drawn? Does the manual provide all the details necessary to create a human being? If it were that easy, scientists would have long ago developed an artificial womb. Human biology acts without a master and in so doing makes use of autonomous processes that are not reducible to a simple set of instructions, although it is one of the conceits of humans that they think control is possible.

The best way to think about this is to reflect again about the relationships among thought, mind, and the brain. People cannot control the billions upon billions of electrical and chemical interactions that make the brain into a mind. In fact, humans hardly know what motivates them to speak since they come to a realization of thought through the *act* of speaking. Again, the autonomy of the process makes it seem as if there were a rational master plan behind speech. At best, the distributed nature of the brain makes it highly unlikely that a master could be discovered if in fact there were one.

Try a simple experiment on yourself. Think about what you are going to say before you say it. Do that repeatedly. You will soon discover that your processes of speech *and* thought have been severely disrupted. Your ability to control speech is limited but broad enough to permit you to engage with the world around you and to be endlessly innovative at the same time.

The work of V. S. Ramachandran and Sandra Blakeslee (1998) engages in a holistic fashion with language, culture, and the neurosciences as they detail in this passage: "We can pick up where Freud left off, ushering in what might be called an era of experimental epistemology (the study of how the brain represents knowledge and belief) and cognitive neuropsychiatry (the interface between mental and physical disorders of the brain) and start experimenting on belief systems, consciousness, mind-body interactions and other hallmarks of human behaviour" (3).

This effort to extend the realm of the neurosciences into culture, psychoanalysis, and belief systems is a radical departure, but an essential one, in order to move beyond mechanical versions of thought and mind. The often simple equation that is drawn among thinking, knowledge, and language has made research into computers and their effect on human consciousness far more reductive than is necessary. Consider the following: Experimental

proof for conventional human behavior comes in large measure from work on abnormality and disease. The knowledge that has been gained from those people whose minds have been affected by accident, disease, or stroke has basically defined much of what is known about the brain (Sacks 1985).

Now that more precise images can be produced of the affected areas of the brain and then correlated with changes in behavior, human consciousness seems to be more accessible than ever. This is such a major jump in how humans define and map subjectivity that it raises profound questions about the materiality of thinking and the body. For example, how does one part of the brain "know" what the other part is thinking with enough effectiveness to bring a sense of awareness to self-aware subjects? How do chemicals "know" enough about each other to avoid messing up the ways in which they communicate? It is apparent that the word *know* does not describe what is happening, and in all likelihood this term cannot explain the complex levels of interaction among electrical charges and chemical soups.

How, therefore, can an image of brain "activity" indicate more than just the behavioral constraints that come with injury, for example? I would suggest that part of the illusion here is that images of brain activity seem to provide concreteness to the relationships of injury, brain, and behavior and this makes it seem as if "mechanisms" can be described. And some researchers believe that this will lead to ways of describing the mind in programming terms. Michael Dertouzos (1997) goes even further: "It's even conceivable that the basic laws of physics, the way chemicals react and biological organisms grow, might be expressed in a handful of 'programming rules'—in other words, with pure information" (74).

At various points in this book, I have referred to the work of Gerald Edelman whose research into the brain and mind has revealed not only how complex the mind is, but also the sheer breadth and depth of how thought arises from the material relations that make up brain activity. If the density and intricacy of DNA and RNA are factored in along with the various levels of interaction that make it possible for the body and its cells to replicate and respond to internal and external stimuli, then Dertouzos is not only simplifying human biology, he is eliminating its most crucial features. (See Hofstadter 1979, 528–548, for a brilliant critique of this approach.)

The question is why do the issues and trajectories represented by Dertouzos's work circulate credibly both within cultural circles and in many areas of research in the computing sciences and engineering? (See Moravec 1991, for the most problematic example of these contradictions.)

Metaphors of autonomy and control circulate regularly within the computer sciences. A belief in these metaphors has paradoxically contributed to advances in computing technology. It is an irony that the mythology of control makes it possible to envision rules and procedures that connect machines to mind. The problem is that the effort to reverse engineer human-machine relations ends up modeling the mind in such a contradictory manner that machines seem to be even more powerful than their inventors ever intended. (See Joyce 2000, 213–238, for an exposition of these contradictions as they relate to the work of Vannevar Bush and his essay "As We May Think," which appeared in the July 1945 issue of *Atlantic Monthly* and is considered to be a foundational essay in computer sciences in the twentieth century (Bush 1945).)

The challenge of autonomous processes is that they lack an ego or a center that can be specified. This means that activities, which are for the most part holistic and cannot be subdivided, govern relations among mind, body, perception, and thought. Although machines seem to operate in a similar fashion, they do not produce the equivalent of consciousness. In the final analysis, even the most complex of machines can be repaired or replaced if something goes wrong with it. Of course, one of the dreams of researchers like Ramachandran and Blakeslee is to arrive at a closer understanding of consciousness in order to be able to solve the riddles of injury or disease. But the transportation of this type of research into the computer sciences has distorted human-machine relations and made it easy to conflate not only fundamental differences but to assume that solutions are at hand (Kurzweil 1999).

Realistic Foundations

As scientists probe the depths of the material world, they are discovering that matter is not as static or inactive as would appear to be the case especially since solidity, shape, and form are fundamental to what humans mean by matter. It is an irony that machines, particularly computers, are allowing researchers to rewrite the underlying codes for the natural world. (This is being taken to an extreme in the research on the human genome and nanotechnology.) In so doing, they are discovering that there are so many layers to every object and so much going on at a subatomic level and so much still to be discovered that central notions of the material universe are being reshaped.

For example, many different forces hold molecular and atomic particles together. Physicists have some clues and answers but are far from the moment when they will fully understand the interaction between matter and forces of connection and disconnection. This comes out in research on quarks, which are "pieces" of subatomic matter that have no dimension or shape. However, quarks have been documented and "seen" within the context of the very fast accelerators that smash matter into bits. I am not suggesting matter is alive. Rather, historically, conventional definitions of the physical have limited the extent to which humans have envisioned a world they are both a part of and have helped to create.

Leon Lederman, who won the Nobel Prize for his discoveries in the subatomic world, describes the role that gluons (another piece of matter) play in relation to quarks. He developed a radically different model of the physical universe in which objects are made up of dust clouds in rapid motion. As solid as an object is, its interior exists in a perpetual state of agitation. There are so many particles involved that scientists now need even more sophisticated accelerators to uncover and understand how the internal worlds of objects function (Lederman 1993). All of this, of course, takes place at a microscopic level and the evidence for these activities are mathematical calculations and experimental evidence that show matter is subdivided in a particular way.

This knowledge changes the way objects can be understood. How can the constituents of matter be visualized when they cannot be seen? This research has qualitative effects on the relationships humans have with their physical environments. To know that matter is more than it is on the surface, and that what is considered to be inert may not be, puts humans in the position where they will have to alter the nature of the relationship they have developed with the world around them. The same issues apply to research into the human mind. Much of what appears to be visible through MRI scanning cannot be reduced to simple notions that link brain activity to thought or emotions. The overall goal of understanding the brain from biological and chemical perspectives is laudable. But mechanical metaphors have an attraction that can lead to reductive notions of human consciousness and even more reductive ideas about how humans learn. If the mind is simply an input-output mechanism, then the ways in which information moves from environment to mind and then from mind to language and expression can be portrayed simply and directly. If computers are, similarly, input-output devices, then the jump to mechanical strategies of learning and information acquisition seems like a natural move.

Even though many of the theories of matter presently being researched by physicists are in their infancy, it doesn't take too much to move some of the insights into the realms of simulation and imaging. Images produced by computers are seductive because digital visualizations bring concreteness to hypotheses that would otherwise exist either at a discursive or mathematical level. This adds more weight to the argument that images are part of a circle of intelligence and a continuum of linkages that transform the relationships humans have with their machines. This is why, irrespective of concerns for truth and reality, images continue as crucial arbiters of what is real and unreal about the material world.

Pacemakers have saved countless lives. Hearing aids have brought sound back to people whose hearing has degenerated. Artificial limbs have allowed people to walk again. Wheelchairs provide a modicum of mobility to paraplegics. Glasses bring clarity to the act of seeing. Elevators allow people to live in high rises. High-speed trains enable people to travel quickly over great distances. MRI machines allow doctors to peer into the living brain. All of these technologies have become a part of everyday life. The reality is that society can no longer do without them. Notions of what it means to be flesh and blood have been transformed by all of this activity. At the same time, there is a residual sense that the use of prostheses, for example, is impure. This is part of an identity crisis steeped in traditional ideas of control. A body not in control of its own features is somehow not a body. This attitude is a profoundly embedded cultural norm and is based on the ideology that technology manipulates humans and overwhelms what it means to be human. Within this framework the human organism should not be mixed or integrated with mechanical objects even though, ironically, most people would be hard pressed to deny patients with kidney disease the opportunity to have dialysis.

Webs of Interaction

The philosopher Charles Taylor (1989) says the following in his book *Sources of Self:*

I am a self only in relation to certain interlocutors: in one way in relation to those conversation partners who were essential to my achieving self-definition; in another in relation to those who are now crucial to my continuing grasp of languages of self-understanding—and, of course, these classes may overlap. A self exists only within what I call 'webs of interlocution.' (P. 36)

In addition to the process of interaction framed by the use of language and the worlds of discourse shared among families, friends, and society, there is also the shared communal context of visual and oral cultures. This means that from the earliest moments of childhood, the role of images, for example, is as significant as the role of language in providing humans with a sense of their own individuality as well as a connection to the world of which they are a part. The importance of language is not being diluted in this argument. Rather, the heterogeneity of contexts that presently define what society means by lived experience far exceeds the webs of linguistic interlocution that are among the foundations for the process of growing up. The web of interlocutors has become wider and more complex. This may well presage a crisis of identity. It may well suggest that conventional definitions of subjectivity have to change as well as the ways in which early childhood is pictured.

What happens when conversations take place between humans and machines? What happens when those conversations are an important part of early childhood? How soon do children see mechanical images of themselves and what are the implications of those experiences for their identities? To what degree are images used to teach cultural values? These are subtle and difficult questions. How do viewers learn from what they see and hear? As more images and screens mediate the material world, these questions take on some urgency. As machines become more intelligent, broad questions arise about human intelligence and the future of the human body. Interestingly, there are many cultural phenomena that both incarnate and represent these possibilities and dangers. In the final three chapters of this book, I explore those phenomena with an eye to examining the new cultural and social landscape that is being created by the ever more complex construction of image-worlds.

CHAPTER SEVEN Peer-to-Peer Communications/
Visualizing Community

For Whitehead the task of philosophy was to
reconcile permanence and change, to conceive
of things as processes, to demonstrate that
becoming, forms entities. Let us emphasize
that he demonstrated the connection between
a philosophy of *relation*—no element of nature
is a permanent support for changing relations;
each receives its identity from its relations
with others—and a philosophy of *innovating
and becoming.*

**— Ilya Prigogine and Isabelle Stengers, *Order Out
of Chaos: Man's New Dialogue with Nature***

The previous chapters of this book dealt with many of the assumptions that circulate in Western culture about the role of digital technologies and the impact of images on daily life. This chapter examines the manner in which networked cultures have grown and proliferated through the use of different modes of exchange and interchange. Electronic networks make it possible for very different communities to be built and maintained over geographically dispersed areas. Crucially, networks are an indication of the strength and intensity with which technology is being integrated into the ecological continuum that I have been describing throughout this book.

A good example of this ecological framework is Internet-based file sharing, in particular, music. A day rarely passes without some comment from various media outlets on the impact of music downloads on the music industry. However, the most interesting aspect of file sharing is the redefinition of intellectual property. What does it mean to purchase a CD? Networked cultures are both private and public arenas for the exchange of ideas, but they are also broadcast media, through which people can do more than simply communicate, but also share what they own (Berners-Lee 1999). The phenomenon of blogs is a good example of this. Blogs are just Web pages, but they are also intimate diaries, photographic galleries, representations of the everyday lives of their creators, and media for the communication of ideas and opinions. In other words, blogs allow and encourage the open exchange of information. Why shouldn't a blog have a few tracks of a CD on it to allow the blogger to share what she enjoys with others? How different is that from having a party and playing music? The answer to this is that networks accelerate the distribution of material that is owned and has been developed by companies that have to make back their investments. This is true and to a large degree acceptable. The problem is that the music industry is still thinking about marketing and merchandise as if networks were not part of the equation. It has also modeled its financial return based on limited if not myopic ideas about consumers. The big question is what happens when the next great band decides to use the Internet as its main vehicle of distribution? This is already happening with the cinema, where digital video allows and encourages creators to set up their own networks for distribution.

The extraordinary thing is that millions of copies of songs, symphonies, and other forms of music were transferred from records to tape in the 1970s and 1980s and then shared with friends and family (which led to the rise of the Sony Walkman and many other similar portable devices). It is also likely that

mix tapes were created not only of the songs people wanted to hear but also for the purposes of trading and exchange. It is possible consumers bought fewer records and tapes as a result of this copying, but the sales figures in the recording industry continued to go up throughout the 1970s, 1980s, and 1990s until, that is, the actual number of recording artists decreased and the industry began to emphasize stars to the detriment of new groups.

This suggests that file sharing in the Limewire and Gnutella tradition is merely the continuation of historical practices of exchange. However, the means and methods have been altered. It also suggests that sound technology was designed to spread its products and to encourage new uses in often unpredictable ways (e.g., the iPod).

The early days of radio were characterized by fears not only that quality would be diluted, but also that copyright holders would lose any chance at earning royalties. Once the system was worked out, radio became one of the *main* sources of revenue for music companies and artists. (Since this is not a book about the history of radio, many of the issues raised in the 1960s about the broadcasting of copyrighted material cannot be discussed in great detail. Suffice it to say, the same issues of ownership and the distribution of profits almost resulted in the shutting down of some radio stations. The golden age of revenues for record companies was 1973–1978 when sales went from $4.75 billion dollars to just over $7 billion dollars. Many of these sales were driven by radio as an instrument of dissemination and distribution. This was also the period when recording off the radio with tapes was increasing at a rapid rate.) This suggests a relationship between the use of music as a cultural product and trading those products. As I have said, the arrival of Gnutella-type systems simply emphasized already existing forms of music dissemination and swapping. The difference was that Web sites like Morpheus enlarged those points of interaction between users into the millions.

File swapping reflects one key aspect of the Internet age. Communications in a networked world are about exchange and interchange. It is not enough to suggest that copyright privileges are primary, especially when the entire purpose of being connected is to trade ideas and information. In any case, ever since the appearance of the gramophone, music has been in circulation in a number of legal and illegal ways. The challenge is to take the energy of exchange and channel it into a balanced relationship of value for producers and artists and value for listeners. New business models are needed at both the product and creative levels.

To some degree, a new model has in fact been surfacing. File swapping is part of the P2P communications phenomenon. P2P communications are

about the establishment of communities of interest across networked environments. (There are actually many different types of communities, but I will return to that point in a moment.) The ability to share what I have on my computer with others depends on what I make available. In so doing, I bypass central servers and connect in a true weblike fashion to other people who share my interests and concerns. One of the most important characteristics of P2P communications is that it is self-organizing. It can develop through land connections or the wireless system (Falk, Redström, and Björk 1999).

Gnutella, which has replaced Napster, is just an interface that allows communities to grow and shrink on a regular basis depending on the needs of the moment. P2P communications results in decentralization and the conversion of individual computers into servers. When users connect to the network, the folders in their computers open up for sharing and become like a Web site. Other users simply access the folders and examine its contents through searches at various Web sites. The entire process of exchange is ephemeral, because the minute a user logs off, his/her folders cease to exist. The beauty is that no one is in real control, and it is very difficult for anyone to know what users are trading with each other at any given time, although the IP addresses of users remain in the system. Furthermore, even though a search produces an index of available items, that index is completely fluid and can change as quickly as the content of the connected computers change. (Another factor is the stability and quality of the network.)

A further example is the growing use of P2P wireless networks. People in neighborhoods extend their ADSL lines by setting up aerials that allow anyone with a wireless card to connect at high speed. The impulse to do this comes from a desire to take control of the networks and to provide people with free and easy access. This movement is an outgrowth of earlier efforts to build Freenets in the late 1980s and 1990s (Beamish 1995). It is also connected to MOOs and MUDs, which were crucial precursors to many forms of interactive networked activities and provided a significant foundation for on-line computer games (Bruckman and Resnick 1995).

In P2P communications the boundaries between computers are defined by the time of connection and not only by what people have on their machines. (It is not an accident that one of the most successful Internet companies is eBay. Although not P2P in the strict sense, eBay is about exchange, swapping, and collecting, which is another key characteristic of digital environments. Collectors have always been a part of market economies, but never at the scale and depth that eBay makes available and promotes.)

The time of connection is what is beguiling about P2P communications. Normally, the Web is regarded as spatial. Even the term "sites" is geographic and suggests that a map of interconnections can be drawn to highlight the organization of the Web. But in P2P environments time defines the relationship. This is especially true when large files are downloaded. Equally important, when one receives a file, it can be sent to someone else. In effect, this reinforces the fact that individuals can become recipients of information as well as broadcasters.

Take this to the next step and imagine sampling music into a new mix of sounds and one can begin to envision how far this notion of production and recreation can be taken. (This phenomenon is known as mushing.) Again, this creative process is an extension of previous efforts to convert recorded music into something suppler. The rise of music videos in the early 1980s is also a reflection of this culture of imitation and transformation. Music videos, aside from their clear connections to the experimental films of the 1960s, represent the apotheosis of borrowing from many different media forms.

The integration of music into image and vice versa was also closely linked to musicals in the cinema. The results are hybrid forms of expression connected to a wide variety of strategies of visualization, including the difficult problem of "giving image to voice." These elements and the struggle to give them form are essential ingredients within the popular cultural mix, and, interestingly, everything migrated to the Internet. In fact, one of the strongest and most productive P2P communities can be found among creators of music who need the collaborative tools P2P offers to learn from each other. These activities and many others are so intense that the challenge is to find better tools of visualization and better devices to enhance and support the need for connection and exchange of information and ideas.

Some of the central characteristics of P2P communities are enumerated in this list:

- P2P communities possess the ability to pursue many different activities at once and the ability to share both the process and the outcomes of sharing files and information over the Internet through decentralized means.
- It is not enough to just connect to the Internet through available interfaces. P2P communities are constantly involved in customizing the interfaces that they use and in designing the way that they can navigate through various networked configurations. This is closely related to the ways in which the open source movement works and how hackers create and exchange information.

- P2P communications is about the continual construction, decline, and reinvigoration of different types of communities. One of the most important features of P2P is the way in which ideas spread. Communities regenerate and then disappear in quick succession.
- P2P participants collaborate, which is as important as the sharing of information and files. Collaboration is about community building, developing projects, and creating awareness. Artists are using P2P networks to pursue a variety of different initiatives. The antiglobalization movement has used P2P communications to develop its own news networks. Health organizations are using P2P networks to facilitate learning and education in rural and less developed areas of the world.
- A variety of notation devices can operate across P2P networks allowing and provoking even more complex levels of collaboration and interaction.
- Asynchronous and synchronous forms of communications are fundamental to the operations of P2P networks. These permit the development of multiuser screen-based environments.
- Wireless P2P devices, such as PDAs and cellphones, are part of a growing movement that involves everything from text messaging to the transfer of photographs and video images. These devices will enhance another characteristic of P2P communities, which is the spontaneous desire to meet like-minded people and build communities while moving from one location to another.

The previous list of P2P characteristics and the diagram in figure 7.1 are by no means exhaustive, but they emphasize the development of further and more complex levels of community-based interaction. However, the issues of visualization and information gathering remain central to the success of P2P networking.

Visualizing Community

Under normal circumstances (e.g., using Google), searching for information produces a large number of results that have to be sifted through, often without a clear set of indicators and annotations. File-sharing software is about information that is targeted and specific, and even the software cannot be trusted to produce the results users seek. Ironically, one of the main characteristics of P2P communications is that it is about a new, networked search process. Data on home computers is no longer private. One

P2P MIX

FIGURE 7.1 Peer-to-peer communications (designed by Julie Andreyev)

can begin to imagine an entirely new Web, one that relies on what people are working on in their homes and, even more so, a Web of interactions that is creative and dependent on the effectiveness of the channels that individuals open up between each other. This system of connections is not entirely stable and will often fail. But this has not and will not deter users. The reasons for this are not only that copyrighted information may be downloaded for free, but also that the very nature of information is undergoing a transformation (Lessig 2001).

Information on the Internet, particularly on P2P networks, is not just data. Rather, information is the *raw material* for a series of possible and contingent transformations by users or viewers. Sometimes these transformations lead in a traditional direction; for example, information becomes news or entertainment that has been packaged and prepared much as it would have been for more traditional forms of broadcasting. More often, the strengths of contingency within networked environments produces a fragmentation of information that allows users the flexibility to put the pieces together in any number of different ways. This may be infuriating for creators and copyright holders, but unless they want to remove themselves entirely from the Internet, it is unlikely that a simple solution will be found.

The issue then becomes how to live within this often contradictory and fluid configuration. Take the example of a film like *Spider-Man*. Within days of becoming a very popular film, *Spider-Man* was available on the Internet, albeit in reduced size and often out-of-focus copies. Various artists were editing and reediting the footage much as rappers sample music. Within two weeks, *Spider-Man* was available in many different versions that were often unrecognizable with respect to the original, either in narrative or aesthetic form.

The point is that everything can be digitized and therefore shifted from its original character to something completely different. This creates and makes possible an environment of intense *contingency* where cultural norms are always being tested. It is also about increasing the number of layers among various forms of information until nothing exists in isolation of a web of connections, conversations, and transformative possibilities.

One of the reactions to this reconfiguration of the role and function of information has been the increasing sense that people are experiencing an information overload (Shenk 1998). Overload both as a term and as a concept explains very little. Rather, the pressures come from the effort to put the pieces together, in other words, to make some sense of all of the fragments and contingent pieces that make up the fluid flow of information in digital environments.

As a result, there is a profound discontinuity between the creation of content for networked environments and the placement of that content within the public sphere. This discontinuity is part of the reason that P2P communications have become so important. This is because P2P facilitates the creation of an increasing number of interactive instruments to disassemble and reconstruct information in order to makes sense of the flow of messages and meanings. And to some degree this is an overload. But this suggests that the pressure to move away from traditional notions of consumption may lead to new and perhaps more creative roles for users, viewers, and even creators.

Classifying Conversations

In the early days of the Internet, a news and information exchange system entitled *Usenet* quickly became the largest and most extensive "Web" of chats and e-mail exchanges on the network. Millions and millions of messages were exchanged on a weekly basis. This first incarnation of P2P communications (albeit one that still used central servers) was like an extended telephone system and hinted at the potential impact of the World Wide Web that came into being six or seven years later. The activities on Usenet were preceded by a variety of digestlike interactions on the Arpanet of the 1970s, where short messages were exchanged and then compiled into lists organized according to topic. As Usenet grew, its topic lists became increasingly specific, reflecting the interests of millions of different people.

The notion of "net.general" was introduced, and within days this catchall content indicator was overwhelmed with messages and had to be subdivided according to topic. (The list of topics that were labeled for exchange is as long and detailed as an encyclopedia. Everything from net.joke to net.bizarre to net.gdead became the site of intense interaction among users from all backgrounds.) Usenet established the ground upon which e-mail developed into the most popular form of information exchange on the Internet.

A variety of classification systems came into being with most being based on groupings of interest. There were extensive debates about naming, the nature of digests (were they just newsletters?), and the way in which information could be routed and preserved. This process of trying to categorize enormous chunks of information is partially a response to the issues I have been discussing. In order to be understood, information has to be disassembled. In some respects, Usenet is one of the best examples of how liberating the Internet can be and, at the same time, how the lack of vantage point

can work to the detriment of the information that is processed through the network.

Current discussions of P2P networks often ignore the lengthy and quite profound efforts on the part of early users of the Internet to discover mechanisms for tying everyone together through noncentralized means such as Usenet. This history raises many issues. What is *data* over a P2P network? Can information be classified in a simple and accessible manner to facilitate P2P relationships? What are the best methods of *connection*? What is the difference between a domain and the ways in which it can be named and the individual nodes that connect users to each other? How can all of these elements be visualized?

The issues of visualization are many, including the need for metaphors to explain how such a vast and interconnected web of interests, information, and debates can be understood and used. How can information be transformed from data to intelligence? Or is all this activity evidence for the degree to which the Internet has become a repository of collective intelligence, which means that very different principles of collection and retrieval are needed?

The key to understanding P2P communications lies in its decentralized and grassroots oriented system of linkages that continues a long tradition of efforts to create alternative modes of communications and interchange. Aside from Usenet, there were many efforts to construct and maintain networks that adhered to the principles of free access and the exchange of information.

An important example was the *Freenet* movement of the late 1980s and early 1990s. Freenets were based on three traditional tenets of community media, *access, participation,* and *self-management.* Local computer sites acted as hubs, destinations, or launching points for immediate access and connection to national and transnational information networks. At the same time, the reverse was also true. Freenets opened up the possibility of expanding the range of information that the community received and created. The characteristic functions of Freenets included discussion groups, database construction, e-mail, archive searches in local, national and international libraries, bulletin boards, community computing, community telecomputing, community bulletin boards, civic networking, community information systems, and, most important, the production of new forms of information exchange which were available on an ongoing, twenty-four-hour basis (e.g., the World Wide Web) (Quarterman 1990).

Civic networks emerged from Freenets, providing a range of services from information on health issues to educational materials as well as encour-

aging and supporting the interactive relationship between people from all walks of life. Crucially, the impetus for the entire process came from people in the community who not only defined what they needed but were able to relate their needs to each other as well as to anyone else throughout the world who might be interested. Many different and often contradictory claims were made for these networks, but the crucial ones, gaining access to information and being able to control the transmission and creation of information, dominated the agenda. This is linked to a strategic effort to dilute the gatekeeping role of mainstream media but also to the potential of computer mediated communications to create new forms of expression and communication (Jones 1995).

The newer forms of P2P communications that have appeared since file sharing exploded onto the Web in the late 1990s, including MUDS, MOOS, and Web sites like Gnutella, Jabber, Groove, ICQ, and SETI@Home, are a continuation of many of the grassroots assumptions of Freenets and earlier forms of community media including bulletin boards like the WELL (Rheingold 1993).

The focus on copyright has covered up the intimate historical connections between most forms of community media and made it seem as if the entire purpose of P2P communications were to steal copyrighted materials. The fundamental issues of what it means to create and sustain community within the settings offered by the Internet are often left to the side. Yet, this is the central purpose of so many of the experiments in P2P communications that not only continue to this day but also have shown themselves to be extremely resilient and innovative. The appearance of high-speed wireless connectivity will add yet another layer to this phenomenon as has been evidenced in the extraordinary take up of instant messaging in Europe and Japan. (Millions of text messages are exchanged in Europe on a daily basis!) A further example is the present expansion of informal wireless networks, effectively people broadcasting their broadband connections from their houses to the surrounding community.

Many different kinds of communities use P2P communications, and these range from businesses to health professionals to artists collaborating on real-time projects. One of the most important characteristics of P2P communications is its "viral" spontaneity. Small connected networks grow into larger ones, and large ones decline when interest in a specific topic or area weakens. It is the character of P2P that these changes never cease. This is as much a sign of weakness as it is strength. There are communities devoted to the simple exchange of information and others that develop screenplays for television shows that no longer exist, such as early versions of the television show,

Star Trek. Some of the communities share content for the purposes of political activism, while others exchange information to develop new software for games or operating systems like Linux. The list of P2P communities would fill several books. The reasons for this are many; however, P2P communications is about the flexibility that comes with networks and their modes of organization—fluid boundaries and many levels of discourse interacting through discontinuous forms of communication. Discontinuity in this instance refers to the increasingly complex relationship among creation, intention, communications, and use.

From a cultural point of view, networks are metaphorically thought about through the wires that connect their parts (Buchanan 2002). However, P2P networks are far more ephemeral and judged to a greater extent by the content that is available and the speed of collaboration than by the reality of connectivity. It is somewhat like telephones where the device recedes into the background and the conversations become the network.

It is this notion of ubiquity and transparency that has driven the project known as SETI@Home, which brings unused computer power in the home together with millions of users to create a P2P network looking for signs of extraterrestrial life in outer space. As Richard Koman (2001) suggests:

The numbers that the SETI@Home project have racked up are truly amazing. As David Anderson, the SETI@Home lead who now works at United Devices, revealed at his speech at the O'Reilly P2P Conference yesterday, the project has 2.7 million users in 226 countries. We've accumulated 500,000 years of CPU time. Our rate of computing is 25 teraflops, which is twice the speed of IBM's ASCII White, the fastest supercomputer in the world. We've analyzed 45 terabytes of data. They handle all this with a staff of three to five people.

Anderson's comments reveal a crucial and often underanalyzed problem in discussions of P2P communities. What does it mean to suggest that 2.7 million people form a community? At a minimum, the SETI community shares the physical connections between its machines. It is highly unlikely that most of the people in this community will ever have the opportunity to interact with each other (although there are newsletters and weblogs that increase the likelihood of more communications channels opening). What then are boundaries of this "community"? I would suggest that, for the most part, the *symbolic* nature of the community is what drives its creative engagement with the project (Cohen 1989).

In the networked age, boundaries are notoriously fluid, unpredictable, and difficult to map. It falls to community members to attribute meanings to what they do, which can be achieved without the necessity of consensus. Traditional notions of community interaction are based on different kinds of agreements around values and shared interests. P2P communications may have those characteristics, but they are not the baseline reason that people are willing to distribute ideas and information.

To be part of something and yet not to be—it may be the best of all worlds and the worst of a series of ambiguous patterns that allow people to connect to each other without having to take responsibility for the results or outcomes. However, an exploration of the symbolic value of SETI@Home suggests that what is shared is a desire to communicate with possible alien cultures, and most of the conceptual ground for that desire has been articulated within popular media and culture. In other words, the science in this instance is as much a product of *Star Trek* and *Star Wars* as it is of the faint hope that alien civilizations not only exist but also want to communicate with humans.

I am not making a pejorative comment here. The interaction of popular culture and science is fundamental to progress on both sides. However, it suggests that for community to work there has to be some agreement about the value of the symbolic universe that very different people from different walks of life are willing to share. The sharing of symbols can happen without any direct human contact. The difficulty is that these interactions cannot be observed since at least a portion of this sharing takes place in the imagination of individuals. This suggests that it is not so much messages or meanings in the traditional sense being exchanged, but contingent, if not hypothetical, concepts that are sustained not only at a real but an imaginary level. This is why, when people who have engaged in P2P communications actually meet, they are as surprised as they are dismayed by the encounters, the outcomes of which cannot be anticipated by their prior interaction.

Imagination and Networks

Does this mean that P2P communities are a sham? On the contrary, it is the *strength* of these imaginary connections that interests me. There are a number of examples that will highlight the importance of the imagination to this process of networking.

Figure 7.2 is a small portion of the "AlphaWorld" community. This is a "satellite" image of the interconnected virtual spaces that people have built.

FIGURE 7.2 Alpha world community. Used by permission. (http://www
.cybergeography.org/atlas/muds_vw.html)

AlphaWorld comprises a massive virtual space, exactly 429,038 square kilometers, an area four percent larger than California. It opened to the general public on the Internet in June 1995, beginning sustained colonization with many thousands of people leading a virtual land-rush to claim the terra nullius *of AlphaWorld. The virtual space came into existence as a flat, featureless plain stretching for hundreds of virtual kilometers in every direction, colored a lush shade of green to denote that it was virgin territory waiting to be claimed by bold homesteaders. There were no 'natural' features, no mountains or rivers, just a perfect green plain sheltering under a unceasing bright blue sky. Everything that now exists in AlphaWorld—48.9 million objects as of February 2000—has been placed there by the homesteaders, using simple block-building tools. Of course, the virtual geography of AlphaWorld, with all its buildings and trees, is an illusion of 3-D computer graphics conjured from a big database running on some anonymous Internet server machine. Nevertheless it is a convincing illusion that can be shared over the Net. (http://www.cybergeography.org/atlas/muds_vw.html)*

Strictly speaking, AlphaWorld is not a P2P communications system. All of the information is loaded onto servers. Yet, it has many of the characteristics of P2P communications, including and, most important, the grassroots desire to build community in new ways. In P2P communications there is a direct connection established from individual computer to individual computer. Yet, what is important about AlphaWorld is that it exists as a simulation of community. Again, this is not a pejorative comment. Simulated communities are not that different historically from communities of other time periods. The contrast can be found in the lack of conventional notions of geography and space.

AlphaWorld is about imaginary constructions—about constellations driven by fantasy and the need to visualize the world through as many different means as possible. This is also why a game like the Sims has been so successful. In the Sims, as in AlphaWorld, players build worlds and universes and place avatars into contact with each other creating and destroying community as they go along.

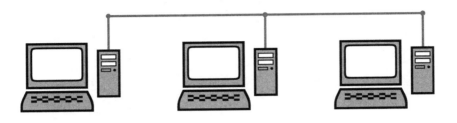

FIGURE 7.3 Peer-to-peer networks

In P2P networking there is a continuous and open reciprocity among users that far exceeds what AlphaWorld and the Sims could provide. That is perhaps why the Sims has also migrated onto the Internet and why many games are networked. At the same time, it is the experiences of virtual worlds like AlphaWorld that have formed the foundation upon which P2P communities have developed and grown.

There is a strong link between the experiences that the Web has provided and expectations about all forms of communications. The relationships developed among the many different sites devoted to fan culture, for example, lead naturally to the idea of more interdependent types of interchange. This is the viral metaphor at work. Another example of P2P communications are communities that work together on cultural and social issues. P2P networking is used to develop ideas and plan actions. Many of the recent protests against globalization were coordinated through P2P networks. In some sense, this takes what would normally have happened over telephone lines and through personal contact and transports the entire process into a series of image-based multiple conversations driven by networked connections.

Listservs operate as if every conversation or piece of information needs to be read and received by hundreds of people. For better or worse, listservs create an interactive space of connection and exchange. The difficulty is that so much of the information cannot be catalogued or indexed or even visualized for the purposes of retrieval and reflection. This problem means that it is

very difficult to develop a model that incorporates an historical overview of the processes of interaction.

Community

Fundamentally, in the P2P environment each computer becomes its own network server. This allows ad hoc communities to form in a spontaneous fashion (O'Reilly 2001). It also encourages what O'Reilly quite aptly refers to as asymmetry. In other words, it doesn't matter if people who were not members of the community decide to join. The system is designed to encourage that kind of spontaneity. In fact, this is one of the key differences between traditional forms of community development and what happens in digital spaces. Community is defined less by the intimacy of the relationships that sustain it, than by the connections people make to achieve particular results or satisfy certain needs. In some respects, this comes back to an earlier point that I made in this book. There is a continuum along which all of these phenomena operate that blurs the boundaries between them. This is often the reason why it is so difficult to see the evolutionary process that is at the heart of network-related activities. Clearly, the dissipation of community is as important as the potential to create it. In the digital age, communities only exist as long as they are needed or as long as the members of the community want to keep working and communicating with each other.

Does this fluidity lead to the destruction of true community interaction and spirit? Not if community is recognized as being essentially a conceptual trope. The trope of community can be used to explore the flow of historical events that make up a continuum of communications and community that links seventeenth-century letter writing with electronic mail, and recognizes the clear links between the creation of encyclopedias in the nineteenth-century (as one way of building learning communities) and the way the World Wide Web harnesses information.

P2P networks are a new and more complex iteration of telephony that in turn are closely connected to the development of the telegraph. In all instances, the fundamental character of the exchanges between people is governed by the desire to communicate and find the best possible way of ensuring the accuracy, truth, and honesty of the information exchanged.

Let me return to the example of popular music for a moment. The ability to use records to make a mix tape was a huge jump in the 1970s, because previously people tended to record songs from radio. This was similar to VCR recordings of television shows in the early 1980s that included all of the ad-

vertisements and peripheral information that no one wanted. What is a mix tape but a form of editing? It is a way of creating a montage. It was the precursor to sampling. When all of this moves into the digital world, there is even more flexibility. Music can be sampled and reedited. Different tracks can be lifted from a variety of sources to create entirely new compositions (a technique that has been developed to extraordinary levels of creativity by the rock star Moby).

This flexible and interpretive space is one of the foundational characteristics of what, for lack of a better term, is called *new media*. The links that connect all of these phenomena are based on the desire to interact flexibly with cultural content. Another feature is the ability to create more or less private media with references and meanings that cannot be understood unless one is part of the "gang." How different is this from the local grassroots-oriented cultures of nineteenth-century Europe manifested through exclusive clubs and guilds (Williams 1966)? Indeed, are all of these activities signs of a return to the type of cultural and social clustering that existed prior to the growth of mass culture? Could one of the ironies of P2P networks be that the phenomenon is actually pointing towards the past?

I mentioned the issues of visualization and information both in this chapter and elsewhere. On its own, a piece of information does not necessarily reveal very much. To visualize complex sets of information, one needs to be able to annotate messages, which is why e-mail programs organize what is received into a series of simple categories, such as date and person. It would be more difficult for every message to be catalogued like a book in a library and to build an ongoing index of the content that has been received. This would require every sentence or paragraph to be tagged with some sort of identifier, which would make the messages very long. Even the identifiers may not actually do the job, since they also have to be simple.

Search engines on the Web use identifiers within the source coding for individual pages to identify content. This creates as many difficulties as it solves, since it does not permit much discrimination to take place among the many pages that are found in relation to a request. This will change as new indexing strategies come on stream, like tags in XML, a programming language designed to simplify the relationship between information and retrieval on the World Wide Web. XML looks at the structure of a document and examines its characteristics at a sophisticated enough level that users can get closer to what they are looking for. XML operates at a higher level than the information itself and so is a metalanguage—a language about language.

The issues of visualization and retrieval of information are not trivial matters and largely depend on so many variables that good results are often difficult to obtain. Again, these issues have been at the core of debates about library indexing systems for centuries. Now the challenge is to examine content in a very different way to account for increasing amounts of information that fluidly interact in unpredictable ways.

Information

How can all of this information be visualized in a manner and with enough indicators to make easy and quick access possible? Will people be able to understand the breadth of P2P communications without that access? Visualization generates an abstract representation of information and, for the purposes of transfer, it is the binary relationship between 1's and 0's that channels the information. The more information there is, the more abstract the visualizations become and the more mapping is needed to understand what has been transmitted.

The danger is that the "visualizations" turn the information into a form that makes it increasingly difficult to understand context (Keim 2001). This is both an engineering problem and a cultural and social issue. The mathematics of information from an engineering perspective has little to do with "content" in the traditional sense of that word (Shannon 1948). One of Shannon's most important points, which was later taken up by Marshall McLuhan (1994), was the following:

The fundamental problem of communication is that of reproducing at one point either exactly or approximately a message selected at another point. Frequently the messages have meaning; that is they refer to or are correlated according to some system with certain or conceptual entities. These semantic aspects of communication are irrelevant to the engineering problem. The significant aspect is that the actual message is one selected from a set of possible messages. (P. 1)

Shannon, an important person in the history of communications, approached his field through an engineering model. However, there are serious issues raised by his work, and I would like to examine some elements of what he said to show how his theories have not only impacted the cultural understanding of information but also the ways in which the exchange of informa-

tion is thought about for the purposes of building connections and community.

P2P networks are as much a response to the issues of information management as they are an expression of the need to maintain some control over the flow of information. Earlier in this book I discussed the relationship between information and knowledge. Here I explore information from the perspectives of the computing sciences and engineering.

Shannon (1948, 2) suggested that information is a quantitative concept used to measure patterns of transmission and the relationship between input and output. As it is used in engineering, information is about the data that passes through a series of pipes; it is not about messages. In other words, information and meaning are not the same, though they are often used interchangeably (Wilden 1972, 233). Information theory examines the extent to which the pipes inhibit or facilitate the movement of data from one location to another. If the connection that you have to the Internet is "broadband," then the pipe connecting your computer to the Internet is a very large one that allows information to be processed at a rapid rate. If you are connected with a 56K modem, then as 56K suggests, there is a maximum to the amount of data that can be transmitted at any one time.

In the technical sense "information" is unconcerned with the status of the sender and receiver. Sender/receiver are no more than heuristic devices, the terminals in a message circuit, and thus involve the arbitrary punctuation of what is a circular process. Whether sender and receiver are actually capable of using language semantically is irrelevant to the measure of information (Wilden 1972).

Having a modem or an ADSL connection is irrelevant to the transmission of meaning but central to the *exchange* of information (which is why members of P2P networks tend to use broadband and wireless connections—many of their exchanges would be impossible without large pipes).

In linguistic terms, information is the syntactical component (grammar) and meaning is the semantic portion of information exchange. For Shannon (1948), meaning was not as important as the flow of data. This is understandable because he was trying to solve the problems of transmission and fidelity. Fidelity is the quality of the transmitted data as it moves from one location to another. The question is, does the data have the same amount of information in the same form that was put into the system as comes out at the other end?

This would be the same as asking whether the dots and dashes of a telegraph system retain their structure as the information is transmitted. Notice

that quality here is not about meaning, but about the relationship between input and output. Another way of understanding this issue is to think about the transmission of images over the Internet. The transmission of DVD quality images is as much about the original as it is about the output. This applies to any content, at least that is the way in which Shannon's information theory sees the issue. If the output is equivalent to the input, then the challenges of transmission and fidelity have been overcome—coding and decoding equivalencies have been achieved. But it is almost impossible to achieve fidelity at levels that would make input and output equivalent. This is because most channels of communications produce varying degrees of distortion. No pipe is free of interference.

Therefore, a great deal of what is described as information transmission is concerned with correcting for the errors that occur in the relationship between input and output. Correcting these errors has very little to do with how people interact with messages and meaning although the impact of mixing up input and output would destroy how meaning is communicated. If, for example, the address of a Web page were not to lead to that page, the effect on users would be very disruptive. If the keys on a keyboard did not respond to the typist's commands, the transparent relationship between typing and words on a screen would disappear. If the images sent over the Internet about an event were to be different from the event, users would think that the communications system was scrambled. If a compression technology designed to make large image files smaller failed in its task, then the pipes would slow down and even collapse under the weight of transmission and exchange. Examples of success and failure in these areas abound. Clearly, information transmission depends on the medium in use, and in that narrow sense the medium is the message. In all of this, the issues of content and semantics seem to disappear. McLuhan's popularization of the medium is the message has had a negative and overdetermined impact on the cultural understanding of communications technologies.

However, the pragmatics of communications is as much about the pipes as it is about the people who interpret and use the information they extract from all of these systems. Therefore, information is the raw material for other, far more complex processes. The problem is that the engineering metaphor has become a dominant feature of the ways in which digital environments are thought about and described (Forsythe 2001). For example, quality of service refers to the quality of data running through a pipe and not to the semantic universe that is made possible by that data.

Ironically, as the pipes have grown larger and as more and more people have connected to them, there has been increasing pressure to develop additional content. After all, why were the pipes built in the first place? But content in this context becomes anything that can be converted into digital form. The confusion here is not among structure, content, and transmission. Rather, the issue is that content needs to be judged by a set of qualitative criteria. These criteria cannot be extrapolated from the effectiveness of the pipes, but rather must be developed through the intersections of critical theory, cultural, artistic and social practice, communications interchange, and cultural history. This is a challenge as much for disciplines in engineering as it is for the social sciences and humanities. Ultimately, it will be necessary to bring engineers, computer scientists, cultural practitioners, and cultural analysts together if only to make sense of the relationship between information and meaning in digital environments. For the time being, it is engineering and computer science metaphors that hold sway, and, in part, this is because the digital revolution is still in its earliest phases.

From the point of view of community and building infrastructures to make P2P communications work, the paradox of the engineering model is that it often does not account for the *need* for noise and disruption. Much of what happens in the P2P world is unpredictable, which is part of its allure. The technology that comes close to duplicating P2P networks is the telephone. Unlike telephones, P2P communications can spread, grow, and redefine the meaning of community. In fact, I would make the claim that P2P communications is a disruptive technology (Christianson 1997). It is a technology that scrambles common assumptions about how technologies can be used and how value can be drawn from them.

In a sense, Shannon contributed to the development of the foundations for the transmission and movement of information, but he also simplified the relationship between input and output. P2P communications is evidence for the complexity of information exchanges. P2P communications foregrounds how important the pipes are but also how they become a minor although essential part of any equation in the relationship between meaning and exchange.

P2P communications also raises important issues about how information can be visualized and then used for interaction and exchange. As devices such as PDA's become more effective at storing and communicating information, the question becomes how to create interfaces that will welcome participants and teach them to make best use of the technology. Interface design and interface experience are driven by aesthetic choices at all levels from

shape and form to color and look. Interfaces are about visualizing use and learning from communities of interactors.

To varying degrees, P2P interfaces are open to change and customization. Users can alter MSN Messenger much as they can change the look of the screen of a cell phone. This personalizes and then bonds users to their devices or computer screens. The interface that is the user's desktop and workspace becomes a familiar place to explore the information and ideas that have been collected. Interfaces are screens, windows, mirrors, and, most significantly, mediators. In the P2P world, interfaces become the signature of the software.

This is why the idea that there is a pipe that needs to be filled doesn't work with respect to P2P communications since both the pipe (be it wireless or land-based) and use are inseparable. Shannon's approach placed information into a decontextualized environment that is not borne out by the ways in which information has come to be manipulated for so many different purposes. Noise can be treated as an aesthetic necessity or as an impediment to the transmission of 1's and 0's.

In the final analysis, phenomena like P2P networks completely reframe not only the connections people create but also the tools they use and develop. The results are as varied as the groups themselves. Mark Slade (1970), in a little-known book, says the following: "The language of change does not collect; it transposes, translates and transforms" (5). This crucial insight is the foundation of the P2P revolution. Slade talks about the energy that is at the source of moving images. For the most part, he suggests that culture remains attracted to and dependent upon inscription and the power of the written word. Slade wrote this more than thirty years ago! It still applies today except that the image-worlds being built have long since left notions of inscription and preservation far behind.

Although music lovers may have hundreds of MP3 songs on their computers, they are constantly looking for more. It is an endless foraging process where the accumulated material recedes into the background. This is the true meaning of a disposable culture, and while this may offend those who seek to preserve the integrity and quality of information and what is done with it, disposable cultures are economic engines. They constantly have to reinvent themselves in order to maintain a continual process of transformation and change.

In much the same way, P2P communities are constantly redefining the nature of their interests and the means of contact and exchange. The metaphor that best exemplifies this shifting ground is the notion of streaming video. Images flow through a variety of devices and levels of compression to

arrive at the user's desktop or PDA as a current of information. Users take the material and transform, edit, save, post, discard, or simply watch the images. The numbers of possible trajectories that can be followed are as numerous as the imaginations of the individuals who are in receipt of the pictures.

As difficult as it may be to accept, these activities are both concrete and ephemeral at the same time. It is this characteristic that sets P2P communications apart from other forms of community development. It is also the reason that P2P communities are such a powerful movement adding yet another layer to the scaffolding of the Internet and the general understanding of networked connections. P2P communications is a crucial example of the harmony that can develop between machines and humans where each augments the intelligence of the other until a symbiotic balance is found. The technology that permits all of this simply becomes part of the overall ecology of communications. In chapter 8, I examine another digital phenomenon, computer games, which further extends and deepens this notion of ecology and communications and expands the breadth and geography of image-worlds. In fact, all of these phenomena suggest shifting boundaries between humans and the objects they use. As more intelligence comes from unpredictable places (e.g., cars using GPS technology to know where they are), a web of interlocution, dialogue, and discourse is created to speed up the symbiotic links humans have to their machines and image-worlds. The boundaries between machine intelligence and human intelligence become "sites" of movement and transgression.

CHAPTER EIGHT Computer Games and the Aesthetics of Human and Nonhuman Interaction

HAL could never exist. The good news is that many Artificial Intelligence researchers have become sophisticated enough to stop imagining HAL-like machines. We can now envision a different class of intelligent machines that we will be able to build and that will be very useful. Such machines will be local experts; that is, they will know a great deal about what they are supposed to know about and miserably little about anything else. They might, for example, know how to teach a given skill, but they will not be able to create a poem or play chess.

— Roger Schank, "I'm sorry, Dave, I'm afraid I can't do that": How Could Hal Use Language?

Computer and video games are at the heart of new definitions of interactivity and immersion. The impulse to play video and computer games comes as much from the desire to play against the expectations of defeat as from the desire to collaborate with the game and understand its rules. The activities of play are infused with a process of testing, probing, and exploration. Will the puzzle be solved? What tricks, detours, and false directions has the designer included in the game? Players enter a labyrinth of possibilities and find their way through the maze. Some players conquer the games they play, but many don't, which suggests that process is far more significant than results or outcome. This illustrates why driving a car at high speed on a screen can still be exciting even though it is an imaginary activity. The fun comes as much from defeat as winning because players are responding to their own desires and to the game itself. Computer games are not treated as distant objects. They are owned by players, personalized and used as if players have had as much input into their creation as the original producers. This is why many of the games are centered on communities of interest and also why so many players end up joining clubs or meeting each other to explore the games and find solutions to the challenges posed by them. Computer games have always been about "telepresence" and "teleportation." Players seek to go into worlds that don't exist but nevertheless have enough empathy for what they are doing to encourage sensations of entry, emotion, and challenge. Sensations—the physical manifestation of psychological processes—allow the players to believe that even though they are inside spaces that have been built within the strict confines of algorithms, the visual landscapes and sounds are consistent with the world of the game. This is an intensely metaphorical environment constructed on a series of hypothetical possibilities that players explore with great intensity. The desire to fantasize is crucial to games and this enables players to "engage in socially unacceptable behavior in a safe environment" (Rouse 2001, 7). Rouse makes the point that players want to engage with their games in an incremental fashion, rather than solving the challenges all in one instant. Pleasure comes from failure as well as success.

Computer games are the firmest indication yet of the degree to which humans and their technologies have become not only interdependent but also profoundly interwoven. It takes over a million lines of computer code to produce a game. The result is an "engine" that keeps all of the parts of the game together and organizes the orientation, direction, and outcomes of the player's interaction with the game. In most games there is a direct relationship

between the actions of the player and the results on the screen. Newer and more sophisticated games are now delaying the outcome of actions to make the plots more difficult and to enhance the mazelike effect of the games. Game engines are complex in large measure because so many elements of games have to be anticipated before any game can be put into the hands of players. In addition, the look and feel of a game (its aesthetic) is the result of the sophistication of the engine. The coding is so complex that many months can be spent on the testing process to see whether the coding has produced the anticipated results. There is nothing particularly romantic about writing and compiling code. In some respects it is like an old-style craft, which requires thousands of hours of work. The limitations of this approach are evident in the narratives of most computer games. The rhythms of creativity in this area are heavily influenced by action and reaction, by characters that "do" things or have things done to them.

This is why sports games are among the biggest sellers and are avidly sought after by fans. Most players know the rules beforehand. Some of the more sophisticated sports games like *Madden's NFL Football* are as much a product of the game industry as they are an outcome of fantasy game leagues that thousands of sports fans play all over North America. The Madden game tracks every player's statistics so that individuals can match each other's abilities, levels, and achievements. There are many Web sites devoted to this game that have been developed by players with tips, patches, and discussions of strategy. In Madden football, it is even possible to ask for a replay if a gamer disagrees with the decision of referees.

One of the most important facets of the game, which is also at the root of its attractiveness, is that players believe the game has enough intelligence to outwit them. Game companies and players talk about the use of artificial intelligence (AI) as if all the variables they encounter are evidence of cleverness and brainpower within the game. The irony is that AI is really no more than a series of random selections that are programmed into the engine such that it appears as if choices are being made by the game. Sometimes the variables are complex enough that the images appear to be thinking. From a gaming point of view, this is a very effective way to challenge players.

There is a long lineage of research in the fields of cybernetics, system dynamics, chaos theory, and adaptive systems that is at the heart of the push to make games more intelligent. There *is* intelligence in the games, but the question is does the game know? The answer clearly is that the game cannot know anything, and so once again it is the vantage point of the player that is at the heart of any assumptions about the location and effectiveness of intelligence

within the game. This is in no way to downplay the complexity of the coding that makes it possible to anticipate so many different game "states" that gamers have to work for days to overcome some of the obstacles.

From another perspective, as the war in Iraq unfolded in April 2003, gamers involved in playing *Civilization* began to use maps and images from the war to discuss tactics and military strategies. As with many on-line games, the players went far beyond the parameters of the games they were playing, and in this way moved beyond the limitations of the engines and/or coding that had been developed.

The leakages from game to reality and from reality to game are essential parts of gaming culture. This is why the coding has to allocate so much of the direction of the games to alternative modes of action, reaction, and behavior. Otherwise, it would be unlikely that the players would "believe" in the game to a large extent because the measurement for a game's effectiveness is often the degree to which it lines up with the real world. This fragmentary approach to fantasy is itself summed up by the fact that the American military used computer-based games to educate some of its troops before they went off to fight in Iraq.

If the military games had guns that were not capable of shooting correctly, then the "physics" of weaponry would be undermined. There would be no point to the simulation. Yet, this contradiction is at the *heart* of the playing process. Part of the trickery and the magic is that the games must do things that by their very nature are antithetical to what would happen in the field and nevertheless "look" as if the impossible is possible. There have to be some rewards for engaging the enemy, and there have to be short- and long-term results. What an extraordinary paradigm! The bridges being built for players between different states of mind are now so dependent on game worlds and imagescapes that vantage point may be the only way of understanding the complexities of the interaction.

Hybrids

In her recent book *Modest Witness@Second Millenium. FemaleMan© Meets OncoMouse™*, Donna Haraway (1997) says the following: "The computer is a trope, a part-for-whole-figure, for a world of actors and actants and not a Thing Acting Alone. Computers cause nothing, but the human and nonhuman hybrids troped by the figure of the information machine remake worlds" (126).

Haraway makes a crucial point that will suffuse this chapter. As I mentioned previously, Modern culture tends to draw easy distinctions between machines (nonhumans) and humans, distinctions that encourage people to believe that the nonhuman is separate from human activity and that people simply use technologies such as computers as tools.

Rather, I believe technology has always been mapped into and onto human bodies. The distinctions that are drawn are not between machines and humans, but between disparate levels of involvement with technologies and many levels of synergy and interdependence, as well as alienation (Haraway 1997). This doesn't mean the tensions that exist between computers and humans, for example, are unimportant. Rather, the diverse levels of mediation that supplement and enhance the depth of the interaction largely define the outcomes of the relationships that humans have with technology in general.

Bruno Latour (1999) has described this set of relationships as a collective of humans and nonhumans, and by this he means that the links between humans and their technologies make things possible that neither could achieve without the other. For Latour, and it is a point with which I agree, technology is an inherent constituent of everything defined as human.

Latour suggests that machines and humans form a collective and are continuously acting together in an associative chain of relationships that is only interrupted as people move to different levels of complexity in the process. Computer games are a good example of the drive and energy humans put into their relationships with machines. Another good example of what Latour means is the way users interact with word processors. The word processor and the individual using it act together and produce many different results. The outcome of the relationship is not predictable although most word processors are basically the same. This unpredictability means that both the word processor and the user are changed as a result of their interaction.

This statement doesn't seem to be correct. How can a word processor change? These same issues of autonomy are at the heart of what keeps gamers working so hard to understand and meet the challenges of the games they play. Autonomy is only possible if a great deal of intelligence is attributed to the technology. As I have mentioned, this is the reason that artificial intelligence has become such a buzzword among players and computer programmers. The notion that the machine can work out problems on its own largely depends on vantage point. Does the machine know that it is acting in an autonomous fashion? Clearly, the player or observer makes the decision as to whether some sort of process has gone on to justify claims about the autonomy of the machine. Aren't the rules governing a computer program fixed?

Isn't the hardware an object that cannot be altered? Aren't all of the variables built-in? This is how Latour (1994) clarifies the question in talking about how humans interact with guns:

You are a different person with the gun on your hand. Essence is existence and existence is essence. If I define you by what you have (the gun) and by the series of associations that you enter into when you use what you have (when you fire the gun), then you are modified by the gun—more so or less so, depending on the weight of the other associations that you carry. This translation is wholly symmetrical. You are different with a gun in hand; the gun is different with you holding it. You are another subject because you hold the gun; the gun is another object because it has entered into a relationship with you. *(Pp. 32–33)*

Latour is talking about a *third* level that is a combination of human usage and machine. It is not that the object changes, but the relationship developed with objects transforms all the partners in the exchange. This third level brings a process that seems fixed into a mediated encounter with a process that is not fixed. The result is a *mediated* space occupied by two partners where both partners are dependent upon each other. Their interdependence creates a hybrid that has a number of the properties of the technology and user. The hybridization is evidence for the ways in which the user and technology have found a common ground that often exceeds the design and engineering objectives built into the hardware and software. Of course, the changes in the technology are not material. Hybrid processes are about new levels of materiality that are the product of a series of interactions and transformations that may not have been built into the original technology, nor have anything to do with its initial purpose.

This hybridity is really another way of entering into the culture of technology. Gamers, for example, know that part of what entices them is the rapid manner in which the technology changes and responds to their needs. Companies like Electronic Arts make the effort to produce as much realism as possible and use motion capture to enhance the fluidity of movement of the characters in their games. Motion capture is an excellent example of the third level that I have been discussing. Football players, for example, wear sensors to record all of their movements as they engage in various actions commensurate with their positions on their teams. The sensors then relay the information to computers, and the information is translated into three-dimensional animations that can be incorporated into the rendering process for the games.

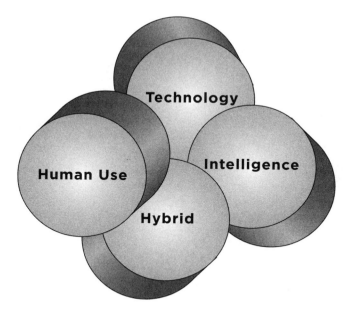

FIGURE 8.1 Intersections of human use and technology

The entire process is based on the biomechanics of human movement so that the size and weight of players will have an impact on how they run and interact with each other. These principles are integrated into the animation. Madden football is somewhere between reality and animation, and that "somewhere" is the third level of hybridity that I have been discussing.

Interaction and Computer Games

The word processor becomes a vehicle for the creation of this "third" space allowing users to feel as if they control the processes of interaction (figure 8.1). A computer game, for example, never brings the answers to the puzzles that it poses directly into the foreground for the player, but instead provokes an exploration of a hybridized new environment that also encourages the player to feel as if he or she were in control. In fact, learning the rules of this new

environment is part of the challenge as well as one of the sources of the plea-sure that games provide. Playing as an activity is about constructing hybrid experiences and overcoming hurdles that can only be circumvented through practice and interaction. Computer games encourage moving into and out of these worlds, which is why they are not only difficult, but require a lengthy ap-prenticeship in order to be mastered (Pesce 1998, 2000).

In this sense, interaction as it has been applied to digital technologies like computer games, is *not* just about use or the pragmatics of handling the challenges that the game sets for players. Rather, playing a game creates a mixed and complex space that exceeds many of the intentions built into the original structure, and it is this excess that is the site of potential mastery. In other words, game technologies are about continually evolving relationships undergoing constant change. It is precisely this lack of stasis that keeps human beings searching for innovative ways to solve the problems that games pose (Cassell and Jewkins 1998).

Humans assign a set of subjective values to the instruments and tech-nologies that they develop. These values do not remain static, but evolve over time and are increasingly "manufactured" into the technology itself. In other words, the synergy generated by interaction is eventually included within the technologies; computer games are one of the best examples of this evolu-tionary process. The intersection of needs that connects humans to their ma-chines means that neither side can work with the other unless they have shared some history (Johnson 1997).

Technologies are born out of needs, amplify and extend those needs, and then help in the redefinition of what it means to be human. This is a continually evolving interaction that shifts and changes in response to the so-cial and cultural context in which it takes place.

Hybridization, then, is about more than a mixture of elements with a particular outcome or result; rather, hybrids underlie the process of change and evolution as technologies and humans encounter each other. To think in these terms is to put intelligence and the subjective back into human-technology relations. Rather than modeling technology in the broadest sense as a series of tools for pragmatic use, there is a need to think about how hu-man subjectivity and the ability to self-reflexively examine identity has evolved out of the relationships humans have with machinery, artifice, and their cre-ative engagement with technology.

The role of design, at the engineering and software levels, has become crucial not only to the ways in which technology functions but also to the manner in which the technology is used. Yet for the most part the design of

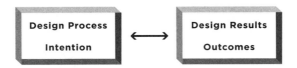

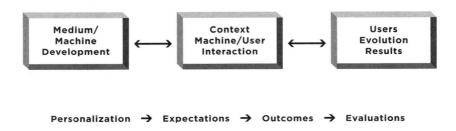

FIGURE 8.2 Design process/design results

games has been in the hands of engineers and computer scientists (Crawford 2002). This is largely because the programming languages that have to be learned to produce a game are so complex that artists and writers have rarely had the opportunity to create them. In this respect, the design process needs to be relatively transparent in order for players to take on the tasks of creating their own games, and in some instances players have modified the games that they play, but these are the exceptions and not the rule.

According to Beynon et al. (2001):

Current frameworks for developing technological products reflect a limited conception of their role. In designing such a product, the emphasis is placed on what can be preconceived about its use, as expressed in its functional specification, its optimization to meet specific functional needs, and

the evaluation of its performance by predetermined metrics. This perspective on design is not sufficient to address the agenda of cognitive technology; it takes too little account of the interaction between a technology, its users, and its environment. (P. 476)

Beynon et al. (2001) make a crucial point about the relationship between intention and outcome in software design although the same questions exist in nearly all forms of design. In figure 8.2, I left out the ways in which the various elements connect, but I show the many different levels of mediation that exist in any usage of technology.

The process of design and use is not linear but circular, evolutionary, and often unpredictable. One of the most important features of good design in the software area is the ability of users to customize not only their relationship to what they are doing but the actual parameters of the software itself. Generally, however, most software prevents the kind of personalization that users might be interested in engaging with and developing (Lohr 2001).

In fact, in discussions with game designers at Electronic Arts, the largest studio in the world for the production of computer games, I was told that customization is crucial, but it must come from the layering of so many variables into the game that players feel "as if" they have control when they really don't. One of the game developers suggested that if players were actually able to alter the fundamentals of the game, then chaos would ensue, and the game would not be entertaining. For me, the point is that customization *is* the game (Adams 2001).

Learning is the crucial impulse in the evolutionary process of exploring and playing a game. Computer games are good examples of these stresses and strains between expectations and what users and players do with the constraints that govern both the design and playing process. At the same time, if all of the variables have been thought out ahead of time, then little room is left for players to transform the core (or engine, the term gamers and programmers use to describe the algorithmic structure that governs the game) of the computer game environment.

At the same time, hybridization (the process of moving beyond subject/object relationships) develops over time through personalization whether expectations are achieved or not. As a result, the *third* space that Latour talks about comes to play a much more significant role in the way users relate to what they do with hardware and software than the original process of design could *ever* anticipate. In other words, computer games, for example, are played within the boundaries of this third space (which is why the learning

process is so central—and why it takes so long to learn all the levels of the games), which is the site of interactivity, intelligence, and creativity.

Another way of thinking about this third space is to examine how people communicate verbally. When an individual says something to a friend and he or she responds, there is no direct way to fully comprehend all the intentions that governed the communication. Instead, both parties agree by convention, habit, and the desire to understand each other that, to a certain degree, the gaps between them will not affect the content of the exchange. Although the gaps are present, they are *part* of the process. Awareness of the gaps, however, pulls the process of communications into a *metacommunication,* where individuals must develop an awareness of what works and what doesn't. They have to know how and why the process works or doesn't. They also have to be aware of the constraints that the gaps introduce into every part of the exchange. It is the combination of exchange, awareness, and communications that produces additional spaces of interaction and conversation—these are *third* spaces that can only be examined by looking at all parts of the exchange (Bateson 1979).

Brian Cantwell Smith has dealt with these issues in his book *On the Origin of Objects* (1998). Smith's most important insight is that the categories governing the creation of software, for example, need to be developed in recognition of their dynamic and evolutionary aspects. It is not enough to make ontological claims about the validity or purpose of programming code to the exclusion of the changes that usage both encourages and makes possible. The interaction of use and design is about parts and the whole, evolving processes of change and personalization.

This is close to what Bruno Latour is saying. It is very difficult to model the complex relationships among context, users, and design. In general, computer programmers use a behavioral approach that builds in many variables, but by its very nature software use often exceeds, if not overturns, the intentions that went into its design. At issue here is whether design can anticipate the process of hybridization, or even whether it should.

To program is to engage in higher-level logic and mathematical modeling. Clearly, the code for the word processor I am using works; otherwise, there would be no relationship between the keyboard, my hands, and the screen. Code is a kind of *virtual toolbox* into which a great deal has been placed and from which a great deal can be extracted. Yet with careful qualifications, the grammar for language is also a higher order system of tremendous abstraction—speakers don't need to know grammar (in the literal sense) in order to speak. If speakers had to think in grammatical terms, speech would

become belabored since it would have to be constructed in a conscious rule-based manner. This is clearly the problem that develops when individuals learn a new language and why it is often so uncomfortable an experience.

It has been one of the major fallacies of software development and programming to assume that code is equivalent to grammar and that it is possible to postulate a rational relationship between creation and use. This is one of the reasons (though not the only one) that the human brain has increasingly been compared to a computer (Churchland 1992). It is important to recognize that the equation of code with grammar actually works against the best interests of programmers. This is because not only is grammar far more complex than code, it also is universal, innate to humans, and a genetic feature of the brain. Noam Chomsky (1980) responds to this issue in the following way:

Investigation of human language has led me to believe that a genetically determined language faculty, one component of the human mind, specifies a certain class of humanly accessible grammars. We may think of a grammar, represented somehow in the mind, as a system that specifies the phonetic, syntactic and semantic properties of an infinite class of potential sentences. (P. 35)

Code is a *product* of these and other properties of mind and thought. Code itself can only play a limited role in what people do with it. Given the opportunity, how would or could users characterize the code governing a word processor? Would it look the same as written music? Music scores are continually open to interpretation, transformation, and change not only in terms of their writing, but when they are performed. The syntactic properties of music writing are very specific, but no two performances are the same. While there may be conventions to the writing of music and while these conventions are often repeated, the beauty of performance is its unpredictability.

I would make the same argument for the use of the computer and most technologies. The outcome of written music and performance is as hybridized as using a technology. All of these spaces are multiple combinations, and cannot be constrained by any one of their parts. This is often why the arrival of a new technology seems like such a scary process. The elements that contribute to hybrid spaces seem to lose their identity for a while or at least until the partners in the process develop enough knowledge to permit their interaction to take on a particular and more conventional character.

The brilliance of Bruno Latour's book, *Aramis or The Love of Technology* (1996), is that he explores the institutional base upon which the hybridized

process both develops and is sustained. Latour's book explores how a massive transportation project failed in Paris. The book is full of personal comments by the "players" in the drama and equally personal reflections by Latour. Most importantly, Latour explores the evolving relationship among projects, the way projects are visualized, and their development into "objects."

In this case, all of the plans for the project were quite far advanced before the project was killed. The project, as a hybrid, took on a life of its own. In a sense, the *project* began to make claims for what it was doing and what it could be, that the institutions that were responsible could not meet and often could not explain. This notion of a project "taking on a life of its own" is another way of talking about hybridized spaces.

Part of the problem is that so much of what makes technology work is not necessarily visible, which contributes to the feeling that the technology is very distant from users, participants, and viewers—distant enough to make it seem as if responsibility for what happens was *with* the technology and not with the relationship between humans and their machines. The gap between the systems that guide the operations of computers and the ability to change the underlying programming language is so vast that issues of responsible engagement seem to be insoluble. This gap tends to reinforce the idea that users are not acting in concert with the computer; rather, it is just seen as a device, and the human use of it is limited and circumscribed by the manner in which it was built and maintained.

In contrast, the Open Source movement has been far more important to the development and growth of new attitudes to computer technologies than initially thought. The idea that a computer operating system, such as Linux, could be constructed through a worldwide and quite spontaneous consortium of people suggests that both the computer and its programming logic are not as opaque as some would believe. But the level of specialization required to engage in this collective process excluded the vast majority of computer users.

As Eric Raymond (1999) has suggested: "Linux is subversive. Who would have thought even five years ago (1991) that a world-class operating system could coalesce as if by magic out of the part-time hacking of several thousand developers scattered all over the planet, connected only by the tenuous strands of the Internet?" (29). Raymond's point is crucial. The spontaneity, as well as the competence of the people involved, made it possible for a sizable community to produce unforeseen results in a dynamic and evolutionary way. Linux continues to evolve and has reinforced the credibility of

hackers and aficionados of computers throughout the world. Most important, the history of Linux suggests that the organized and rather strict world of computer programming is in fact very messy.

Writing code appears to be the most concrete of activities—there is after all a direct link between coding and the operations of a computer. The power of this metaphor is initially very strong, but what happens when codes combine with other codes in an autonomous fashion and produce results that exceed anything that was programmed in the first place? Does this challenge the role of subjectivity and the position that humans have in hybrid spaces? Before I return to the importance of computer games in answering some of these questions, I will reflect for a moment on the contradictory and yet crucial role that the artificial life movement has played in suggesting a measure of autonomy to the way computers work.

Code and Artificial Life

The artificial life movement has been defined with great clarity by one of its founders: "Artificial life is the study of man-made systems that exhibit behaviors characteristic of natural living systems" (Langton 1989, 1). Genetic algorithms are designed to send instructions to a series of encoded "strings," and these mutate and change, "evolve" with results that cannot be predicted by what the algorithm originally put in place. "In GA's (genetic algorithms) computer organisms e.g., computer programs encoded as strings of ones and zeros (bit strings) reproduce in proportion to their fitness in the environment, where fitness is a measure of how well an organism solves a given problem" (Mitchell 1998, 7). Mitchell goes on to reproduce a classic example of a genetic algorithm (see figure 8.3.).

Mitchell (1998) makes the point that "reproduction" is really about copying, which is an idealized version of the evolutionary process. In the end, a highly evolved and very fit "string" can be used to solve complex questions. Mitchell mentions how problems in circuit design as well as robot navigation and the economy have been dealt with using genetic algorithms.

The point to retain here is that although there are many different kinds of programming, and many languages have been developed over the last thirty years (assembly languages, procedural programming, functional programming, logic programming, object-oriented programming, and so on), they are all abstract representations of potential actions and behaviors on the part of users. In the instance of artificial life, biological metaphors are used to

Assume the individuals in the population are computer programs encoded as bit strings. The following is a simple genetic algorithm.

1. Generate a random initial population of M individuals.

Repeat the following for N generations.

2. Calculate the fitness of each individual in the populations. (The user must define a function assigning a numerical fitness to each individual. For example, if the individuals represent computer programs, the fitness of an individual is calculated by running the corresponding computer program and seeing how well it does on a given task.)

3. Repeat until the new population has M individuals:

 (a) Choose two parent individuals from the current population probabilistically as a function of fitness.

 (b) Cross them over at a randomly chosen locus to produce an offspring. That is, choose a position in each bit string, form one offspring by taking the bits before that position from one parent and after that position from the other parent.

 (c) Mutate each locus in the offspring with a small probability.

 (d) Put the offspring in the new population.

This process is iterated for many generations, at which point hopefully one or more high-fitness individuals have been created.

FIGURE 8.3 Genetic algorithm

describe mathematical codes that "evolve" as a result of autonomous processes among the various programming strings.

This level of abstraction is difficult to understand, but, ironically, it depends increasingly upon a hypothetical space. This hypothetical space can develop its own autonomy. It can even appear as if the algorithms were evolving on their own without the apparent influence of their creators. The reality is that unless the machines become completely autonomous and cease to be viewed, interpreted, fixed, and so on, it is unlikely that they will survive on their own.

The most important issue here is once again vantage point, which was analyzed in great detail in the introduction and in chapter 1. How can the evolutionary process be observed if it is autonomous? If this issue is approached from the point of view that the *notion* of autonomy were a hybridized outcome of human-machine relations, then it becomes possible to conceive of programming logics that might operate independently of human observation. Artificial life proponents would argue that they are creating "animals" and other "living" beings within virtual worlds. This is more than a question of nomenclature, because it goes to the heart of what is meant by life and, certainly, the mind.

If, as I have argued throughout this book, the virtual were an extension of reality, then artificial life is only possible as a product of human interference and engineering. The idea that there is autonomy results from confusing the hybridized third space of interaction with the computer itself. Although artificial life deals with simulations and models, its origins and the ways in which those models are observed are derived from a behavioral approach to phenomena.

A behavioral approach has taken root in software development with the result that programs are written in anticipation of certain actions and responses on the part of users. It is this behavioral template that dominates the way code is written, even though when thousands of lines of code are needed to make a system work, many things can and do go wrong. An input/output model dominates behavioral approaches in this area, which is why it appears as if autonomy were possible, if not desirable, and why artificial life seems to be so attractive since it reinforces the seeming autonomy of the computer and its activities.

The "Life" in Computer Games

Ironically, computer games are one of the best examples of the effort to break down the behavioral model. When gamers play a snowboarding game, they input certain actions into a PlayStation, such as turning and following the route that the game lays out for them. A certain amount of information has to be processed by the software in the PlayStation in order for their commands to be translated from hand to machine and so on. There are numerous variables from which gamers can choose, but the game has strict limits, which are defined by its primary purpose to offer players a photorealistic experience of going down a hill. This major constraint conditions everything from the graphics to the coding. And observing a player or deriving certain conclusions from his or her behavior will not help too much in understanding the experience.

It may seem as if there were countless choices available to the player, but the "trick" of the game is that there are actually very few choices. To "win" the game, players must discover the constraints of the game and the limitations of their own experience as well as solve the problems the game sets for them. The player, the game, and the context of the playing provide the foundation for a process of *hybridization* that doesn't need all the characteristics of its parts. This is one of the sources for the "magic" of digital games. There seems to be a kind of sorcery involved in the subjective intensity with which players engage with their games—an enchantment that quickly moves from reality to imagination and back again, and only some of this can be attributed to the game itself.

The most important point to remember is that the magic comes from the unexpected exploration of a space and time that seems to be outside the constraints posed by the game. This is partially because the game may have the qualities of the virtual attached to it, but the "place" of the player remains quite conventional. Irrespective of the intensity, the person playing is not going down a hill. However, he/she agrees to imagine that the hill is there and, in so doing, supports and enhances his/her relationship to the game.

A simple but elegant way of understanding how a computer game is created can be seen in figure 8.4. Inside a game certain problems can be posed that cannot be replicated anywhere else. For example, when gamers begin to play the snowboard game, the character flies off the edge of the course, crashes, screams, and so on. Yet, this leads to even more effort and a strong desire to control the character and its movements. Game controllers and all the various accoutrements that come with games from steering wheels to accelerators for car games are all based on controlling an object

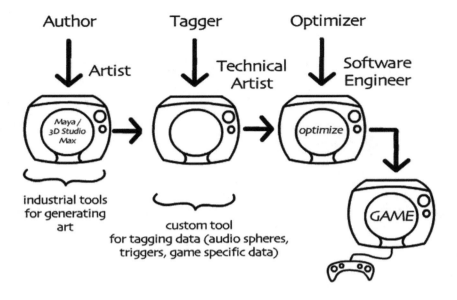

FIGURE 8.4 Elements in the creation of a computer game (John Buchanan, Electronic Arts) (drawing by Maija Burnett)

from a distance. Yet, much of that control is not necessarily related to what the player is doing; rather, the game is providing a number of opportunities that limit the quantity of choices that can be made. The magic is that those limitations seem to be within the user rather than within the game. Actually, the limitations are a product of the interaction and therefore not entirely within the control of either the player or the game.

At a deeper level, the desire to overcome the limitations of the computer screen as an interface among experience, doing and seeing has resulted in a paradoxical desire to transform the screen itself into a device of interaction. The joy of traveling through the screen in an imaginary fashion is partially about taking some control over the technology and exercising a degree of power over the images and sounds that computers produce (Cubitt 1998). But, for the most part, games remain spatially bounded by frames and hindered by the characteristics of the screen as a two-dimensional device.

The extraordinary thing is how ready users are to "play" with these limitations and how so much energy has been devoted to conquering the problems that the interfaces pose. This is evidence of the collective effort in which participants are engaged. And the interesting thing is how this is fundamentally altering the material basis for the player's experience of the world. If people were not already collectively engaged with technology in this fashion, they would not be able to adapt to the cultural shifts that computers are generating (Herz 1997). So, in this carefully delimited sense, humans are constructing simulations that have all of the appearances of modeling life, but the key word to keep in mind is *model:* It is a big jump from model to life (Burnham and Baer 2001).

The cover of the video game *SSX* says the following: "SSX (an Electronic Arts game for PlayStation 2) delivers knee-pounding, board-clattering rides on the wildest runs ever imagined. No matter how you carve it, you're hauling tail with some of the sickest speed freaks to ever hit the snow. Push the edges, hang off ledges, and stomp killer jumps in an insane push to the finish line" (cover). The key to the language here is the inclusive way in which the player becomes the game. The tensions between identification and the reality of being in front of a television set produces the "thirdness" of which I have been speaking. It is only in the combined real/imaginary space, inside a hybrid, that it becomes possible to *feel* as if the player were hitting the snow, as if the model or simulated space has managed to exceed the boundaries that govern its operations.

What would happen if the landscape were to change dynamically in response to additional variables such as weather and other unforeseen natural events? Would the sense of realism increase even further? What would happen if the animated character were to rebel against the player and reject his or her style of play? All of this is possible inside these worlds—only possible, that is, if the world does not obey conventional rules of space and time.

Computer games typically control individual characters according to scripts that are written at design time. As a result, a character's behavior is limited in its ability to respond to unanticipated run-time contexts. Combinations of generative and reactive planning algorithms provide the means for creating customized, novel behavior that changes each time a game is played (Amant and Young 2001, 18).

This type of customization and flexibility may finally alter the bridge between the real and the virtual, collapsing both of them into another, perhaps different space where the virtual "feels" like a more personal visualization of desire, pleasure, and need (Vilhjálmsson 1997).

"Hacking" the Game

Computer games and the excitement they generate are a partial response to the need to actualize the collective human engagement with technology in general and with image-worlds in particular. They are also a response to the complexity of the hybridized spaces that human-technology relations create. There are tensions among gamers and creators, and an increasing desire among users to control more fully every aspect of the games they play. An entire subculture has arisen devoted to transforming the look and feel of computer games through "hacking" and "patching" in order to overcome the organization of the game as well as the coding.

In a crucial article that appeared in the journal *Interactions,* Mitchell Resnick, Amy Bruckman, and Fred Martin argued for a constructionist approach to computer technologies that builds in the capacity to create computer-driven objects and programs that connect to the user's personal and intellectual interests. One example this research produced was the LEGO game *Mindstorms* that allows children to build robots with tiny chips in them. The robots can be programmed in a very simple way on a computer. The toy has been a major success for the LEGO Company. It takes the conventional relationships that novices have with computers and creates an immediate and easy level of access. The virtual space represented by the screen of a computer suddenly moves from a flat world to a three-dimensional and sculptural one. The creators of *Mindstorms* put it this way: "Developers of design-oriented learning environments can not 'program' learning experiences directly. The challenge, instead, is to create frameworks from which strong connections—and rich learning experiences—are likely to emerge" (Bruckman, Martin and Resnick 1996, 47).

Anne-Marie Schleiner (2001) comments on this phenomenon in relation to computer games in the following way with particular reference to Lara Croft and the *Tomb Raider* games:

The Internet provides the techno-culture researcher with a visible mapping of desire, digital evidence of an internationally shared lust for the Nude Raider patch. A Web search for Nude Raider produces innumerable fan sites requesting the Nude Raider patch and displaying Nude Raider screen shots (1,072,226 hits from one search with the Excite search engine). An older version of the official Tomb Raider homepage itself even contained a link to the Nude Raider patch. Nude Raider strips Lara Croft's already scant clothing to reveal polygonal tits and ass as she fights her way up the game levels, operating within the

bounds of gender-subject configurations: Lara as fetish object of the male gaze. Not all game patches so explicitly echo or reinforce a particular feature of the original game—in the case of Nude Raider, an exaggeration of Lara's synthetic erotic appeal. A concentrated Web search on almost any shooter produces a stratum of alternate and more subversive game scenarios in the form of game plug-ins and patches offered freely from fans' personal websites. Some game companies, like Bungie, developers of Marathon, and Id Software, developers of Doom and Quake, have even capitalized on this widespread hacking by packaging software with their games that makes it easier to manipulate and create new game scenarios. (P. 225)

Schleiner's own artistic work explores the transformation of the attributes of computer and video games. She is part of a large and growing community that is confronting the seeming "solidity" of programming languages in the same vein and with the same intensity as hackers (Cassell and Jenkins 1998). It is significant that the movement to alter games is so widespread that creators of games often face a crisis about how to program and protect their intellectual property.

It may be, however, that the issue is far broader than just individual games. The underlying motivation to hack a game comes from the same culture and history that helped in the development of computers in the 1950s (Johnson 1997). Thousands of players have formed guilds and communities devoting themselves not only to playing but also to understanding the games they love from a variety of narrative and technical perspectives. For example, downloadable "cheat mods" are patches that permit, if not encourage, players to make the games work to their advantage. Unlike patches, which may alter the look and feel of characters, mods change the programming. Since they are often so private, mods can give some players a major edge over their competitors. Ironically, these interventions are what the early inventors of computer technology envisaged for their machines (Shurkin 1996). Application program interfaces are part and parcel of games like *Quake* and *Half-Life,* and they permit profound changes in the organization and dynamics of the games (Amant and Young 2001).

The video and computer game industry has been developing more sophisticated models of interactivity to allow players to fully explore the closeness they have established with screen-based experiences. But the connections between interactivity and technology have been with consumers since popular culture became a part of everyday life in the nineteenth century. The futurists, for example, argued for the destruction of conventional

theater in the 1920s as a way of overcoming the distance between spectator and stage:

As Futurism became popular, it afforded artists an opportunity to create environments for the public eye. The location of the café-cabaret proved to be a logical solution because it had established itself as an open avenue for the inventive sensibility. The artists Vladimir Tatlin, Alexander Rodchenko, Giacomo Balla, and Leo Van Doesburg produced café-cabaret environments between the years 1917 and 1926. Visual arenas were created to coincide with the theatrical and musical experiments that took place in the café. In 1921 Balla created a visual environment in the Bal Tic Tac in Rome, Italy. Acoustics, lighting, and visual effects interacted with and influenced each other. Projections of dancers upon the walls of the café created a display of colors, lines, and planes. Van Doesburg, in collaboration with Jean Arp and Sophie Tauber-Arp, created murals at the Café L'Aubette, a café-cabaret cinema in Strasbourg, Germany, between 1926 and 1928. Doesburg's goal was to break up the symmetry of the interior architecture by creating passages of color that seemingly flowed within the spaces of the entrance, foyer, staircase, and room for dancing. (Gallagher 2000)

The desire to produce interactive environments accelerated in the 1960s and found its fullest expression in the use of cybernetic concepts and ideas from research into artificial intelligence. There is a wonderful story to be told here in the movement from performance art to happenings, installations, and the advent of sophisticated imaging devices. More sophisticated information storage technologies like PlayStation 2 have been wrapped into gaming culture in order to facilitate playing, but PlayStation 2 can also be used for artistic purposes. Among the artists who have explored these levels of interaction to the fullest are David Roekby, Stelarc, and Perry Hoberman. As Rokeby (1996) says:

Interactive artists are engaged in changing the relationship between artists and their media, and between artworks and their audience. These changes tend to increase the extent of the audience's role in the artwork, loosening the authority of the author or creator. Rather than creating finished works, the interactive artist creates relationships. The ability to represent relationships in a functional way adds significantly to the expressive palette available to artists. The power of this expression is multiplied by the fact that the interactors themselves become referents of the work. The works are somewhat

akin to portraits, reflecting back aspects of the interactors, transformed so as to express the artist's point.

The gaming community has contributed to the development and growth of a new medium that responds and even acts on what Rokeby is saying (Daubner 1998). In some respects gaming has provided the foundation for the shift into digital and virtual environments. Many of the claims for "virtuality" are in essence claims about the breadth, the infinite ability that people have to use their imaginations to bring them into contact with any number of different phenomena. All these elements are about the expansion of the traditional ground for "play" in Western culture. The difference is that a great deal of power is now being attributed to the technology of play. The implications of this cultural choice need to be explored in the context of the shared dialogue that individuals have developed with these nonhumans and the new hybrid spaces that have been created.

HAL's Legacy: 2001's Computer as Dream and Reality (Stork 1997b) devoted itself to examining whether the human characteristics of the HAL computer were or are possible. Generally, most of the writers in the book came to the conclusion that HAL was ahead of its time and unlikely in the future. Interestingly, the book was written by scientists who were genuinely interested in the cultural assumptions that went into the creation of HAL as a character in the film *2001: A Space Odyssey.* As I mentioned earlier in this book, even though the chess computer Deep Blue appears to confirm the worst cultural fears about technology, it remains extremely limited when compared to the full range of knowledge and emotions that make up human consciousness. Yet, there remains a sense that intelligence can be programmed into computers. As Roger Schank (1997) suggests: "To tackle the question of whether a machine like HAL could exist, we need to ask how such a machine would acquire knowledge. The answer must be that the machine would need to be endowed with sufficient intelligence to understand any experience it confronted" (183).

It is not a question of programming computers to be like humans. It is a matter of understanding that humans share a similar ground with computers that now precludes the possibility of existing without them. Another entry point into this discussion is through the aesthetic choices made about the interfaces that both separate and invite users into the digital world. When players talk about the *look* of a program, in this case a game, what are they talking about? It would be useful to develop some taxonomies of the "look" of digital games as well as digital environments. As three-dimensional Internet

games become more popular and more practical, the interfaces become more complex. And the claims made for those interfaces raise general expectations for the experiences that the games offer and for the intelligence of the machines being used.

For example, the *Ultima 2* online game is described as a "Persistent State World." This is a world that players "cohabit" with thousands of other people, "simultaneously." According to the *Ultima 2* Web site, "It's persistent in that the world exists independent of your presence, and in that your actions can permanently shape the world" (*Ultima 2* 2002a). The role-playing possibilities of the game are extended into something far more complex. Fantasy becomes the basis for an extension of the body into the protected spaces of the screen. But this is also about the shared ground upon which fantasy can develop. It is about the prostheses that Western culture has used to enhance and strengthen imaginary spaces for play and interaction. In this sense, conventional notions of aesthetics used for analogue media may not be that easily transferable to the digital area, challenging what is meant by interactivity.

Building New Worlds

The links between the computer and the television screen are very suggestive of an aesthetic that is struggling to redefine flatness and three-dimensionality. Part of the struggle is located in the creation of "worlds"—the idea that worlds can be constructed by programming that introduces a whole host of variables into screen-based experiences. Yet it seems clear that games are about a creative mix of worlds and otherworldliness. Games are about gaps, and gaps are about finding a place for the player to affect the experiences he or she has. They are about role playing and imaginary projections of self into interfaces that have enough power to absorb a variety of needs and desires. In other words, they are about using the power of fantasy to allow players to see into their motivations and to hear their desires through the avatars that are generated in the screen environment (Vilhjálmsson 1997).

Games are about substitution, displacement, and the extraordinary need gamers have to reinvigorate ancient mythic stories and tales. I think there is more than a passing relationship between the medium of the computer and the desire to create complex fantasies within its screens. I would even posit that what is described as hypermedia is about the joy that comes from virtual travel, a phenomenon that has its roots in literature, art, and the relationship humans have always had with technology. (This argument might encourage critics and analysts to look at the origins of writing, storytelling,

and the mapping of technology onto human bodies and into human fantasies from a different perspective.)

What does it mean to suggest that players inhabit the screen? Is the bridge among fantasy, screen, and reality such a flimsy one? Or have gamers understood that the distinction itself has never been as useful as their culture and society would like them to believe? From the very beginning of the cinema, for example, screens were used as vehicles to draw audiences into other worlds. The fascination, the sheer excitement of discovering the range, depth, and infinite storytelling capacity of the cinema has not only sustained an industry, it has transformed screens into vehicles of excitement, entertainment, and learning.

The contrasting popular cultural complaint has been that viewers are victims of this process—the common argument, for example, that violent games produce violent children. I believe this point of view to be fundamentally incorrect although I am fascinated by the way it resonates as an explanation for many social ills and how it leads to all sorts of conclusions about the "value" of games, if not of the value of popular culture itself. The arguments about violence are weak in large measure because there is no way of specifying *exactly* which part of a story or a set of images has a particular effect or whether the cumulative impact of images can be measured.

Within all of this, the power to control what happens on screens, to change and transform the aesthetic of screen-based experiences has more often than not been made possible by the attentiveness of creators and producers to the needs of their audiences. Western culture has built up a vast inventory of what works and what doesn't. In this respect, gamers are and have been interacting with computer games using a vast repertoire of already existing abilities and knowledge. The tone, design, and direction of computer games have been set by a host of cultural assumptions driven by the audiences that use them.

It is nevertheless important to understand that players cannot change the aesthetic of individual games unless they become the authors of the code that organizes the game's orientation, direction, and content. The movement here is along a trajectory of participation at the level of the game itself to influencing the design and appearance of the game in its next version. By now, there are many generations of games; the surprise is that there has not been even more inventiveness, more new interfaces, and more new ideas about the worlds that are generated (Schleiner 1998). Perhaps these are limitations that cannot be overcome unless screen interfaces change. The biggest challenge facing gaming companies is that they need to create more complex operat-

ing systems (game engines) for the games, which may work against transparency and simplicity. There needs to be a synergistic relationship among code, game, interface, player, and design.

Ironically, ever larger screens still remain enclosed by frames, and this may preclude the simple movement from game experience to total virtual enclosure. Perhaps this desire for the immersive experience is not as much about mastery as it is about the very character of the technology itself. In other words, the technology (and not necessarily what it does) may be the real attractor here. Immersion makes an assumption about human experience that is verified by reference to the technology itself. At the same time, flight simulators, for example, come as close to the "real" thing as is possible. American corporations now spend over $10 billion a year on three-dimensional design for a whole host of military and nonmilitary applications. Most areas of product design use digital tools to achieve their goals. *Ultima 2 Online* promotes itself as one of the most "amazing" immersive experiences in the game world, and this is largely based on assumptions about immersion. Immersion is a trope for the experiences of virtual space. Those experiences are framed by interfaces, which means that highly mediated and organized *metaphors* for seeing facilitate and encourage users to feel as if they are inside images. Ultimately, these virtual environments can only be visualized through representations, and the experiences can only be validated if participants have the will to do so. In other words, virtual spaces have no ontological foundation, and claims that suggest participants are capable of entering into virtual spaces are more than likely claims about the strength of interfaces than they are about human experience. This would even apply to the use of tele-immersive tools for medical purposes. The ability of doctors to engage with these tools will be largely dependent on the ability they have to learn how to use the interfaces that link them to patients in remote locations. The notion of presence, so crucial to games as well, is about a mental act of will to try and overcome the lack of immediacy. This requires imagination as much as it requires "presence." The confusion here is how to distinguish among the use of the tools, experience, and interpretation. Virtual spaces are, by themselves, not the medium of communications. Rather, virtual spaces are the context within which a variety of image and sound-based media operate. And participants, in ways that cannot be extrapolated from the technologies, will determine the effectiveness of those operations.

Unlike the cinema, which borrowed freely from photography, theatre, opera, music, and other traditions and media, computer games have evolved as a result of their interaction with the history of games and vari-

ous forms of cultural expression. The games have been designed using categories that have links into the history of stories but not into the artistic traditions for the creation of those stories.

Many of the traditions being drawn upon are essentially linked to the capacities of the technology, which is perhaps why so many games try to generate role-playing situations and simulations. So when the creators of *Ultima 2* suggest that gamers can become a "master craftsman" or a "monster" or an "expert weapon smith," they are suggesting that gamers can learn to accommodate the fantasy process by reveling in their actualization of it, as well as in the immersive space that *Ultima* has created for participants.

The technology disappears so that participants can also disappear into their imaginaries. The embedded chip may well be within humans as well as outside of them, which ironically was a recurring theme of the television show *The X-Files* over a number of seasons. An important feature of *Ultima Online* is found in the many contacts people make with each other outside of the game context through conventions and other public events. This further extends the boundaries of the virtual from one context into another.

I regard the period of aesthetic experimentation in video and computer games to be in its early phase. This phase has been characterized by the incorporation of traditional styles, narrative structures, and themes into the particular look and feel of simulated gaming spaces. At the same time, an understanding of the particularities of space and time that characterize the way the games and their participants orient themselves within the screen environment is still being developed. Some of what is now going on could be described as reverse engineering. A computer animator creates an artificial world of fish in a pool. He programs them to act like real fish by first filming fish in their natural habitat. He creates his graphics by developing the drawings from the originals and then regenerating three-dimensional models with richly endowed computer-based colors. He then lets the digital fish play in their digital pool and films their behavior for a fishing game.

"A virtual world is an Internet community where thousands of players simultaneously live out fantasy lives in an everchanging virtual environment.

ORIGIN created the virtual world game genre in 1997 with the launch of Ultima Online, which has sold over 1 million copies to date.

Four years after its launch, *Ultima Online* still is growing and has more than 225,000 active players who spend an average of between 10–20 hours per week immersed in the land of Britannia and the virtual world of Ultima Online" (*Ultima 2* 2002b).

As Dimitri Terzopoulos (1998) puts it: "Rather than being a graphical model puppeteer, the computer animator has a job more analogous to that of an underwater nature cinematographer. Immersed in the virtual marine world, the animator strategically positions one or more virtual cameras to capture interesting film footage of the behaviors of the artificial fish" (71). The increasingly complex mediations here suggest that the creative process of producing virtual spaces has moved beyond artifice into new kinds of physical and mental environments with radically different ways of using time and dramatically new ways of envisioning the role of sight and the human body.

For example, how do participants deal with the normal sensations of space in a snowboarding game that puts them face to face with a screen large enough for them to "locate" their experiences on a mountain? The speed of descent increases with each shift of their bodies, but clearly there is neither a descent nor real speed being reached here. An argument can be made that the space being entered is an inner one, located, if that is the word, within a highly contingent imaginary sphere. This brings the body of the "player" into close contact with emotions that are linked to the "descent" even if the boundaries of the experience are ultimately of a hypothetical nature.

Here is a wonderful irony. Most games of this sort reside in a theoretical world in which a variety of hypothetical possibilities are continuously tested. The excitement and adrenaline come from the process of testing many of the inner states that are suppressed when people are on the mountain itself, as well as learning the new sensations of space and time that come with telesnowboarding.

On the mountain, the testing must be approached with great care or the player will lose his or her concentration and take a tumble. The beauty of playing at snowboarding, in an emporium devoted to virtual games or at home with a large screen and rap songs blasting over the sound system, is that players can simultaneously focus on all the elements of being within and outside the experience. This is one of the reasons why a player's sense of space is transformed. In order to really play this type of game, the participant must learn its rules and the expectations that have been built into its structure. Telepresence is about the creation of new aesthetic forms driven by photorealism and efforts to link human physical movement with responsive screen environments. In other words, telepresence is not an easy process in which to enter, nor is it foreign to other strategies that have been developed to play within any number of imaginary and real spaces.

Depending on one's perspective, these imaginary places are often miniature models of hypothetical worlds that players are asked to inhabit. The

jump from presence to telepresence may be the only way to sustain the hypothetical relationship that players develop with the gaming environment. Telepresence is about playing with contingency, about the joy of testing and challenging oneself as if everything and nothing were at stake.

From an aesthetic point of view, the graphical interfaces that are designed to contain these worlds must increasingly be created according to their own rules and must allow players a smooth transition from one state of mind to another. I watched a young boy lie down on a virtual hang gliding machine at a games emporium and loudly gasp at the vista presented to him. He transited with great speed from the real to the virtual. The key word is *transit,* which means that no one could, by observation alone, fully understand how he had prepared himself for the experience or what he went through. Presumably, he had a sophisticated enough Nintendo machine to have already accepted the process of modeling, and the jump to hang gliding was merely one of many steps that he had already made in his exploration of virtual spaces and simulation.

A game is just a representational data structure with thousands of variables built into it. This structure makes it possible for certain "events," for the actual modeling, to take place. But how does that structure make it "feel" as if the screen were a useful and exciting place to create and sustain the intense relationships of a game? Can new ideas appear within this structure if the information at the core of the game is carefully organized to represent a particular design and form? These are crucial questions that require further research into the ways computer games have evolved and the synergies that have been created between images and playing.

Three-dimensional screen worlds are built on a two-dimensional foundation. The markers within those worlds must be clearly understood in order for participants to wend their way through the spatial architecture. Those markers are oriented toward simulated experiences, but what does the word *simulation* actually suggest in the context of a game? Does it imply a direct relationship between the events of the game and the world of the player? I think not.

Simulation is about a world that has a measure of autonomy built into its very grammar, but that autonomy is illusory. In simulated environments the programming can make it possible for independent choices to be made by players or users. Players use their senses in so many different ways that part of the challenge is to integrate the intensity of playing with enough self-awareness to maintain some control. This suggests that the ability to use visual signs and cues is as much about the intersections of popular culture and

simulation as it is about already existing "bodies" of knowledge. As the body is transformed into digital characters capable of doing anything within the limits of the screen and within the limits of the interface, players experience a rush of power (as in the game *Grand Theft Auto 3*).

The process of getting into the games is related to the amount of time it takes to train oneself in all of the characteristics of the simulation. Perhaps this is what permits, if not encourages, the ease of movement from physical presence to telepresence. One has to be careful because simulation seems to suggest a loss of self, or a loss of control over what one defines as real to oneself. Clearly, the feelings associated with simulation are powerful. But they are limited by the interfaces and by the fact that there are always mediators among experience, fantasy, and simulation.

Could it be that the games reflect the cultural move from sensate experiences to mediated screen-based relationships? Could it be that the structure of these experiences has legitimated the ways telepresence is now accepted as an experience worth having? It may be the case that a generation that grows up with avatars, intelligent agents, and substitute worlds will lose interest in the distinctions that I am drawing here.

The flatness of the screen encourages the transposition of the games into arcades and the production of as many related toys, figurines, magazines, and texts as possible. (Books about *Myst* and *Riven* have sold hundreds of thousands of copies.) The exigencies here are not only market-driven, but the electronic pets, Playdiums, IMAX rides, and so on, are symptomatic expressions of the need to somehow bring screen experiences to another level that actualizes the physical traces of sensation even as these processes loop back again into the virtual. There could be no better evidence of the unity of these experiences than the virtual emporia I have been discussing and the increasing presence of large screen-based entertainment centers in the home.

From an analytical point of view, this once again highlights the gradual manner in which a variety of mediations support a structure that includes many levels of the real mixed in with artifice. The artifice is permanent scaffolding for buildings that will never be completed. Players don't like it when characters are killed off and can't return, because players want to keep constructing and reconstructing the scaffolding. It may be that this restructuring is actually the physical underpining for interactive processes.

Gamers discuss the interaction of the physical, visible, sensate, and screen in a holistic manner, which suggests that they are talking about a co-evolutionary process. The games evolve as players collaborate with them. Such interactions generate increasingly complex levels of play. The various compo-

nents of a game, from setting the scene (exposition), facing a variety of crises, encountering obstacles and overcoming them, resolving problems and then completing the game by outwitting its structural constraints (coding), are all about the use of surrogacy to gain control over virtual environments.

All the dimensions of interaction, experience, and reconstruction that I have described and analyzed in this chapter are part of an unfolding world for which there are only temporary maps. For cultures that have been attuned to permanence and the need to preserve artifacts and experiences, this fluidity poses many challenges. Computer games are pointing toward a new process of engagement with image-worlds. At the same time, as part of the living archeological process that I mentioned earlier, all the layers of previous forms and experiences remain in place. This is as confusing as it is enticing. It could also be the site for reenvisioning the relationships humans have with the technologies they are creating and using. Crucially, computer games signal how important vantage point is, because without some perspective on subjectivity and identity, image-worlds make it appear as if players are not at the center of game experiences. The mediations among images, experiences, and players suggest a struggle with what intelligence means in digital environments. The concluding chapter of this book examines the implications of "reanimating" the world inside hybrid image spaces.

CHAPTER NINE Reanimating the World: Waves of Interaction

Although still in their infancy and specialized in their fields such as telecommunications and computer based technologies, it is becoming more and more clear that interactive technologies are not just another interdisciplinary approach. In the emerging fields of Interactive Computer Art and graphical computer science, art and science increasingly influence and fertilize each other. Results can be applied not only to engineering, research and technology, but are significant for art and the discourse of art as well.

— Christa Sommerer and Laurent Mignonneau, "Art as a Living System: Interactive Computer Artworks"

A central theme of this book has been the relationship between machines and human beings. I have also been exploring an intuition that digital technologies are contributing to the reinvention of human identity and the meaning of human subjectivity. I have made the claim that digital technologies are pointing toward a lengthy process of *fundamental* cultural and social *transformation*. The term *Zeitgeist* provides another way of thinking about the spirit of the times or the spirit of this age. This culture is not merely extending previous technologies, lifestyles, and survival strategies, but is involved in redeveloping some of the most basic notions of what it means to be human and how humans organize themselves with particular reference to the technologies they use and the communities they live in.

This continues to be a challenge to many core values, particularly in Western countries, at a time when it may not be that easy to explain why the changes are happening and if the changes are in everyone's best interests. Katherine Hayles discusses this shifting mind-set and its impact on the ways meaning and messages circulate in our society. She explores the confusion between information and materiality, an issue that I dealt with earlier in my discussion of Claude Shannon and his research in the 1950s (Hayles 2000).

The notion that information can be disembodied and can function in a dematerialized way is a trope of tremendous power. It makes it seem as if meaning were merely an add-on to technology and (as I mentioned earlier) the "pipes" used for the purposes of communications and exchange are the "medium," and therefore the message. In the process, human subjectivity, desire, and imagination are transformed into terms like "user" which, as I mentioned in the introduction, cannot account for the complexity of human-technology relations. There is a danger that the human subject will become an add-on to what digital technologies provide and that human beings will end up as translators of information, navigators rather than creators.

Hayles discusses the dissolution of the human body into a network of data and information, and the problems that arise when the human body is thought about as a series of codes, genes, and signals. What does it mean to decode the human genome and to think about human biology as if it were a system of information? The innovations in genetics and technology and the changing landscape for the production of media means that there is a need to find new *discourses* to understand these transformative forces and their effects (Hayles 1999; Sheehan and Sosna 1991; Feigenbaum and Feldman 1963).

The challenge is that even though information circulates in a disembodied fashion, and even though there is a constant tension between the way information is received and thought about, meaning is never absent. Rather, meaning is both within the apparatus of transmission and in the process of exchange between machines and humans. Even the simplest information protocols are governed by assumptions that are cultural and specific to the purposes for which they were designed.

To make matters more difficult, there is often some confusion as to the differences between data and information. Data is seen as "raw" information, waiting for interpretation and categorization, while "information" seems to be more articulated and therefore closer to what is generally meant by knowledge. As I discussed earlier, at a symptomatic level, the conflation of levels here is a sign of transitional changes in the ways human experience and memory are viewed, and this includes the understanding of embodiment. The use of algorithms to encode the processing of information (even when those algorithms are generated by machines in an autonomous fashion) is never simply a matter of technique (Smith 1998).

For example, irrespective of the fact that a digital image is just a collection of 1's and 0's that flow through circuits at high speed, images are meant to retain and have enough qualities to be viewed. The mathematics of digital construction aside, the purpose is to create objects for vision and possible visualization. At this stage, digital artifacts are being approached and used as if they had a level of autonomy that is far greater than is actually possible. It is as if the material basis for the operations of digital machines had been metaphorically sidelined to confer greater power on them. Yet, they remain extremely fragile instruments.

For example, dates are important features of programming. The recent problems with the year 2000 aside, computers would have a hard time being effective if their dating systems were to collapse. This is also why the internal clock of a computer is fundamental to its successful operation. Spill some coffee on your portable computer or drop it and the physical context of casing and chips comes into sharp relief. How is plastic molded into the shape of a computer? How are screens built? The various minerals that are crucial to the operations of a computer still have to be mined from the earth. The "body" of the computer has these and many other constraints.

The question is, why would the notion of information as autonomous and consequently not linked to context become such a powerful metaphor? The answer can be found in a confusion of levels. Algorithmic codes may be

mathematical and therefore abstract, but the circulation of codes is governed by many different conditions, the most important being the context of use. The pragmatics of communication processes is ruled by the limitations that humans have by design or accident included in the technologies they create. It is amusing, yet also ironic, that "hard" disks have a limited lifetime and that storage devices from the 1980s contain information on them that is almost impossible to recover because they are incompatible with present-day technologies. This built-in obsolescence is as much about information as it is about the changing circumstances and context within which information can be extracted and displayed.

Mind / Memory / Visualization

In previous chapters, I discussed the different ways in which particular models for mind and consciousness have become dominant in engineering and computer science circles, and this led me to counter that perspective by talking about visualization as a central characteristic of human interaction with digital technologies. Visualization is very much about embodiment and the transformation of information into knowledge and understanding through human activity and the conversion of information and knowledge by humans into material and aesthetic forms. The scientific depiction of subatomic matter also requires extraordinary levels of visualization. Visualization is not just about the creation of artifacts, but it is also an essential internal characteristic of human thought processes and an important way to picture human experience (Tufte 1990).

Another approach to understanding this point is to refer to nineteenth and twentieth century concepts of memory and perception. If human memory is simply seen as a storage device, then perception becomes a mode of internal and external retrieval and response to external events. (This is where mechanical models of mind link up with engineering precepts and make it appear as if consciousness is one of the many readable devices that make up the human body.) Gerald Edelman (2001) says it well:

To say, as is commonplace, that memory involves storage raises the question: What is stored? Is it a coded message? When it is "read out" or recovered, is it unchanged? These questions point to the widespread assumption that what is stored is some kind of representation. This in turn implies that the brain is supposed to be concerned with representations, at least in its cognitive function. . . . In this view, memory is the more or less permanent laying

down of changes that, when appropriately addressed, can recapture a rep-
resentation—and, if necessary, act on it.

As Edelman suggests, the processes of interaction among brain, mind, and world are never as direct or even as understandable as might be desired. There are so many ambiguous points of connection and disconnection that any assumptions about perception and memory must be carefully contextu-alized. Edelman proposes that human memory is essentially nonrepresenta-tional. This raises the levels of complexity of human-cultural interaction even further, because it suggests a far greater degree of autonomy to the opera-tions of mind than notions of input and output can account for.

There are no simple codes at work when humans interact with images, their culture, each other, or their surroundings. This is why I have stressed the notion of visualization (with particular reference to what humans do), which is about creating as well as responding, generating as well as recognizing the intersections of knowledge, information, and thought. Visualization takes many forms. In particular, the activity of engaging with image-worlds means that viewers, at a minimum, share the psychology of viewing with each other even if they have very different experiences. The crucial point here may be that images are not just information. If they were, then the tasks of viewing and interpretation would be simple and relatively direct. The rich diversity of image-worlds means that visualization is simultaneously a part of the per-ceptual realm and the thinking mind. Simple methods of organizing informa-tion will not solve the complexities of interaction between humans and images.

The test becomes to find the common ground upon which people can share the visualizations with which they engage. This is the real challenge for interactive technologies, and, as I discussed in chapter 8, the gaming community is beginning to find solutions through some very inventive and sophisticated strategies in their use of two- and three-dimensional spaces (Pearce 2002).

At the same time, visualization allows for extraordinary leaps of imagi-nation, impossible juxtapositions of the real and the surreal, and the integra-tion of fantasy and reality. In some respects, the plasticity of digital images brings images closer to what can be done with language, poetry, and speech. P2P communities are the collective example of efforts to create flexible lan-guages of communication that are not singularly or solely reliant on speech and text, but make use of the potential of images and sounds for exchange and interaction.

Think of visualization as a combination of perceptions, thoughts, day-dreams, and projections. When a child listens to a story, the full force of this rather hybrid and unpredictable process is applied to visualizing the elements of the narrative. This has as much to do with the veracity or strength of the representations in the story as it does with the listener's capacity to use his/her imagination. It has a great deal to do with the flow or continuum of relationships that are established to link the voice of the narrator to the images in the story. Most importantly, the listening activity is converted into what I have referred to earlier in this book as reverie.

Reverie is a crucial concept that explains how the experiences of interacting with images and stories of all sorts connect to listening and daydreaming. Reverie is a reflective process that allows for what I call "waves of interaction." This metaphor refers to the complex movements of waves on a beach as viewed by human subjects. Although there is regularity to the movement, waves come and go with different heights, different intensities, and, depending on the weather, radically dissimilar sounds. There is both predictability and unpredictability, and humans interact with waves in any number of ways from gazing at them to touch and immersion (Calvino 1986).

It must be remembered that gazing is not the same as looking. To *gaze* is to scan, while to *look* means that an effort has to be made to focus on some features of the environment being observed. (My use of gazing as a term is marginally related to its important role in film theory.) Gazing is more of a background activity, while looking is more related to an effort to understand the foreground—this ranges from the immediacy of what is happening to more consciously engaging with the consequences of having looked. Reverie as a process is like opening and closing many different doors into the foreground and background of gazing, allowing thoughts and images into the mind and simultaneously projecting outwards. None of these activities need be logical; much of this process works through analogy and inference.

As viewers gaze, look, and think, inner and outer cease to be divided. Boundaries dissolve, and new boundaries are created. There is as much mystery in this engagement as there is clarity, which is why reverie is such a rich encounter with the world. The links between reverie and visualization are not linear. Each suffuses the other as reality shifts fluidly between the senses to daydreams and then from sleep to dreams.

As I mentioned, the plasticity of digital images and the digital world means that many facets of looking, listening, and gazing can be shaped into aesthetic forms. This is a frontier that is only now being breached and within which accepted conventions of communication are a passing reference point

for greater efforts at exploration and transformation. Traditional notions of representation no longer carry the same force as they did in previous historical periods. It is also a frontier in which it is difficult to retain conventional notions of classification since not only have the materials of information and exchange become more flexible and variable, the designative power of language has shifted.

There is a fundamental difference between what I have been describing and conventional notions of information visualization within the computer sciences.

Information visualization combines aspects of imaging, graphics, scientific visualization, and human-computer and human-information interactions, as well as information technology. Unlike scientific visualization, information visualization focuses on information that is often abstract, thus lacking natural and obvious physical representation. A key research problem for information visualization designers involves identifying new visual metaphors for representing information and understanding the analysis tasks they support. (Gershon and Page 2001, 33)

The goal of Gershon and Page's research is to bring the representation of information together with human perception. Visual metaphors in this context are designed to service and strengthen the relationship between information and experience.

The process of visualization that I am talking about is far less direct and involves more implicit and often oblique processes of thought, knowledge, and interpretation. What happens when any object in the world can be reproduced with great fidelity and at the same time "recreated" with almost no reference to its origins? What happens to the discrete and quite particular ways in which language is used to describe the world, when the transformative possibilities of digital technologies outpace, even outrun, the human capacity to organize information and knowledge into a coherent pattern?

Surrealist poets and painters of the early twentieth century dreamed about this fluidity, this latent, almost inherent instability—to destroy reference and recreate the world using different mediums—to leave the world behind so that it could be reinvigorated and renewed. Now these dreams can be realized by anyone with a computer and some graphic software. The difference is that the Surrealists used poetry, painting, film, and theater to make their outlook on the world concrete and visible. Digital technologies allow for an eruption of the imaginary into nearly everything (this is the true meaning of

plasticity), and this means that truth has become an increasingly relative concept, based more on context than on anything absolute.

This has important consequences for aesthetic exploration and creativity within digital environments. In fact, it is animation that is providing some of the most interesting examples of this shift to greater and greater plasticity.

Reanimating the World

The growing importance and increasingly sophisticated world of digital animation is one of the essential components of digital culture. In fact, it is crucial to recognize how important animation has become not only as a tool of expression but also as a guiding metaphor for new ways of visualizing the world and dealing with its material characteristics. To varying degrees, analogue forms of animation have not disappeared. Rather, the foundations for the plasticity, which I discussed earlier, were put in place during some of the most exciting experimentation in the history of the cinema. (Méliès's films explored the outer edges of the surreal and real in the late 1890s.) Those experiments have been transported to the digital world with great effectiveness.

For example, the Dreamworks movie *The Prince of Egypt* retells the biblical story of Moses and the exodus from Egypt that many people in North America and elsewhere not only know but also refer to in their daily lives. Its mythic qualities are so important that the idea of making yet another film about this story seemed, when I first heard about it, to be quite unimaginative. Then, I had the opportunity of visiting the Dreamworks studio and looking at the drawings, cells, and story line of the film. There was more going on than a retelling of the conventional narrative. In fact, to varying degrees, the effort to produce the film had moved from its origins as myth into a context created by the exigencies of combining digital and analogue images. The pressures of "animating" a world that no longer exists and providing the animation with enough strengths to make the experience of viewing a pleasurable and productive one entails the creation of a relatively autonomous production environment. This is also the case with computer games. To some degree, *The Prince of Egypt* is a hybrid production because a great many of its features could not have been developed without digital technologies. But rather than simulate the Egypt of old through the careful use of three-dimensional space, the film opts for a flat, almost hieroglyphic and painterly look. At the same time, the *mixture* of cell animation and three-dimensional computer-generated images creates a level of cinematic realism that has a far less synthetic look than animated films made entirely with digital means.

At Dreamworks there was palpable excitement about *The Prince of Egypt* project. Individual artists, designers, illustrators, directors, animators, sound technicians, and producers had spent months developing the orientation and structure of the animation. The intensity of feeling was so strong that every discussion of the film was heightened; overstatement and hyperbole were the norm. I was told that the more people work together as a group that knows it will be successful, the better prepared they are to weather the storms of dissent and disagreement that develop among them. Equally, the excitement and hope they are on a winning team motivates them to a deeper and perhaps more absolute commitment to the project. It is significant that these processes are rarely visible in the result.

This environment, ironically called a studio (a word that means both a place of study and the effort to apply study to a practical task—hence, its use in the world of painting), has to develop its own rules and its own specific practices and language. As I was taken through the hallways of Dreamworks, I sensed the extraordinary separation of the animators and their producers from the world outside the studio. I found that this sense of autonomy was comparable to what happens in a scientific laboratory with researchers working on a variety of problems that may only intersect with the real world after many years of investigation.

This is such a crucial point that it warrants further explanation. Much of the romanticism attached to studio work is related to the idea of autonomy (hence the notion of reanimating the world). In a separate environment anything can happen, and that separate space often looks very attractive to outsiders. The process of creative engagement with researching ideas and creating animated films, for example, does not by itself constitute the autonomy that I am discussing.

It is a culture of place—a culture that encourages a film or gaming studio to develop an entire repertoire of activities and levels of human interaction that take on a life of their own. (Electronic Arts, which is the largest game production company in the world, has prioritized the development of an enriched internal culture to facilitate exchange and creativity. The studio in Vancouver is structured around play, work, and shared events among employees.)

The challenge to the studios is that the products of these processes are then disseminated and distributed to the public. There is no easy or transparent link between what has happened in the studio and what the public does with the results. This is why so many films fail even though the internal culture of the studio promotes success and supports the fantasy that success is likely. This is also why the costs of production are so high because

overidealized aspirations for success have to be incorporated into the costs from the start.

I am talking here about what Bruno Latour (1999) has described as a chain of mediations that become increasingly autonomous and sealed off from everyday realities. This is accentuated even further as more and more of the animation work is shifted to computers. For example, one of the most startling aspects of digital animation studios, such as Pixar and Mainframe Entertainment in Vancouver, is rendering farms. (Rendering is the process that translates all of the information in an animation file into single or multiple frames.)

I visited the studios of Mainframe Entertainment in Vancouver, which produces a variety of short and feature-length digital animated films. The studio is made up of a series of rooms with computers, sound studios, and editing rooms. Everything feeds into a rendering farm of approximately one hundred Silicon Graphics hard disks, each of which is networked and all of which are used to store image files that grow in size through the various stages of digital animation.

Unlike Mainframe, the Pixar studio I visited has as many spaces devoted to traditional drawing tables as it does to computers. The rendering farm at Pixar is one hundred times as large. And, although Pixar is a pioneer in digital animation (*Toy Story*), the actual creative process it follows is more like traditional animation than one would imagine. The process includes the development of storyboards, drawing scenes, settings and characters, and shooting video of the drawings to get a sense of the personalities of the characters. Most important, animators must pitch their ideas and narratives to a critical panel of producers. The drawings are also scanned so they can be studied and prepared for the transition to movement. Eventually, if the pitch is accepted, the material is moved from a two-dimensional into a three-dimensional space. From this stage onward everything moves into a digital environment.

Pixar's animators neither draw nor paint the shots, as is required in traditional animation. Because the character, models, layout, dialog and sound are already set up, animators are like actors or puppeteers. Using Pixar's animation software, they choreograph the movements and facial expressions in each scene. They do this by using computer controls and the character's avars [avars are hinges that allow characters to move] to define key poses. The computer then creates the "in-between" frames, which the animator adjusts as necessary. (Pixar Studios 2003)

On average it takes six hours to render one frame of the material the animators have developed. What is interesting here is the extent to which the process is industrial and creative, profoundly internal but also with the checks and balances needed to stay hooked into the market.

However, the assumption is that production in the studio will lead to audience or at a minimum to some recognition in the public sphere. The process of creation and production is itself so multilayered that it is unclear how the connections can be established which is partially why there is so much reliance on the marketing and distribution departments. This is a richly mediated activity, which precludes a simple connection among story, film production, and audience. In fact, this recasts the ways stories are told within contemporary culture.

Without going into too much detail here, the marketing system that has been developed in the arts and popular culture and in other areas is largely the result of these often contradictory mediating elements at work. The effort is to try to understand and find the measure of the audience so there will be a reciprocal relationship between what is produced and what is understood and bought. The information that is gathered is fed back into the production system, which is why the pitch for every film makes it appear as if each were a winner. (Most films do not make a profit.)

In some respects these gaps and contradictions are nothing to worry about. They reveal the extent to which audiences must *learn* about the process, breaks, and fissures as well as solidity that result in the final versions that they see.

The autonomy of the studio process means that outsiders have to learn how to open the doors onto what is expected of them and what they expect from themselves. The outcomes from this continuous engagement with exchange, communication, and interaction are never clear. These are what Latour calls "gnarled entanglements." They are fundamental to the way culture works. Nevertheless, they do not really point to a simple set of causes that might explain or even clarify the operations and impact of cultural practices and products upon the daily lives of audiences. The increasingly complex artifacts produced using digital tools further complicate the learning process for audiences because viewers have to work with material that has developed its own language but still remains very opaque.

This is one of the reasons why animation is so interesting. For example, what makes a film like *A Bug's Life* plausible? The answer can be be found from *within* the structure of the film itself as well as from the audience's experience. Bugs don't speak. Yet, watching the film is pleasurable precisely

because the impossible not only happens but is essential to the structure of the narrative. (This is fundamental to analogue and digital animation.) The strength of the film is largely the result of its faithful recreation of a world that has consistency and logic. The logic is only partially derived from reality; the internal look and feel of the film come from the way in which it opens its world to viewers. In other words, the bugs are given enough characteristics and motivations that the autonomous world they inhabit can be visited *and* experienced by the viewer.

Here the issues of visualization become crucial. In order for *A Bug's Life* to retain its credibility and for the story to work, the audience must accept the internal logic of the film. At the same time, there has to be enough realism to the world that has been created to sustain its coherence. If one sees water flowing in a stream in an animation, there has to be the sense that the flow meets some minimum expectations about movement and texture (Thon and Ghazanfarpour 2002).

One of the emerging goals of narrative in the digital age is to foreground these creative processes for audiences. (This is why most DVDs include details about production and allow for and encourage insights into the production process. The DVD version of the film *Moulin Rouge* is very detailed in this regard.) Another goal is to merge animation and live-action images to achieve a more profound realism in the use of the special effects. (The film *The Matrix* is a very effective merger of animated and live-action footage.)

At the same time, the impulse to generate photorealistic effects tends to hide the infrastructure needed to produce these images. For example, the extraordinary detail needed to animate cloth as it blows in the wind pushes the relationship between effects and computer technology to its limits. The movement must appear to be natural to the object and happening in the real time of the narrative. The use of algorithms to achieve this result is where the intelligence of what has been put into the image comes into play.

In the digital world, images are not created but are mapped and generated through extensive processes of visualization and rendering. How do creators make water look like it is flowing using digital tools? How do artists generate different levels of viscosity? How do they generate light? All of these questions can be answered through the use of algorithms but are also part of the expectations that audiences have of artificial environments.

Without getting into the technical details here, it is self-evident from figure 9.1 that the need to animate movements with such intense realism is about recreating and controlling the world through remote means. It is also evidence

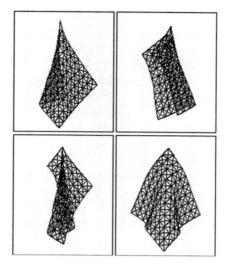

FIGURE 9.1 Scaled preparation of fabric for animation

of the increasing impact of the computer sciences on storytelling and assumptions about visualization within virtual spaces.

There are many problems and binds associated with this impulse to photo-realism. Among them is the concentration on the artifice to the exclusion of what it means to tell stories. The other is the assumption that realism binds visualization to communications. This latter problem is perhaps the most serious because it makes assumptions about the power of symbolic languages that cannot be verified. In other words, the impulse to realism assumes connections among viewing, experience, and interpretation that are not determined by the audience but by the presumed internal coherence of the technological output.

These issues are equally complex with a film like *Toy Story,* which consists of toys that are "alive." (There are quotes around alive to indicate my difficulty in dealing with terminology here. Although I am using the word *alive,* I know that it is not valid. The anthropomorphic impulse has the power to overcome the fuzzy lines of differentiation between animate and inanimate beings

and objects. Objects and icons used to be seen as distinctly different, even though religious symbols, for example, cross the boundaries between animate and inanimate on a continual basis. The conferral of life upon inanimate objects is one of the characteristics of image-worlds. The increasing plasticity of digital images and modes of viewing means that distinctions between animate and inanimate will weaken even further. This does not mean that inanimate objects will somehow develop intelligence, but it does suggest that intelligence will increasingly become a distributed phenomenon.)

In *Toy Story* there are few claims to realism other than within the internal organization of the story. In *Toy Story* the issue of whether toys talk, walk, or feel disappears within a few minutes of the film's beginning. Audiences are able to imagine and experience the scenes and events inside a world that does not exist. This leap of imagination is transformed into a series of perceptions of space, time, and narrative that have coherence only because viewers are ready to accept all the limitations, not necessarily because of technical prowess.

The degree to which the viewer is able to enter the world of *Toy Story* is the result of a longterm learning process that begins in childhood. The role of make-believe is important here (Walton 1990). It is therefore crucial to the success of *Toy Story* that it transforms those objects of childhood pleasure into living creatures: "In order to understand paintings, plays, films, and novels, we must first look at dolls, hobbyhorses, toy trucks, and teddy bears. The activities in which representational works of art are embedded and which give them their point are best seen as continuous with children's games of make-believe. Indeed, I advocate regarding these activities as games of make-believe themselves" (Walton 1990, 11).

At first glance, Walton's statement seems to be simple and direct. Yet, the world of make-believe is complex precisely because of the human imagination, and very little is understood about how minds interact with and create the possibility for imaginary leaps of thought and reflection. In my discussions with animators at Pixar, producers at Dreamworks, and computer and video game creators at Electronic Arts, play was discussed but generally from the perspective of the adults or young adults who had created either the animations or the games. However, at no point did my interviewees ever talk about representation as a way of generating make-believe worlds. Instead, they continuously referred to the games and animations as *places* they were building, and for them the worlds they were creating were very real.

This was a necessary *condition* for the productions they were engaged in developing. Most of the projects had been mapped out in blueprints—

specs—in a fashion not dissimilar to what architects produce for buildings. The specs were vast and diagrammatic. At Dreamworks, the specs for *The Prince of Egypt* were all over the walls of their temporary studio buildings. Every part of the studio visualized Egypt and the plot of the animated film. This is a wonderful example of the way in which visualization works as a foundation for the development of stories. Something completely immaterial is given materiality, which is one of the most important functions of creative practice and engagement.

As autonomous as the visualization process is in the studios, visualization always involves the audience either as a potential interlocutor during the creative process or as an actual participant when the film is finally distributed and disseminated into the public sphere. Visualization allows creators and viewers the chance to share each other's passions, which is why audiences can become so profoundly engaged with the stories they hear or watch or the games they play.

Another aspect of visualization is more ephemeral. When viewers, users, or creators look at a screen or images or listen to stories, there is a division between the experiencing subject and a part of the self that is contemplating the entire event. Even in those instances of profound absorption, viewers are quite capable of pulling away or at a minimum contextualizing the experience. One concrete way of thinking about this is to examine how television is watched. As I mentioned in chapters 1 and 2, contrary to popular myths about couch potatoes and other such reductive descriptions of television viewing, I would suggest that television promotes a struggle between attention and reverie (Crary, 1999).

According to Gaston Bachelard (qtd. in Crary 1999), "Reverie bears witness to a normal, useful *irreality function* which keeps the human psyche on the fringe of all the brutality of a hostile and foreign nonself" (102). Bachelard refers to the encounter between control and loss of control—the sense that as attractive as a show might be, there is always a limit to what is acceptable and what isn't. He also refers to the eruption of desires that viewing engenders. When viewers watch a thriller on television, do they know or can they anticipate what their experience will be? Doesn't part of the excitement come from simultaneously not knowing and knowing what will happen? On the one hand, they enter and sustain the experience because of a desire to engage with narratives; on the other hand, there is a need to disassociate or distance themselves from what they are watching.

This is not a simple opposition. Rather, in order to feel in control of the emotions and one's status as a viewer, what Crary (1999) describes as a prac-

ticed "disassociation" comes into play. And I use the word *play* here in order to emphasize the relationships among viewing and engaging with games and other forms of play. The significance here among play, games, and viewing is part of what makes all forms of engagement with media and culture interactive. This is why it is possible to establish an intimate link with images and to confer a great deal of intelligence onto them. It also begins to explain why animation, a medium that works *because* of the obviousness of its artifice, is so attractive. This juggling of involvement, disassociation, and play is also why the hyperlinked qualities of the World Wide Web continue to attract users, navigators, and readers.

However, a good deal of the work of interaction is being sustained *within* the viewer or user. None of the media that I have mentioned, including games, allow fundamental changes to occur in their structure, although computer games go the furthest with enough variables incorporated into the games to encourage a wide number of possible choices by users. The user, however, cannot rebuild the game from scratch. The variables are there to generate the illusion of choice. I asked the former head of Dreamworks Interactive and now an important figure at Electronic Arts whether this illusion worked against the interactive goals of the games created at Electronic Arts. He responded that as long as the gamer is not aware of the constraints, it "feels" like all of the variables are open and can be changed. Interaction means negotiating with and through all of these elements, but it does not involve a redesign (Glenn Entis 2002).

In *Toy Story* there are close to sixteen-hundred shots, and as Burr Snider (1995) says:

Each one of the movie's 1,560 shots was created on Silicon Graphics and Sun workstations by artists working from some 400 computer-generated mathematical models and backgrounds. The shots were then edited using Avid editing systems and painstakingly rendered by powerful Pixar-developed RenderMan software. (That software consumed 300 Mbytes per frame, provided by 117 Sun SPARC 20s. Four years in the making, the 77-minute film required 800,000 machine-hours just to produce a final cut.) (P. 2)

Detail is not the only goal here. According to John Lasseter (qtd. in Snider 1995):

Key to the entire process is a Pixar-developed program called Menv (Modeling Environment). Nine years in the making, Menv is an animation tool used

to create 3-D computer models of characters with built-in articulation controls; these controls enable the animator to isolate specific frames of a desired motion—the hanging of an elbow, say, or the movement of lips to match dialogue—and then leave it to the computer to interpolate the whole sequence of animation. (P. 3)

This passage reveals the degree of integration between technical requirements and narrative structure and photorealism. Much of the integration is based on the filmmaker's need for internal coherence of motion and character modeling premised on the idea that stories cannot be told without a balanced relationship between technique and action. More often than not, the complexity of modeling for digital animation and the powerful array of computers that are needed for rendering scenes overwhelms narrative detail. This means that the "surface" of the narrative has to move along at a fairly quick pace, which is why so many digital animations are action-oriented.

This does not justify or fully explain the lack of interesting character development or the rather stereotypical stories. Rather, it indicates the relative lack of maturity of the medium, as creators struggle with its aesthetic and its capacity for narrative. At the same time, what must be understood here is that the dependence upon and celebration of technique is crucial to the excitement surrounding digital animation. There is similar excitement about the integration of digital techniques into films that use live actors. The *Star Wars* series is an excellent example of this evolution.

The "virtual camera" is an important element that is a consistent part of all digital animation Scenes are set up and organized in three-dimensional spaces so that creators can, so to speak, look through the lenses of a virtual viewfinder. They can move through the space and make judgments about the position of characters, lighting, and sets. The virtual camera generates a simulation that allows for movement and tracking, which duplicates what would happen if a real camera were used. An assumption is made about the physical laws that govern the motion of people and objects, which then organizes how the virtual camera "sees" the world.

This is done through algorithmic means, but the simulation is effective enough that animated characters can be "directed" in almost the same way as live actors. There are many intermediate levels that are followed before arriving at this stage, including the use of storyboards and drawings to "visualize" the characters, setting, and action. The crucial point is that visualization crosses the boundaries of creative engagement and the engineering

principles behind everything digital. To reanimate the world, animators need far more than just a few special effects.

Final Fantasy, Waking Life, and Emergent Forms of Animation

What happens when an entire film depends on digital characters? This is one of the questions posed by *Final Fantasy: The Spirits Within,* which appeared in theaters in 2001 (Brooks 2000). What kinds of stories can creators tell when animated actors who look very human, who walk and talk like humans, are the foundations for a narrative? *Final Fantasy* begins with a dream that takes place in a landscape that replicates many science fiction films of previous eras. At first, the viewer sees an eye, then the landscape, and then the sun. Suddenly, the main character Aki sees herself in a pool, and the dream ends with the words, "Dream Recorded, December 13, 2065."

Aki wakes up and says: "Every night the same dream, the same strange planet, but what are they trying to tell me?" This is indeed the struggle of the film, which is a failure as a narrative but extraordinarily important in the evolution of the animated cinema (Seager, Stokes, and Ragan-Kelley 2000).

Digital characters operate within human parameters and make decisions much like humans do. Their presence is complicated by the fact that they appear to live and breathe in transformed worlds. It is as if animators now have the capacity to extend the world of fantasy far beyond what is normally possible with real actors. This is not a matter of special effects designed artificially to create and sustain environments in which the impossible becomes real. This is a transformation of what is meant by reality within the normal constraints of the cinema. It may well signal a redesign of the relationship between technology and human beings.

Imagine an avatar that looks like a person, walks like a person, and is able to participate in worlds that people could never dream of entering. The magic here remains under the viewer's control. Spectators are able to explore microworlds and macroworlds through their avatars. They can return in time to the terrible excesses of a decaying Rome or go forward to hypothetical futures. As viewer-avatars play or walk among the people and places they and animators have created, they can change their characteristics to suit the feelings and responses they are having to the experience.

This comes close to the fictional *Holodeck* from *Star Trek, Voyager* where the thin boundary between the virtual and real often collapses. Extend what I have just said and imagine that it becomes possible to build computer games as players engage with them and as they play the games they are open

to redesign, if not transformation. The opaqueness of the digital world, the complex coding that underlies all software, could become transparent.

The notion that subjectivity and materiality can be molded to fit into digital spaces through an act of imagination is not only the central theme of *Final Fantasy* but is at the core of what computer scientists have been thinking about for decades. In late 1956, J. C. R. Licklider, who was a key figure in the history of the computer sciences, was wandering through the Lincoln Laboratory in Lexington, Massachusetts, when he encountered Wesley Clark and proceeded to talk to him about the future of computers: "Clark explained that he and his group were developing a new machine called the TX-2. Very cutting-edge stuff: not only was it one of the first computers to be built with transistors instead of vacuum tubes, but it had a display screen that you could program and interact with in real time. The whole idea was to make the computer interactive, exciting and fun, said Clark" (Waldrop 2001, 141). This is a vision that is still being explored today.

In *Final Fantasy* an entire future is built on assumptions that are derived from this drive toward interactivity within virtual and digital worlds. The story is simple. The earth has long ago been "invaded" and the battle for the future is premised on finding the correct pieces in a puzzle. Once the pieces have been found, the fragmentary and violent invasion will end and order will be restored. This narrative has been repeatedly explored in science fiction films. For the most part, the film's narrative is irrelevant since *Final Fantasy* is about technology and the sheer wonder of digital and virtual spaces. This is also why the box office receipts were very poor. Reanimating the world from a technical point of view is just not enough.

Why is *Final Fantasy* so different from its predecessors? It comes down to the ways in which cultures define their present and futures. Every story is about projection and the relationship between identification and character. Julia Roberts, for example, invites identification. This is her cultural role even though she may believe she is acting and playing characters viewers want to see. Roberts is a conduit for the desires of viewers and the need to move around in different imaginary and real spaces. She is relatively unimportant because so much of what she is as a star is dependent on the collective desire to "produce" her. This is a subtle point. The assumption is that Julia Roberts represents a look and personage that everyone wants to emulate. Rather, she is the basis for a series of projections that place viewers in contact with their own imaginations.

As it turns out, this is also the theme of *Final Fantasy*. The invaders who now control the earth are themselves ghosts. They extract the "spirits" of

people and as they eat the spirits, they fulfill some kind of primeval role that allows them to survive. They are hostile, but the activity seems to be painless to those who "die."

Aki's goal is to find nine spirits who will make her and civilization whole again. Over time, she becomes a conduit for the aliens and eventually she finds the solution. It is this sense of a conduit that is so crucial to the film's technical prowess and the success of the animation. Through projection, viewers slowly transform Aki and her friends into real characters. While the same process of projection and identification occurs with other animated films like *Monsters, Inc.* and *Toy Story, Final Fantasy* pushes further into the borders between reality and animation. Additional connections can be established with computer games, since the landscapes of *Final Fantasy* are very similar to what might be seen in a game, and it is not an accident that *Final Fantasy* first appeared as a computer game.

Of course, apocalyptic scenarios of destruction and dystopia also drive this film. The central importance of *Final Fantasy* is that photorealistic impulses construct a world that cannot be replicated in any other way. This questions what photorealism means and raises issues about the impact of engineering principles on storytelling. The photorealism operates from within the constraints of the screens and technology built and used by the creators of *Final Fantasy*. This is a microworld built from within the culture of computer-generated images (CGI) programmers.

It has long been the CGI artist's dream to create a computer-generated human character so real that a distinction cannot be made between its CG images and a live human. To realize that dream, SGITM visual workstation and server technology was chosen for the creation of the very first hyperreal all-CGI feature film, Final Fantasy: The Spirits Within. *With a cast whose physical and emotional characteristics are virtually indistinguishable from those of live human beings. (*Final Fantasy *2002a)*

This assertion, which was at the center of the publicity for *Final Fantasy*, details the degree of faith that CGI programmers have in the artificial worlds they create. In a sense, the images are meant to have so much intelligence built into their very fabric that any gaps between representation and visualization disappear.

This is, of course, the final fantasy of animators, to create worlds that are at one and the same time flexible, new, and faithful to the cultural standards of realism they are trying to uphold. It should not come as a surprise that this

has always been the fantasy of image creators, and at different historical moments, claims have been made about the realism of images that would seem quaint today. (In the early twentieth century, the mere appearance of "live" figures in a scene was considered strong evidence for the reproductive powers of the cinema.) In the following passage, animators take this desire to even greater heights:

Perhaps the greatest challenge is the reproduction of human skin texture. In some live-action features, images are actually digitally altered to reduce the wrinkles of the actors. In Final Fantasy: The Spirits Within, *the opposite was done: artists intentionally added wrinkles to characters with smooth skin texture to make them look natural and real.*

*Portraying the fluidity of human movement was also an integral part; animators maneuver the characters to show emotion through facial expressions and body movement. A human body changes shape and form as muscles extend and flex. Research on body deformation was essential to create a photorealistic human. (*Final Fantasy *2002b)*

The animators are dealing with the calculus of body reconstruction. I am not making a moral judgment here. Rather, the issue is one of conflation of the real and the animated—the differences between the "real" world and the "animated" world are what make the medium interesting. Second, irrespective of the "realism," images are images, and effects, however well constructed, are sites of visualization, not reproduction.

Ironically, then, the creators of *Final Fantasy* have fallen prey to one of the most fundamental myths of the cinema and art. Their energies and technology have been used to reproduce the human body in as much detail as possible. In this instance, they could have saved a great deal of money by using live actors. Instead, the "process" and all of its attractions pushed them forward. In this instance, the medium truly became the message.

By way of contrast, it is quite a shift for a film to be shot in digital video and then transformed into animation. Yet, that is exactly what Richard Linklater has done with his recent film *Waking Life*. In this instance and as a contrast to *Final Fantasy,* live video footage was "rotoscoped" or animated, frame by frame. This is not an unusual technique in the cinema, but it is rare for video, in part, because there are no frames in video. Rather, images flow by with little to indicate what separates them. In rotoscoping, the images are captured one by one and then transferred to a computer program where they can be altered, rendered, and recomposited in a variety of creative ways.

Waking Life reveals the extraordinary balance that can be created between hand-drawn and video images and the mixture of realism and animation that results. The style of the film cries out in a self-referential manner, suggesting that the "story" is as much about a character wandering through a dream as it is about the strategic choice to reanimate the world.

The intersection of rotoscoping, traditional animation, and digital technology suggests a new medium in the making as well as a new kind of creative work.

At the same time, audiences accustomed to the conventional separation of realism and fantasy will have to adjust to their integration. This hybridity is perhaps the most important characteristic of new forms of visualization. Equally, what is meant by visualization will have to change. This will have an impact on the role of information and the relationship between information and understanding.

One of the ironies of *Waking Life* is that it explores all these intermediate zones within which standard categories of explanation and creativity are being challenged. The main character cannot visualize a world without cause and effect. As he wanders from location to location and from person to person, he discovers that the absence of causality and conventional forms of explanation provide him with increasingly complex information about himself and the world. The natural links among knowledge, discovery, information, and predictability fall apart. This is, I would suggest, a central characteristic of the digital age.

It is also the most threatening aspect of visualization, since images no longer simply represent the world; they have become the foundation for understanding the spaces, places, and historical moments humans inhabit. The imagescapes and image-worlds that are being built recast what it means to engage with culture and context. It is not enough to claim that information communicated over networks is simply an add-on to existing forms of communications. Rather, image-worlds are dependent upon, and make possible, broader forms of interaction not only among people and images, but also between people and the communities in which they live.

So, Do Images Think?

The new forms of interaction I have been describing in this chapter are why, in my opinion, intelligence has become a *distributed* phenomenon. In the past, the holders of knowledge were a tiny elite of individuals trained in specialized areas. At present, so many elements of cultural and social activity are part of increasingly complex networks that it becomes impossible to specify one

center of information or knowledge. *Waking Life* was made by hundreds of individuals somewhat like P2P communities that work together to produce any number of images or artifacts. Musicians now regularly collaborate on compositions over great distances. Scientists use high-speed networks to develop and expand the parameters of their research. Doctors can work from city centers and still have an impact on remote areas. The intersections of human creativity, work, and connectivity are spreading intelligence through the use of mediated devices and images, as well as sounds. Layers upon layers of thought have been "plugged" into these webs of interaction. The outcome of these activities is that humans are now communicating in ways that redefine the meaning of subjectivity. It is not so much the case that images per se are thinking as it is the case that intelligence is no longer solely the domain of sentient beings. Throughout this book, I have emphasized the importance of hybrid forms of communication and interaction. The relations humans develop with their machines are as much about utilitarianism as they are about a middle ground of communication and interchange. Computers and humans are cooperating and producing outcomes that are not in one part or another of the exchange. This book has explored that middle ground or mediated space where images become more than just vehicles of communication: Images turn into intelligent arbiters of the relationships humans have with their mechanical creations and with each other.

REFERENCES

Adams, Ernest. 2001. "My 'Next' Games: Families, Psychology, and Murder." *Gamasutra*. Available online at <http://www.gamasutra.com/features/20010808/adams_01.htm>.

Arkin, Ronald C., Masahiro Fujita, Tsuyoshi Takagi, and Rika Hasegawa. 2001. "Ethological modeling and architecture for an entertainment robot." *Proceedings of the IEEE, International Conference on Robotics and Automation.* Seoul, Korea.

Alpha Worlds. 2003. Available online at <http://www.cybergeography.org/atlas/muds_vw.html>. Viewed on March 27, 2003.

Amant, Robert, and Michael Young. 2001. "Artificial intelligence and interactive entertainment." *Intelligence* 17 (summer).

Arnheim, Rudolf. 1969. *About thinking*. London: Faber and Faber.

Baer, Ulrich. 2002. *The Photography of Trauma*. Cambridge, MA: MIT Press.

Baigrie, Brian. 1996. Descartes' scientific illustrations and "la grand mécanique de la nature." In *Picturing knowledge: Historical and philosophical problems concerning the use of art in science,* Brian Baigrie, 86–134. Toronto: University of Toronto Press.

Barry, Anne M. 1997. Visual intelligence: Perception, image, and manipulation in visual communication. Albany: State University of New York Press.

Barthes, Roland. 1981. *Camera lucida: Reflections on photography.* Trans. Richard Howard. New York: Farrar, Straus and Giroux.

Bateson, Gregory. 1979. *Mind and nature: A necessary unity.* New York: Dutton.

Baudrillard, Jean. 1990. *Fatal strategies.* Trans. Philip Baitchman and W. G. J. Niesluchowski. New York: Semiotext (e).

Baudrillard, Jean. 1996. *Baudrillard on the new technologies.* An interview with Claude Thibaut. Available online at <http://www.uta.edu/english/apt/collab/texts/newtech.html>. Viewed on January 15, 2002.

Baudrillard, Jean. 2001. *Jean Baudrillard: Selected writings.* Ed. and with an introduction by Mark Poster. Stanford: Stanford University Press.

Beamish, A. 1995. *Communities on-line: A study of community-based computer networks.* Unpublished master's thesis, Massachusetts Institute of Technology. Available online at <http://sap.mit.edu/anneb/cn-thesis/>. Viewed on February 14, 2002.

Beaulieu, Anne. 2002. "A space for measuring mind and brain: Interdisciplinarity and digital tools in the development of brain mapping and functional imaging, 1980–1990." *Brain & Cognition* 49: 476.

Benedikt, Michael. 1992. "Cyberspace: Some proposals." In *Cyberspace: First steps,* ed. Michael Benedikt. Cambridge, MA: MIT Press.

Benjamin, Walter. 1968. *Illuminations.* Ed. and with an introduction by Hannah Arendt. Trans. Harry Zohn. New York: Harcourt, Brace & World.

Benjamin, Walter. 1999. *The arcades project.* Cambridge, MA: Harvard University Press.

Berger, John. 1980. *About looking.* New York: Pantheon.

Bergson, Henri, and Meredith George. 1956. *Comedy: An essay on comedy.* Garden City, NY: Doubleday.

Berners-Lee, Tim. 1999. *Weaving the web: The original design and ultimate destiny of the World Wide Web by its inventor.* New York: HarperCollins.

Beynon, Meurig, Yih-Chang Ch'en, Hsing-Wen Hseu, Soha Maad, Suwanna, Rasmequan, Chris, Roe, Jaratsri Rungrattanaubol, Steve Russ, Ashley Ward, and Allan Wong. 2001. "The Computer as Instrument." In *Cognitive technology:*

Instruments of mind, 476–489. Proceedings of the International Cognitive Technology conference. Berlin: Springer-Verlag.

Biocca, F. 2001. "The space of cognitive technology: The design medium and cognitive properties of virtual space (extended abstract)." In *Cognitive technology: Instruments of mind,* ed. M. Beynon et al., 55–56. Proceedings of the International Cognitive Technology conference. Berlin: Springer-Verlag.

Bohm, David, 1987. *Unfolding meaning: A weekend of dialogue with David Bohm.* London: Ark Paperback.

Bolter, Jay David. 1991. *The writing space: The computer, hypertext and the history of writing.* New York: Lawrence Erlbaum Associates.

Bolter, Jay David, and Richard Grusin. 1999. *Remediation: Understanding new media.* Cambridge, MA: MIT Press.

Bourdieu, Pierre. 1990. *Photography, a middle-brow art.* Stanford: Stanford University Press.

Brahm, Gabriel Jr., and Mark Driscoll. 1995. *Prosthetic territories: Politics and hypertechnologies.* Boulder: Westview Press.

Brooks, Troy. 2000. Interview about *Final Fantasy.* Available online at <http://www.arstechnica.com/wankerdesk/01q3/ff-interview/ff-interview-1.html>. Viewed on December 7, 2001.

Brown, John Seely, and Paul Duguid. 2000. *The social life of information.* Boston: Harvard Business School Press.

Bruckman, Amy, and Mitchell Resnick. 1995. "The mediaMOO project: Constructionism and professional community." *Convergence* 1, no. 1: 94–109.

Bruckman, Amy, Fred Martin, and Mitchell Resnick. 1996. "Pianos not stereos: Creating computational construction kits." *Interactions* 3, no. 6: 40–50.

Buchanan, Mark. 2002. *Nexus: Small worlds and the groundbreaking science of networks.* New York: Norton.

Burnett, Ronald, ed. 1991. *Explorations in film theory.* Bloomington: Indiana University Press.

Burnett, Ronald. 1995. *Cultures of vision: Images, media and the imaginary.* Bloomington: Indiana University Press.

Burnett, Ronald. 1996a. "Video: The politics of culture and community." In *Resolutions: essays on contemporary video practices,* ed. Michael Renov and Erika Suderberg, 283–303. Minneapolis: University of Minnesota Press.

Burnett, Ronald. 1996b. "A torn page . . . ghosts on the computer screen . . . words . . . images . . . labyrinths: Exploring the frontiers of cyberspace." In *Connected: engagements with media at the end of the century,* Late Editions #3, ed. George E. Marcus. 67–98. Chicago: University of Chicago Press.

Burnett, Ronald. 1999. "To document, to imagine, to simulate." In *Gendering the nation: Canadian women's cinema,* ed. Kay Armatage, Kass Banning, Brenda Longfellow, and Janine Marchessault. 120–133. Toronto: University of Toronto Press.

Burnham Van, and Ralph H. Baer. 2001. *Supercade: A Visual History of the Videogame Age 1971–1984.* Cambridge, MA. The MIT Press.

Bush, Vannevar. 1945. "As we may think." *Atlantic Monthly,* July. Available at <http://www.theatlantic.com/unbound/flshbks/computer/bushF.htm>. Viewed March 26, 2003.

Calvino, Italo. 1986. *Mr. Palomar.* London: Picador Books.

Calvino, Italo. 1988. *Six memos for the next millennium.* Cambridge, MA: Harvard University Press.

Campanella, Thomas. J. 2000. "Eden by wire: Webcameras and the telepresent landscape." In *The robot in the garden: Telerobotics and telepistemology in the age of the Internet,* ed. Ken Goldberg. Cambridge, MA: MIT Press.

Camus, Michel. 2002. *Transpoétique.* Montreal: Editions Trait D'Union.

Carey, James W. 1989. *Communication as culture: Essays on media and society.* Boston: Unwin Hyman.

Carpenter, Edmund. 1970. *They became what they beheld.* New York: Outerbridge & Dienstfrey.

Carpo, Mario. 2001. *Orality, writing, typography, and printed images in the history of architectural theory.* Trans. Sarah Benson. Cambridge, MA: MIT Press.

Carruthers, Peter, and Andrew Chamberlain. 2000. *Evolution and the human mind: Modularity, language and meta-cognition.* Cambridge: Cambridge University Press.

Carter, Paul. 1996. *The lie of the land.* London: Faber and Faber.

Cassell, J., and H. Wilhjálmsson. 1999. "Fully embodied conversational avatars: Making communicative behaviours autonomous." *Autonomous Agents and Multi-Agent Systems* 2, no. 1: 45–64.

Cassell, Justine, and Henry Jenkins, eds. 1998. *From Barbie to mortal Kombat: Gender and computer games.* Cambridge, MA: MIT Press.

Castells, Manuel. 1996. *The rise of the networked society.* Oxford: Blackwell Publishers.

Casti, John L. 1997. *Would-be worlds: How simulation is changing the frontiers of science.* New York: John Wiley & Sons.

Chomsky, Noam. 1968. *Language and mind.* New York: Harcourt, Brace and World.

Chomsky, Noam. 1980. "On cognitive structures and their development: A reply to Piaget." In *Language and learning: The debate between Jean Piaget and Noam Chomsky,* ed. Massimo Piatelli-Palmarini. 44–62. Cambridge, MA: Harvard University Press.

Chomsky, Noam. 2000. *New horizons in the study of language and mind.* Cambridge: Cambridge University Press.

Chong, Denise. 1998. *Girl in the picture: The story of Kim Phuc, the photograph and the Vietnam War.* New York: Viking.

Christianson, Clayton. 1997. *The innovator's dilemma: When new technologies cause great firms to fail.* Boston: Harvard Business School Press.

Churchland, Paul M. 1992. *A neurocomputational perspective: The nature of mind and the structure of science.* Cambridge, MA: MIT Press.

Churchland, Paul. 1995. *The engine of reason, the seat of the soul: A philosophical journey into the brain.* Cambridge, MA: MIT Press.

Clifford, James. 1988. *The predicament of culture: Twentieth century ethnography, literature and art.* Cambridge, MA: Harvard University Press.

Cohen, Anthony. 1989. *The Symbolic Construction of Community.* London: Routledge.

Coyne, Richard. 1999. *Technoromanticism: Digital narrative, holism and the romance of the real.* Cambridge, MA: MIT Press.

Crary, Jonathan. 1999. *Suspensions of perception: Attention, spectacle and modern culture.* Cambridge, MA: MIT Press.

Crawford, Chris. 2002. "Artists and engineers as cats and dogs: Implications for interactive storytelling." *Computers & Graphics* 26, no. 1: 13–20.

Cubitt, Sean. 1998. *Digital aesthetics.* London: Sage Publications.

Damsio, Antonio. 1999. *The feeling of what happens: Body and emotion in the making of consciousness.* New York: Harcourt, Brace and Company.

Daubner, Ernestine. 1998. *Interactive strategies and dialogical allegories: Encountering David Rokeby's transforming mirrors through Marcel Duchamp's open windows and closed doors.* Available online at <http://www.interlog.com/~drokeby/daubner.html>. Viewed on January 15, 2002.

Davis-Floyd, Robbie, and Joseph Dumit, eds. 1998. *Cyborg babies: From technosex to techno-tots.* New York: Routledge.

Debray, Regis. 1996. *Media manifestos: On the technological transmission of cultural forms.* London: Verso.

Deleuze, Gilles. 1986. *The time-image.* Trans. Hugh Tomlinson and Robert Galeta. Minneapolis: University of Minnesota Press.

Deleuze, Gilles. 1988. *Bergsonism.* Trans. Hugh Tomlinson and Barbara Habberjam. New York: Zone Books.

Dennett, Daniel. 1998. *Brainchildren: Essays on designing minds.* Cambridge, MA: MIT Press.

de Rosnay Joël. 2000. *The symbiotic man: A new understanding of the organization of life and a vision of the future.* New York: McGraw-Hill.

Dertouzos, Michael. 1997. *What will be: How the new world of information will change our lives.* New York: HarperEdge.

Eco, Umberto. 1984. *Semiotics and the philosophy of language.* London: Macmillan Press.

Eco, Umberto. 1997. *Kant and the platypus: Essays on language and cognition.* New York: Harcourt.

Edelman, Gerald. 1989. *The remembered present: A biological theory of consciousness.* New York: Basic Books.

Edelman, Gerald. 1992. *Brilliant air, brilliant fire: On the matter of mind.* New York: Basic Books.

Edelman, Gerald. 2001. "Building a picture of the brain." In *The brain,* ed. Gerald Edelman and Jean-Pierre. Changeux. New Brunswick: Transaction Publishers.

Edelman, Gerald, and Giulio Tononi; 2000. *A universe of consciousness: how matter becomes imagination.* New York: Basic Books.

Elkins, James. 1999. *The domain of images.* Ithaca, NY: Cornell University Press.

Engelbart, Douglas C. 1962. *Augmenting human intellect: A conceptual framework.* Summary report AFOSR-3223 under Contract AF 49(638)-1024, SRI Project 3578 for Air Force Office of Scientific Research, Stanford Research Institute, Menlo Park, California. Available online at <http://www.histech.rwth-aachen.de/www/quellen/engelbart/2framework.html#II.C.1>. Viewed on April 9, 2002.

Entis, Glenn. 2002. Personal communication. March 14, 2002.

Falk, Jennica, Johan Redström, and Staffan Björk. 1999. "Amplifying reality." *Proceedings, First International Symposium on Handheld and Ubiquitous Computing (HUC).* Berlin: Springer-Verlag.

Feigenbaum, Edward, and Julian Feldman, eds. 1963. *Computers and thought.* New York: McGraw-Hill.

Felman, Shoshana, and Dori Laub. 1992. *Testimony: crises of witnessing in literature, psychoanalysis, and history.* New York: Routledge.

Final Fantasy: The spirits within. 2002a. Available online at <http://www.sgi.com/features/2001july/fantasy>. Viewed on March 15, 2002.

Final Fantasy: The spirits within. 2002b. Available online at <http://www.sgi.com/features/2001july/fantasy>. Viewed on June 5, 2002.

Fodor, Jerry. 2000. *The mind doesn't work that way: The scope and limits of computational psychology.* Cambridge, MA: MIT Press.

Forsythe, Diana. 2001. *Studying those who study us: An anthropologist in the world of artificial intelligence.* Stanford, CA: Stanford University Press.

Friedländer, Saul. 1984. *Reflections on Nazism: An essay on kitsch and death.* New York: Harper and Row.

Fritz, Jimi 1999. *Rave culture: An insider's overview.* Vancouver: Small Fry Press.

Frölich, Torsten. 2000. "The virtual oceanarium." *Communications of the ACM* 43, no. 7: 95–101.

Frontiers, the electronic newsletter of the National Science Foundation. Available online at <http://www.nsf.gov/od/lpa/news/publicat/frontier/7-97/7retina.htm>. Viewed on May 28, 2002.

Fukuyama, Francis. 2002. *Our posthuman future: Consequences of the biotechnology revolution.* New York: Farrar, Straus and Giroux.

Fuller, Steve. 2000. *Thomas Kuhn: A philosophical history for our times.* Chicago: University of Chicago Press.

Gallagher, Jean. 2000. *The merging of the arts with technology.* ACM Multimedia Workshop. Del Ray, California. Available online at <http://www.acm.org>. Viewed on February 17, 2002.

Gershon, Nahum, and Ward Page. 2001. "What storytelling can do for information visualization," *Communications of the ACM* 44, no. 8: 9–15.

Gigliotti, Carol. 2002. "Reverie, Osmose and Ephémère, an interview with Char Davies." *n.paradoxa* 9:64–73.

Gladwell, Malcolm. 1999. "Clicks and mortar, don't believe the internet hype: The real e-commerce revolution happened off-line." *New Yorker,* December 6.

Gould, Stephen Jay. 2002. *The structure of evolutionary theory.* Cambridge, MA: Harvard University Press.

Grau, Oliver. 1999a. *The history of telepresence: Automata, illusion and the rejection of the body.* Available online at <http://www.itaucultural.org.br/invencao/papers/Grau.html>. Viewed on January 25, 2002.

Grau, Oliver. 1999b. *Into the belly of the image: Historical aspects of virtual reality.* Available online at <http://waste.infomatik.hu-berlin.de/mtg/graubell.html>. Viewed on January 25, 2002.

Grau, Oliver. 2003. *Virtual art: From illusion to immersion.* Cambridge, MA: MIT Press.

Grier, David. 2001. "Human computers: The first pioneers of the information age." *Endeavor* 25, no. 1: 28–32.

Grotstein, James S. 2000. *Who is the dreamer who dreams the dream?* London: The Analytic Press.

230 Habermas, Jürgen. 1984. *The theory of communicative action,* vol. 1. In *Reason and rationalization of society,* trans. Thomas McCarthy. Boston: Beacon Press.

Hankins, Thomas, and Robert Silverman. 1995. *Instruments and the imagination.* Princeton: Princeton University Press.

Haraway, Donna J. 1991. *Simians, cyborgs, and women: The reinvention of nature.* New York: Routledge.

Haraway, Donna J. 1997. *Modest_Witness@Second_Millenium. FemaleMan©_ Meets_OncoMouse.* New York: Routledge.

Harris, Craig. 1999. *Art and innovation: The Xerox Parc Artist-in-Residence Program.* Cambridge, MA: MIT Press.

Hayles, Katherine. 1999. *How we became posthuman: Virtual bodies in cybernetics, literature, and informatics.* Chicago: University of Chicago Press.

Hayles, Katherine. 2000. "The condition of virtuality." In *The digital dialectic: New essays on new media,* ed. Peter Lunenfeld. 68–95. Cambridge, MA: MIT Press.

Hayles, Katherine. 2002. *Writing machines.* Cambridge, MA: MIT Press.

Helmreich, Stefan. 1998. *Silicon second nature: Culturing artificial life in a digital world.* Berkeley: University of California Press.

Herz, J. C. 1997. *Joystick nation: How videogrames ate our quarters, won our hearts, and rewired our minds.* New York: Little, Brown and Company.

Hillis, Ken. 1999. *Digital sensations: Space, identity and embodiment in virtual reality.* Minneapolis: University of Minnesota Press.

Hofstadter, Douglas. 1979. *Gödel, Escher, Bach: An eternal golden braid.* New York: Basic Books.

Horgan, John. 1999. *The undiscovered mind: How the human brain defies replication, medication and explanation.* New York: Free Press.

Huizinga, Johan. 1966. *The autumn of the Middle Ages,* trans. Rodney J. Payton and Ulrich Mammitzsch. Chicago: University of Chicago Press.

Jay, Martin. 1993. *Downcast eyes: The denigration of vision in twentieth-century French thought.* Berkeley: University of California Press.

Johnson, Mark. 1987. *The body in the mind: The bodily basis of meaning, imagination and reason.* Chicago: University of Chicago Press.

Johnson, Steven. 1997. *Interface culture. How new technology transforms the way we create and communicate.* San Francisco: HarperEdge.

Johnson, Steven. 2001. *Emergence: The connected lives of ants, brains, cities and software.* New York: Scribner.

Jones, Steven G., ed. 1995. *CyberSociety: Computer-mediated communication and community.* Thousand Oaks, CA: Sage Publications.

Joyce, Michael. 2000. *Othermind-edness: The emergence of networked culture.* Ann Arbor: The University of Michigan Press.

Keim, Daniel. 2001. "Visual exploration of large Data sets." *Communications of the ACM* 44, no. 8: 39–44.

Kember, Sarah. 1998. *Virtual anxiety: Photography, new technologies and subjectivity.* Manchester: Manchester University Press.

Kittler, Friederich, A. 1986. *Gramophone, film, typewriter.* Berlin: Brinkmann and Bose.

Koenen, Rob. 1999. *Beyond MPEG-2—New possibilities for multimedia services.* International Broadcast Convention in Amsterdam, the Netherlands. Available online at <http://mpeg.telecomitalialab.com/documents/ibc_tutorial/rob/ppframe.htm>. Viewed on April 13, 2002.

Koman, Richard. 2001. "David Anderson: Inside SETI@Home." Available online at <http://www.openp2p.com/lpt/a//p2p/2001/02/15/anderson.html>. Viewed on May 14, 2002.

Kreuger, Myron. 2001. "Myron Kreuger live." Interviewed by Jeremy Turner. *CTHEORY* 25, nos. 1–2.

Kuhn, Thomas. 1962. *Structure of scientific revolutions.* Chicago: University of Chicago Press.

Kurzweil, Ray. 1999. *The age of spiritual machines: When computers exceed human intelligence.* New York: Viking.

Lakoff, George, and Mark Johnson. 1999. *Philosophy in the flesh: The embodied mind and its challenge to western thought.* New York: Basic Books.

232 Landow, George. 1997. *Hypertext 2.0: The convergence of contemporary critical theory and technology.* Baltimore, MD: Johns Hopkins University Press.

Langton, C. G., ed. 1989. "Artificial life." *SFI Studies in the Sciences of Complexity* 6: 1–44. Redwood City, CA: Addison-Wesley.

Latour, Bruno. 1994. "On technical mediation: Philosophy, sociology, genealogy." *Common Knowledge* 3, no. 2: 29–64.

Latour, Bruno. 1996. "Do scientific objects have a history?" *Common Knowledge* 5, no. 1: 76–91.

Latour, Bruno. 1996. *Aramis or the love of technology.* trans. Catherine Porter. Cambridge, MA: Harvard University Press.

Latour, Bruno. 1999. *Pandora's hope: Essays on the reality of science studies.* Cambridge, MA: Harvard University Press.

Latour, Bruno. 2002. "What is iconoclash? Or is there a world beyond the image?" Available online at <http://www.ensmp.fr/~latour/livres/cat_icono_chap.html>. Viewed on March 29, 2003.

Lederman, Leon. 1993. *The God particle: If the universe is the answer, what is the question?* New York: Dell Books.

Lenoir, Tim. 2000. "All but war is simulation: The military-entertainment complex." *Configurations* 8: 289–335.

Lessig, Lawrence. 1999. *Code and other laws of cyberspace.* New York: Basic Books.

Lessig, Lawrence. 2001. *The future of ideas: The fate of the commons in a connected world.* New York: Random House.

Levi, Primo. 1988. *The drowned and the saved.* New York: Simon and Schuster.

Lévi-Strauss, Claude. 1997. *Look listen read.* New York: Basic Books.

Llinás, Rodolfo. 2001. *I of the vortex: From neurons to self.* Cambridge, MA: MIT Press.

Lohr, Steve. 2001. *Go to: The story of the math majors, bridge players, engineers, chess wizards, maverick scientists and iconoclasts—the programmers who created the software revolution.* New York: Basic Books.

Maeda, John. 2001. *Screen: Essays on graphic design, new media and visual culture*. Princeton, NJ: Princeton Architectural Press.

Mann, Charles. 2002. "Why software is so bad." *Technology Review* 105, no. 6: 33–38.

Manovich, Lev. 2001. *The language of new media*. Cambridge, MA: MIT Press.

Manuel, Peter. 1993. *Cassette culture: popular music and technology in North India*. Chicago: University of Chicago Press.

Marcus, George, and Michael Fischer. 1986. *Anthropology as cultural critique: An experimental moment in the human sciences*. Chicago: University of Chicago Press.

Maynard, Patrick. 1997. *The engine of visualization: Thinking through photography*. Ithaca: Cornell University Press.

McCarthy, Anna. 2001. *Ambient television: Visual culture and public space (Console-ing passions)*. Durham: Duke University Press.

McLuhan, Marshall. 1994. *Understanding media: The extensions of man*. Cambridge, MA: MIT Press.

Menzel, Peter, and Faith D'Aluisio. 2000. *Robo-sapiens: Evolution of a new species*. Cambridge, MA: MIT Press.

Meyer, Mark, Gilles Debunne, Mathieu Desbrun, and Alan Barr. 2001. "Interactive animation of cloth-like objects in virtual reality." *The Journal of Visualization and Computer Animation* 12: 1–12.

Mignonneau, Laurent, and Christa Sommerer. 2001. "Creating artificial life for interactive art and entertainment." *Leonardo* 34, no. 4.

Minsky, Marvin. 1982. "Why people think computers can't." *AI Magazine* 3, no. 4.

Mitchell, Melanie. 1998. *Life and evolution in computers*. Paper from the Los Alamos National Laboratory for the Santa Fe Institute. Available online at <http://www.santafe.edu/~mm/paper-abstracts.html#lec>. Viewed on February 8, 2002.

Mitchell, W. J. T. 1986. *Iconology: Image, text, ideology*. Chicago: University of Chicago Press.

Mitchell, William J. 1992. *The reconfigured eye: Visual truth in the post-photographic era*. Cambridge, MA: MIT Press.

Mohammadi, Ali, and Annabelle Sreberny-Mohammadi. 1994. *Small media, big revolution: Communication, culture, and the Iranian revolution.* Minneapolis: University of Minnesota Press.

Moravec, Hans. 1991. "The universal robot." In *Out of Control.* Linz: Landesverlag.

Murray, Janet. 1997. *Hamlet on the holodeck: The future of narrative in cyberspace.* Cambridge, MA: MIT Press.

Nardi, Bonnie, and Vicki O'Day. 1999. *Information ecologies: Using technology with heart.* Cambridge, MA: MIT Press.

Newman, Charles. 1985. *The post-modern aura: The act of fiction in an age of inflation.* Evanston, IL: Northwestern University Press.

Noble, Jason, Seth Bullock, and Ezequiel Di Paolo. 2000. "Artificial life: Discipline or method?" *Artificial Life* 6.

Norman, Donald A. 2001. "Cyborgs." *Communications of the ACM* 44, no. 3: 36–37.

Norretranders, Tor. 1998. *The user illusion: Cutting consciousness down to size.* New York: Viking.

O'Donnell, James. 1998. *Avatars of the word: From papyrus to cyberspace.* Cambridge, MA: Harvard University Press.

O'Reilly, Tim. 2001. "Remaking the peer-to-peer meme." In *Peer-to-Peer: Harnessing the power of disruptive technologies,* ed. Andy Oram. Sebastopol, CA: O'Reilly & Associates.

Ossman, Susan. 1994. *Picturing Casablanca: Portraits of power in a modern city.* Berkeley: University of California Press.

Paittelli-Palmarini, Massimo, ed. 1980. *Language and learning: The debate between Jean Piaget and Noam Chomsky.* Cambridge, MA: Harvard University Press.

Picard, Rosalind. 1997. *Affective computing.* Cambridge, MA: MIT Press.

Park, David. 1997. *The fire within the eye: A historical essay on the nature and meaning of light.* Princeton, NJ: Princeton University Press.

Pearce, Celia. 2002. "Emergent authorship: The next interactive revolution." *Computers & Graphics* 26.

Pesce, Mark. 1998. 3D Epiphany. Available online at <http://www.salon.com/21st/feature/1998/07/cov_13feature.html>. Viewed on January 10, 2002.

Pesce, Mark. 2000. *The playful world: How technology is transforming our imagination.* New York: Ballantine Books.

Piaget, Jean. 1951. *Play, dreams, and imitation in childhood.* New York: Norton.

Piekarsky, Wayne, and Bruce Thomas. 2002. "ARQuake: The outdoor augmented reality gaming system," *Communications of the ACM* 45, no. 1: 36–38.

Pinker, Steven. 1997. *How the mind works.* New York: Norton.

Pinker, Steven. 2002. *The blank slate: The modern denial of human nature.* New York: Viking.

Pixar Studios. 2003. Available online at <http://www.pixar.com/howwedoit/index.html>. Viewed on March 25, 2003.

Powers, Richard. 2000. *Plowing in the dark.* New York: Farrar, Straus and Giroux.

Price, Mary. 1994. *The photograph: A strange confined space.* Stanford: Stanford University Press.

Quarterman, John S. 1990. *The matrix: Computer networks and conferencing systems worldwide.* Bedford, MA: Digital Press.

Ramachandran, V. S., and Sandra Blakeslee. 1998. *Phantoms in the brain: Probing the mysteries of the human mind.* New York: Morrow.

Raymond, Eric S. 1999. *The cathedral and the bazaar: Musings on linux and open source by an accidental revolutionary.* Sebastopol, CA: O'Reilly & Associates.

Resnick, Mitchell. 1997. *Turtles, termites and traffic jams: Explorations in massively parallel microworlds.* Cambridge, MA: MIT Press.

Rheingold, Howard. 1993. *The virtual community: Homesteading on the electronic frontier.* Reading, MA: Addison-Wesley.

Roethke, Theodore. 1966. "Bring the day." In *The collected poems of Theodore Roethke.* New York: Doubleday.

Rokeby, David. 1996. *Transforming mirrors: Designing the future.* Available online at <http://www.interlog.com/~drokeby/mirrorsconclusion.html>. Viewed on January 15, 2002.

Ronell, Avita. 1989. *The telephone book: Technology-schizophrenia-electric speech.* Lincoln: University of Nebraska Press.

Rorty, Richard. 1989. *Contingency, irony and contingency.* Cambridge: Cambridge University Press.

Rorty, Richard. 1991. *Objectivity, relativism and truth.* Cambridge: Cambridge University Press.

Rouse, Richard. 2001. *Game design: Theory and practice.* Plano, TX: Wordware Publishing.

Ryan, Marie-Laure. 2001. Narrative as virtual reality: Immersion and interactivity in literature and electronic media. Baltimore, MD: The Johns Hopkins University Press.

Sacks, Oliver. 1985. *The man who mistook his wife for a hat and other clinical tales.* New York: Summit Books.

Schank, Roger. 1997. "I'm sorry, Dave, I'm afraid I can't do that": How Could HAL Use Language?" In *HAL's legacy: 2001's computer as dream and reality,* ed. David Stork. Cambridge, MA: MIT Press.

Schama, Simon. 1995. *Landscape and memory.* New York: Knopf.

Scharf, Aaron. 1968. *Art and photography.* London: Penguin Books.

Schleiner, Anne-Marie. 1998. *Gendered avatars.* Available online at <http://www.opensorcery.net/skool/games&art/avatar.html>. Viewed on January 14, 2001.

Schleiner, Anne-Marie. 2001. "Does Lara Croft wear fake polygons? Gender and gender-role subversion in computer adventure games," *Leonardo* 34, no. 3: 221–226.

Schuler, Douglas. 1996. *New community networks, wired for change.* Reading, MA: Addison-Wesley.

Schwartz, Hillel. 1996. *The culture of the copy: Striking likenesses, unreasonable facsimiles.* New York: Zone Books.

Scientific American. 2000. News Briefs 283, no. 1 (July): 26.

Seager, Dave, Jon "Hannibal" Stokes, and Jonathan Ragan-Kelley. 2000. Interview about *Final Fantasy.* Available online at <http://www.arstechnica.com/wankerdesk/01q3/ff-interview/ff-interview-1.html>. Viewed on December 7, 2001.

Searle, John. 1998. *Mind, language and society: Philosophy in the real world.* New York: Basic Books.

Searle, John. 1992. *The rediscovery of the mind.* Cambridge, MA: MIT Press.

Seiter, Ellen. 1999. *Television and new media audiences.* Oxford: Oxford University Press.

Semprun, Jorge. 1997. *Literature or life.* New York: Viking.

Serres, Michel. 1995. *Michel Serres with Bruno Latour: Conversations on science, culture and time.* Ann Arbor: University of Michigan Press.

Shannon, Claude E. 1948. "A mathematical theory of communication." *The Bell System Technical Journal* 27.

Shapin, Steven. 1998. "The philosopher and the chicken: On the dialectics of dis-embodied knowledge." In *Science Incarnate: Historical Embodiments of Natural Knowledge,* ed. Christopher Lawrence and Steven Shapin, 26–42. Chicago: University of Chicago Press.

Sheehan, James, and Morton Sosna, eds. 1991. *The boundaries of humanity: Humans, animals, machines.* Berkeley: University of California Press.

Shenk, David. 1998. *Data smog: Surviving the information glut.* San Francisco: Harper.

Shurkin, Joel. 1996. *Engines of the mind: The evolution of the computer from mainframes to microprocessors.* New York: Norton.

Slade, Mark. 1970. *The language of change: Moving images of man.* Toronto: Holt, Rinehart & Winston.

Smith, Brian Cantwell. 1998. *On the origin of objects.* Cambridge, MA: MIT Press.

Snider, Burr. 1995. "The Toy Story, story." *Wired* 3, no. 12.

Snyder, Ilana, ed. 1998. *Page to screen: Taking literacy into the electronic era.* New York: Routledge.

Sommerer, Christa, and Laurent Mignonneau. 1998. "Introduction: Art and science—a model of a new dynamic interrelation." In *Art@Science,* ed. Christa Sommerer and Laurent Mignonneau, 7–23. New York: Springer-Verlag.

Sontag, Susan. 1978. *On photography.* London: Allen Lane.

238 Stafford, Maria Barbara. 1996. *Good looking: Essays on the virtue of images.* Cambridge, MA: MIT Press.

Stafford, Maria Barbara, and Francis Terpak. 2001. *Devices of wonder: From the world in a box to images on a screen.* Los Angeles, CA: Getty Publications.

Standage, Tom. 1998. *The Victorian Internet.* The remarkable story of the telegraph and the nineteenth-century's on-line pioneers. New York: Berkley Books.

Stanton, Jeffrey. 1997. Available online at <http://naid.sppsr.ucla.edu/expo67/map-docs/labyrinth.html>. Viewed on March 25, 2003.

Steadman, Philip. 2001. *Vermeer's camera: Uncovering the truth behind the masterpieces.* Cambridge: Oxford University Press.

Steinberg, Leo. 2001. *Leonardo's incessant last supper.* New York: Zone Books.

Stephens, Mitchell. 1998. *The rise of the image and the fall of the word.* New York: Oxford University Press.

Stock, Gregory. 2002. *Redesigning humans: Our inevitable genetic future.* New York: Houghton Mifflin Company.

Stone, Allucquère. 1995. *The war of desire and technology at the close of the mechanical age.* Cambridge, MA: MIT Press.

Stork, David G. 1997a. *The end of an era, The beginning of another? HAL, Deep Blue and Kasparov.* Available online at <http://www.research.ibm.com/deepblue/learn/html/e.8.1c.html>. Viewed on May 26, 2002.

Stork, David G., ed. 1997b. *HAL's Legacy: 2001's computer as dream and reality.* Cambridge, MA: MIT Press.

Swade, Doron. 2000. *The difference engine: Charles Babbage and the quest to build the first computer.* New York: Viking.

Taylor, Charles. 1989. *Sources of self: The making of modern identity.* Cambridge, MA: Harvard University Press.

Terzopoulos, Dimitri. 1998. "Artificial life for computer animation." In *Art@Science,* ed. Christa Sommerer and Laurent Mignonneau, 69–77. New York: Springer-Verlag.

Thacker, Eugene. 2001. "The science fiction of technoscience: The politics of simulation and a challenge for new media art." *Leonardo* 34, no. 2.

Thon, Sebastien, and Djamchid Ghazanfarpour. 2002. "Ocean waves synthesis and animation using real world information." *Computers & Graphics* 26: 14–22.

Torsten, Fröhlich. 2000. "The virtual oceanarium," *Communications of the ACM* 43, no. 7: 95–101.

Tufte, Edward. 1990. *Envisioning information.* Cheshire, CT: Graphics Press.

Turoff, Murray. 1997. "Virtuality." *Communications of the ACM* 40, no. 9: 38–43.

Turkle, Sherry. 1995. *Life on the screen: Identity in the age of the internet.* New York: Simon and Schuster.

Tyler, Stephen. 1987. *The unspeakable: Discourse, dialogue and rhetoric in the postmodern world.* Madison: University of Wisconsin Press.

Ultima 2. 2002a. Available online at <http://www.u02.com>. Viewed on October 19, 2002.

Ultima 2. 2002b. Available online at <http://www.origin.ea.com>. Viewed on October 19, 2002.

University of Utah Computing Science Department. 2002. Available online at <http://www.cs.utah.edu/research/areas/immersive/locomotion.html>. Viewed on March 25, 2003.

Uttecht, S., and K. Thulborn. 2002. "Software for efficient visualization and analysis of multiple, large multi-dimensional data set from magnetic resonance imaging." *Computerized Medical Imaging and Graphics* 26: 43–58.

Van Dam, Andries. 2001. "User interfaces: disappearing, dissolving, and evolving," *Communications of the ACM* 44, no. 3: 50–52.

Vasseleu, Cathryn. 1998. *Textures of light: Vision and touch in Irigaray, Levinas and Merleau-Ponty.* New York: Routledge.

Vilhjálmsson, H. 1997. *Autonomous communicative behaviors in avatars.* Master's thesis in Media Arts and Sciences, Massachusetts Institute of Technology.

Waldby, Catherine. 2000. *The visible human project: Informatic bodies and posthuman medicine.* New York: Routledge.

Waldrop, Mitchell M. 2001. *The dream machine: J. C. K. Licklider and the revolution that made computing personal.* New York: Viking.

240 Wall, Jeff. [1998] 2002. *Jeff Wall.* London: Phaidon.

Walton, Kendall. 1990. *Miemsis as make-believe: On the foundations of the representational arts.* Cambridge, MA: Harvard University Press.

Warwick, Kevin. 2000. *I, Cyborg.* Prometheus 04.

Weiss, Allen. 1989. *The aesthetics of excess.* Albany: State University of New York Press.

Wilden, Anthony. 1972. *System and structure: Essays in communication and exchange.* London: Tavistock.

Williams, Raymond. 1966. *Culture and society, 1780–1950.* New York: Harper and Row.

Williams, Raymond. 1989. *Raymond Williams on television: Selected writings,* ed. Alan O'Connor. Toronto: Between the Lines.

Winnicott, Donald. 1965. *The child, the family and the outside world.* Harmondsworth, England: Penguin Books.

Wittgenstein, Ludwig. 1965. *The blue and brown books.* New York: Harper Torchbooks.

Wolf, Mark, ed. 2001. *The medium of the video game.* Austin: University of Texas Press.

Woolley, Benjamin. 1992. *Virtual worlds.* Oxford: Blackwell.

Yates, Francis. [1966] 1974. *The art of memory.* Chicago: University of Chicago Press.

Youngblood, Gene. 1970. *Expanded cinema.* New York: Dutton.

INDEX